The

Interior
Design

Reference +
Specification
Book

M000284943

**Updated +
Revised**

Inspiring | Educating | Creating | Entertaining

Brimming with creative inspiration, how-to projects, and useful information to enrich your everyday life, Quarto Knows is a favorite destination for those pursuing their interests and passions. Visit our site and dig deeper with our books into your area of interest: Quarto Creates, Quarto Cooks, Quarto Homes, Quarto Lives, Quarto Drives, Quarto Explores, Quarto Gifts, or Quarto Kids.

© 2007, 2013, 2018 by Rockport Publishers, Inc.

This edition published in 2018
First published in 2013 by Rockport Publishers, an imprint of The Quarto Group,
100 Cummings Center, Suite 265-D, Beverly, MA 01915, USA.
T (978) 282-9590 F (978) 283-2742 QuartoKnows.com

All rights reserved. No part of this book may be reproduced in any form without written permission of the copyright owners. All images in this book have been reproduced with the knowledge and prior consent of the artists concerned, and no responsibility is accepted by producer, publisher, or printer for any infringement of copyright or otherwise, arising from the contents of this publication. Every effort has been made to ensure that credits accurately comply with information supplied. We apologize for any inaccuracies that may have occurred and will resolve inaccurate or missing information in a subsequent reprinting of the book.

Rockport Publishers titles are also available at discount for retail, wholesale, promotional, and bulk purchase. For details, contact the Special Sales Manager by email at specialsales@quarto.com or by mail at The Quarto Group, Attn: Special Sales Manager, 100 Cummings Center, Suite 265-D, Beverly, MA 01915, USA.

Originally found under the following Library of Congress Cataloging-in-Publication Data

Grimley, Chris.
 Color, space, and style : all the details interior designers need to know but can never find / Chris Grimley, Mimi Love.
 p. cm.
 Includes index.
 ISBN 1-59253-227-6
 1. Interior decoration–Handbooks, manuals, etc. I. Love, Mimi. II. Title.
 NK2115.G75 2007
 747–dc22

 2007015924

ISBN: 978-1-63159-380-2

The orignial edition of this book, *Color Space, and Style*, was published by Rockport Publishers in 2007.

The content of this book is for general information purposes only and has been obtained from many sources, including professional organizations, manufacturers' literature, and national codes and guidelines. The authors and publisher have made every reasonable effort to assure that this work is accurate and current, but do not warrant, and assume no liability for, the accuracy or completeness of the text or illustrations, or their fitness for any particular purpose. It is the responsibility of the users of this book to apply their professional knowledge to the content, to consult sources referenced, when appropriate, and to consult a professional interior designer for expert advice if necessary.

Editor and Art Director: Alicia Kennedy
Additional Content: Linda O'Shea
Cover Image: Knoll, Inc.
Graphic Design: Chris Grimley and Shannon McLean for over,under

The

Interior
Design

Updated + Revised

Reference +
Specification
Book

Everything Interior Designers Need to Know Every Day

Chris Grimley +
Mimi Love

CONTENTS

i.

INTRODUCTION

This book was conceived as a resource for a wide readership, whether in answering specific questions for established interior designers or providing an overview of the design process for the layperson. It is compact and easy to slip into a shoulder bag, but precisely because of its handy size, it cannot address every issue related to interior design. Instead, we believe that by distilling the essential principles of interior design and clarifying steps and goals of the design process itself, higher quality design will reach the broadest possible audience.

Guides to interior design generally fall into two categories. The first type is the beautiful coffee table book by style mavens. These books are full of personality and style, but lack an overall structure that describes the fundamental principles for making design decisions. The second type is the design manual. These volumes are full of useful information, but eschew a specific attitude about design strategies. Our goal is to create the classic textbook for interior design, yet with more inspiring design theory and better visual taste. We hope this book presents a fresher approach that represents the cultural preoccupations of a younger generation of designers.

The book has been organized thematically into six sections:

Section 1, "Fundamentals," provides a step-by-step examination of an interior project. It describes the scope of professional services, the project schedule, and drawing and presentation techniques.

Section 2, "Space," offers an overview of the design of rooms and larger sequences of spaces, while addressing functional and life-safety issues.

Section 3, "Surface," details specific tactics for designing with color, materials, textures, and patterns. It also considers performance and maintenance issues.

Section 4, "Environments," looks at aspects of interior design that help to create a specific mood or character, such as natural and artificial lighting, and the invisible systems that impact the comforts of a space.

Section 5, "Elements," identifies useful details for a range of interior applications. It also includes a chart of canonical twentieth-century furniture—pieces every interior designer should know. In addition, it outlines ideas for the display of artwork, collectibles, and accessories.

Section 6, "Resources," provides a wealth of useful information, from a summary of sustainable design strategies to lists of recommended books, blogs, and websites.

Finally, we have interspersed throughout the book interviews with our favorite practitioners to demonstrate how the topics covered in each section can be creatively interpreted in practice.

1.

FUNDAMENTALS

Managing an interior design project requires as much creative thought-fulness as the design itself, and the best projects begin with a carefully planned project schedule. Typically, a project process is broken down into distinct phases to establish decision-making milestones, both within the design team and with the client. At the beginning of the design process, innumerable options present themselves, but as the design progresses, the number of options gradually reduces as the project gels around specific themes and configurations.

Drawings are the primary format through which design choices are explored and communicated. The mode of drawing changes as the project is refined and finessed. At the beginning of the design, freehand sketches are the best way to test concepts, while later in the process, computer-aided design (CAD) is necessary to fine-tune dimensional decisions and coordinate with consulting engineers. New technologies are making it easier to explore design concepts in three dimensions at several stages of the design process.

Chapter 1: Starting an Interior Project

The thought of starting an interior project can be daunting; however, with a bit of strategic planning, a project can be launched smoothly and effectively. Whatever the scale of the project, four basic elements must be considered from the beginning: **project site**, **program**, **schedule**, and **budget**. These four items are seldom determined exclusively by the client or the designer, but usually by both in collaboration. The fewer the variables, the more efficient the process will be.

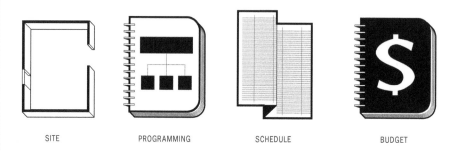

| SITE | PROGRAMMING | SCHEDULE | BUDGET |

PROJECT SITE

In general, a client engages a designer once a site or space is in hand. It is then the designer's task to analyze the space to ensure that it will meet the client's needs. Sometimes, a client may not have a single space in mind, but rather a few options that the designer will test to ascertain which one best suits the client's needs. Both of these scenarios suggest that the client is working toward a particular program; however, sometimes the physical space generates the program. In this case, the designer's task is to decide the best layout for the space and design a program within those constraints.

PROGRAMMING

Programming *is the process of defining the needs of those who will use the space, in advance of creating the design.* Whether for a home kitchen renovation or for a newly constructed restaurant, this exercise should evaluate the functional performance, opportunities, and constraints of the existing space. Furthermore, the program should articulate what spaces, features, or attributes must be added to improve functionality and give an appropriate and compelling character to a space. The programmatic goals should be precisely qualified in a brief, the written document that outlines all functional, dimensional, and relational requirements. This list of objectives will form the basis for evaluating design solutions in subsequent phases of the project.

Programming can be broken down into three central types of activities: *gathering, analyzing, and documenting* information. Within this framework, the process for establishing the project goals and the format of the program wish list can vary widely. For small projects, gathering data and analyzing the client's needs are essential; providing a written report is less so. That said, to avoid miscommunication, some record of the process must be made. Thus, programming might consist of a filled-in questionnaire, a detailed interview, or a inventory that defines the microdeterministic issues, such as the number and type of shoes within a closet or the amount of cupboard space needed to accommodate everyday dishes and fine china. For large corporate and institutional projects, the designer will need to listen to and put in order criteria from a broad range of stakeholders. Often, the interior designer must synthesize conflicting information and make recommendations to the client that can have policy implications beyond physical planning. Documentation is essential. In all cases, the designer is required to prioritize wish lists to make meaningful and finite design decisions.

Although this step might at times seem extraneous, **programming** *is critical to the design process because it is here that the client's problems and goals are clearly identified.* Good communication is key to articulating the program and managing expectations for the design phase. A lack of understanding the goals at this stage may result in cost overruns during the construction phase or, even more detrimental, a project that does not meet the client's basic needs. Ideally, the program serves as a core map from which design objectives, spatial adjacencies, and building constraints are elaborated.

PROGRAMMING ACTIVITIES

Gathering Information	Analyzing Information	Documenting Information
· Collect floor plans. · Visit site with client. · Report field observations. · Determine client structure and end users (Who makes the decisions? Who uses the spaces?). · Compile information on client (client's mission, structure of organization, future goals, etc.). · Interview client representatives and end users.	· Analyze interview notes. · Create bubble diagrams of ideal spatial relationships. · Determine staff counts and future projections. · Develop lists of type and quantity of spaces. · Define specific needs within a given space (i.e., storage for a specific number of files). · List issues that need clarification or resolution.	· Document client's mission and project goals. · Summarize program for current needs and future growth. · Include meeting notes from interviews. · Obtain client approval on program and projections. · Compile report.

SCHEDULE

An ideal **project schedule** *specifies not only the designer's responsibilities, but also the important decisions to be made by the client, as well as the critical role of the contractor as a member of the project team.* As a result, the *schedule should address all of the project milestones*, in the form of a checklist, and assign to a team member the primary responsibility for oversight. Schedules include, but are not limited to, establishing the timeframe for executing contracts and acquiring existing condition surveys; defining the length of design phases; receiving concept design and budget sign-off; bidding and negotiating with contractors; obtaining permits; defining construction duration; and fixing a move-in date. If the date for moving in is already known, it is best to work backward from this date to determine the duration of each milestone. Reviewing the overall timeframe against the checklist of activities will determine its reasonableness. It is also important to research the duration of the regulatory and approvals processes in the local area because they often consume more time than expected.

CHECKLIST	Week														
	1	2	3	4	5	6	7	8	9	10	11	12	13	14	15
Contract Negotiations															
Programming / Pre-Design															
Interior Survey															
Presentation of Design Concepts															
Approval of Design Concept															
Schematic Design															
Conceptual Price Estimate															
Review and Approval of Budget Estimate															
Design Development															
Review and Approval / Design Sign-Off															
Construction Documents															
Bids and Negotiations															
Award Contract															
Acquisition of Permits															
Mobilization of Site															
Construction Administration															
Installation of Furnishings															

																		Month					
19	20	21	22	23	24	25	26	27	28	29	30	31	32	33	34	35	36	1	2	3	4	5	6

BUDGET

Establishing a project budget is crucial for streamlining the design process. It instantly communicates the scope of the work and the level of finishes. Project budgets are divided into hard and soft costs. For an interior project, **hard costs** cover the cost of construction and fixtures, furniture, and equipment **(FF&E)**. A typical assumption for an FF&E budget is 10 percent of the overall construction cost. **Soft costs** include, but are not limited to, designer's fees, consultant's fees, project management fees, permitting fees, insurance, and project contingencies.

A designer's primary concern is to meet the budget for hard costs. To ensure that a budget is realistic, a conceptual pricing estimate should be conducted early in the process. For small projects, it may not be realistic to have an estimator or a contractor on board at the initial stage. Instead, the designer may be able to provide "ballpark" numbers based on their experience. The danger is that construction costs are extremely volatile and subject to change depending on many factors, such as inflation and shifting market conditions. So for early pricing studies or ballpark assumptions, it is important to include **contingencies** for unknown factors. There are several types of contingencies, whose percentages of the total estimate will change as the design develops.

TYPES OF CONTINGENCIES

Design Contingencies	*Money that is reserved for design elements* that are not known during a pricing study. The earlier that a pricing estimate is completed, the higher the percentage for design contingencies should be. As the design is further documented, this percentage decreases—until the category disappears at the end of the construction documents. These contingencies typically range from 5 to 10 percent of the overall estimate.
Construction Contingencies	*Money reserved for unknown conditions* due to the renovation of existing buildings. These contingences can range from 5 to 15 percent of the overall estimate.
Owner Contingencies	*Money an owner reserves for change orders* once a project is in construction. Change orders typically occur due to a change in scope, schedule, or a combination of the two. These contingences can range from 5 to 15 percent depending on the condition of the existing building. Generally, the older the building, the more the owner should reserve for unforeseen situations.
Escalation	*Money reserved for increased costs for materials and labor* due to time lapses from the initial pricing study to actual construction. These contingences can range from 3 to 5 percent per year, from when the project was originally priced.

BUDGET TERMINOLOGY

Change Order	Document submitted by the contractor *indicating a change in the cost, schedule, or scope of service* required to complete a project.
Competitive Bid	*Open request for bids on a project based on completed construction documents and specifications.* Whether the client is a government agency, institution, or private business owner, the job is typically awarded to the lowest bidder.
Guaranteed Maximum Price (GMP)	*Cost for construction, guaranteed by a construction manager based on incomplete design documents.* Given the risk of pricing with incomplete documents, the client and construction manager must agree to the timing of the GMP. If set too early in the process, the scope can easily shift, and change orders will upset the GMP.
Invitation to Bid	*Request for prequalified contractors to bid on a project* based on completed construction documents and specifications.
Value Engineering (VE)	*Effort to reduce project costs by eliminating or downgrading items that add costs* without benefiting a particular function or answering the program requirements. VE requires the involvement of the client, construction manager/contractor, and designer.

SCOPE OF PROJECT

As the design of a small project is further developed, it is important to work with a contractor who will estimate the project costs based on drawings and specifications that the designer provides. For small projects, estimates should not be based on square footage, but rather, should identify and price all construction materials and labor costs. For medium to large projects, either a cost estimator or a construction manager will prepare the budget. Cost estimators are hired exclusively to put together construction estimates. Construction managers are contractors/builders that are hired early in the design process to manage the cost of a project through the design phases. These experts typically have significant market experience and can establish a project budget based on a dollar value per square foot; however, the budget should always be tested against a detailed breakdown based on project scope. For very large projects, it is standard to request several estimates to test the market value of the project. When large discrepancies appear in prices, quantity surveyors might be hired to verify material quantities. Price variations are more symptomatic of different material quantities than of different unit prices, and the quantity surveyor can help resolve these disputes.

Budget Formats

For small projects, budgets are typically itemized based on how a general contractor would ask a subcontractor to bid the job. The trades may be broken down in general categories such as carpentry, plumbing, electrical, plaster and paint, millwork, and so on. For medium to large projects, budgets should be formatted according to the **Construction Specification Institute's (CSI)** index, *a standard index that breaks down construction costs by trade.* This helps the designer evaluate where most of the construction costs are concentrated. The following table outlines the CSI index and expands on the divisions that are most relevant to interior projects.

CSI INDEX

Index No.	Divisions	Subdivisions	
01000	General Conditions		
02000	Site Work		
03000	Concrete		
04000	Masonry		
05000	Metals	05010	Metal Materials
		05030	Metal Finishes
		05700	Ornamental Metal
06000	Woods & Plastics	06200	Finish Carpentry
		06400	Architectural Woodwork
		06600	Plastic Fabrications
07000	Thermal & Moisture Protection		
08000	Doors & Windows	08100	Metal Doors & Frames
		08200	Wood & Plastic Doors
		08250	Door Opening Assemblies
		08400	Entrance & Storefronts
		08500	Metal Windows
		08600	Wood & Plastic Windows
		08700	Hardware
		08800	Glazing

09000	Finishes	09100	Metal Support Systems
		09200	Lath & Plaster
		09230	Aggregate Coatings
		09250	Gypsum Board
		09300	Tile
		09400	Terrazzo
		09500	Acoustical Treatment
		09540	Special Surfaces
		09550	Wood Flooring
		09600	Stone Flooring
		09630	Unit Masonry Flooring
		09650	Resilient Flooring
		09680	Carpet
		09700	Special Flooring
		09780	Floor Treatment
		09800	Special Coatings
		09900	Painting
		09950	Wall Coverings
10000	Specialties	10100	Chalkboards & Tackboards
		10260	Wall & Corner Guards
		10500	Lockers
		10600	Partitions
		10650	Operable Partitions
		10670	Storage Shelving
		10800	Toilet & Bath Accessories
		10900	Wardrobe & Closet Specialties
11000	Equipment		
12000	Furnishings	12050	Fabrics
		12100	Artwork
		12300	Manufactured Casework
		12500	Window Treatment
		12600	Furniture & Accessories
		12670	Rugs & Mats
		12700	Multiple Seating
		12800	Interior Plants & Planters
13000	Special Construction		
14000	Conveying Systems		
15000	Mechanical		
16000	Electrical	16500	Lighting
		16700	Communications
		16900	Controls

Chapter 2: Project Management

The designer and client must reach a common understanding of the contracts, fees, and design process for a project to succeed. For large projects, a project manager will assume responsibility for coordinating these business aspects of the job. For smaller projects, the designer has both to design and to manage the project. Typically, management issues weigh heavily at the beginning of a project, but they must be attended to throughout to ensure that the fees, schedules, and agreements are all being met.

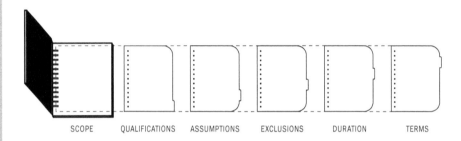

SCOPE QUALIFICATIONS ASSUMPTIONS EXCLUSIONS DURATION TERMS

CONTRACTS

The first step in embarking on a project is for the designer and client to sign a contract. The **contract** *defines the scope, qualifications, assumptions, exclusions, duration, and terms of the project.* Ideally, it is set up in a manner that separates the scope into specific design tasks, determining, for example, the number of meetings to be held or the number of renderings or sample boards to be provided. In addition to detailing the scope, the contract should include a list of qualifications, which are limitations placed on the scope. A typical qualification might be "the project fee is based on 20,000 square feet" or "the project fee is based on a six-month design period." Including a list of assumptions will avoid miscommunication; for example, "as-built AutoCAD drawings will be provided by owner" or "the project will be phased into two construction projects." It is *equally important to list exclusions to the contract,* such as "an interior survey is not in contract" or "furniture selections are not part of contract." This will help to identify issues or consultants for which the designer is not responsible. The contract must also provide a written description or a graphic schedule that outlines the project timeline.

Terms of Agreement to Include in Every Contract

Limitations of liability

Payment terms

Code interpretations and ADA compliance

Ownership of documents

No consequential damages

Termination or suspension

Insurance and indemnification

Common Mistakes to Avoid When Establishing a Contract

Not defining a detailed scope of work

Starting before the contract is signed

Not defining a method of compensation

Not red-flagging additional services as they arise

Not listing reimbursable items

Not halting work when payments are overdue

DESIGN FEES

When negotiating a fee, it is up to the designer and the client to agree on the fee structure. For most design disciplines, *there is no such thing as "typical" or "standard" fees for design services, due to the vastly different nature of individual projects*. A residential project, for instance, can range from a modest renovation to a new custom-tailored design, and the fee may be best structured on an *hourly basis*. At the other end of the spectrum, for a large commercial project, it would be reasonable to assume a fee *based on the number of square feet* (or meters). That said, most designers choose among several methods for structuring fees, either alone or in combination, and adjust them to suit a client's particular needs.

FEE STRUCTURES

Fixed Fee (or Flat Fee)	*Specific sum* that is based on human resources, hourly rates, and duration of phases for all services. Reimbursable expenses are eliminated from the fixed fee.
Hourly Fee (or Time and Material)	*Compensation for every hour spent* by the designer on a project, based on a predetermined hourly rate. In addition to the hourly fee, materials (e.g., color copies, printing, samples) are also billed.
Hourly Fee to a Maximum Fee	Compensation for every hour spent by the designer up to a *maximum set fee* based on the agreed scope.
Cost Plus	*Fee based on the designer purchasing* materials, furnishings, and services (e.g., carpentry, drapery workrooms, picture framing) and reselling them to the client at the designer's cost, plus an additional specified percentage to compensate the designer for time and effort.
Percentage of Construction Costs	Fee structured on the *overall cost of construction.*
Calculated Area Fee	*Fee determined by multiplying the project area*, generally in square feet (but in square meters for federal commissions), by an agreed-upon cost per square foot or meter. Typically, the larger the project becomes, the lower the cost per square foot (or meter).

Until recently, cost plus was the most widely used fee structure for residential designers. Now, however, it is becoming more common for designers to charge an hourly rate for design services and cost plus for products.

In general, a designer will request a *retainer* upfront. A retainer is money paid by the client to initiate the design process. It is usually due when the contract is signed and is deducted from the project's final invoice.

ENGAGING CONSULTANTS

No set standards exist for engaging consultants for an interior project. Hiring a consultant will depend on the size, type, and scope of the project. For example, however important lighting is to a kitchen renovation, it may not be necessary to enlist a lighting designer, but their expertise is indispensable for an art gallery project. It is the designer's responsibility to make suggestions to the owner for hiring consultants. The chart on the opposite page lists the consultants an interior designer may recommend for a project.

TYPES OF CONSULTANTS

Consultant	ID	A	Responsibilities
Acoustic Engineer	✕	✕	Design, detail, and specify construction methods for acoustic criteria.
Art Consultant	✕		Recommend and install artworks.
Color Specialist	✕	✕	Recommend and specify paint scheme.
Fire Protection Engineer	✕	✕	Design fire sprinkler system and provide calculations for building officials.
Furniture Consultant	✕	✕	Recommend, select, and specify furniture, fixtures, and equipment.
Kitchen Consultant	✕		Design and detail a custom kitchen.
Landscape Architect		✕	Design ground plane and landscape components.
Lighting Consultant	✕	✕	Design and specify lighting and lighting controls.
Mechanical, Electrical, and Plumbing Engineers	✕	✕	Design and specify mechanical, electrical, and plumbing systems.
Media Consultant	✕		Design and install audio-visual systems.
Signage/Wayfinding Consultant	✕	✕	Design and specify building signage.
Sustainability Consultant	✕	✕	Provide recommendations for integrating sustainable solutions.
Structural Engineer	✕	✕	Design and specify structural components of the project.

ID = Interior Designer
A = Architect

DESIGN PHASES

All practitioners must address the standard phases of the design process. The table below identifies the duration and goals for each phase of a small-to-medium-sized interior design project. Depending on the circumstances of a particular project, the timeline can vary greatly; however, the project goals should be adhered to for each design phase.

Programming	Conceptual Design	Design Development
2 Weeks		
• Negotiate a contract.		
• Develop a project schedule.	**3 Weeks**	
• Survey and document existing conditions.	• Prepare graphic materials to describe each design concept.	**6 Weeks**
• Determine design objectives and spatial requirements.	• Review design concepts with client.	• Develop the approved design concept.
• Document project goals.	• Identify life-safety and building code issues.	• Prepare drawings, including plans, reflected ceiling plans, interior elevations. and details.
• Identify additional consultants that may be required.	• Evaluate and select a design concept to be developed.	• Develop art, accessory, and graphic/signage programs.
		• Prepare a list of materials and equipment for specification.
		• Engage a contractor or estimator for preliminary pricing of design.

PROJECT PHASES DEFINED

Programming: Identification, analysis, and documentation of the client's needs and goals in a written document. This becomes the basis for evaluating design solutions in the subsequent phases.

Conceptual Design: Brainstorming phase of the design process, where many options are considered and evaluated. The goal is to gain client approval for a single design concept that will be further developed as the project progresses and to agree on a direction for the character and aesthetic intent of the project.

Design Development: Most design-intensive phase of a project, in which all design elements are developed, including the partition and furniture layout; wall, window, floor, and ceiling treatments; furnishings, fixtures, and millwork;

Construction Documents	Construction Administration
8 Weeks	
	Duration of Construction
• Gain approval of scope based on pricing exercise. • Prepare documents for construction. • Identify and interview qualified contractors. • Assist client with awarding contracts. • Prepare specifications.	• Confirm that building permits have been obtained. • Review and approve shop drawings and samples. • Conduct site visits. • Oversee the installation of furnishings, fixtures, and equipment (FF&E). • Prepare a punch list of pending construction deficiencies.

color, finishes, and hardware; and lighting, electrical, and communication systems. The goal is to define and gain approval of all of the design recommendations.

Construction Documents: Preparation of working drawings and specifications that define the approved recommendations for non-load-bearing interior construction, materials, finishes, furnishings, fixtures,

and equipment. At the end of this phase, the designer must communicate the design intent in an illustrated and written format for construction purposes.

Construction Administration: Administration of contract documents. Acting as the client's agent, the designer must approve shop drawings and regularly visit the site during construction to ensure that the project is being built according to the documents.

Chapter 3: Drawing Basics

The ability to draw is essential to the design process. In the interior deign profession, the meaning of "to draw" takes many forms: It can refer to hand drafting, to computational drawing, or even to photography and other methods of communication. A number of standards have been established to facilitate the transmission of visual data and ideas about a design, and it is important to understand how they function within the world of the interior designer.

MEASUREMENT IN INTERIOR DESIGN

Before the first line is drawn, the interior designer must grasp the *language of measurement*. The worldwide system of measurement collectively known as the International System of Units, or SI, is the most widely used standard for determining the length, weight, or volume of an object and its relation to other objects. It comprises a decimal system whose the base unit is the meter, which when increased or decreased by a power of 10, generates all other units of measure. Designers working in the United Sates should be familiar with both the metric system and the U.S. customary units system. Derived from a method originally developed in the United Kingdom, the latter is an irregular system that combines several unrelated base measurements—inches and feet (and their fractioned derivatives), for example—for linear measurement. Although all federal commissions require projects to be in SI units, the construction industry in North America continues to refer to measurements in customary units (a 2" × 4" piece of wood, a 4' × 8' sheet of plywood), as do many architectural and engineering practices.

CONVERTING UNITS OF MEASURE

Often, dimensional units are interchanged freely, and it is helpful to know how to translate between units. Designers will find a range of publications and websites with extensive conversion tables for length, area, and volume, among other measurements. Numerous online calculators also allow for swift conversions of specific dimensions. Interior designers will most frequently turn to the following formulas.

USEFUL CONVERSION FORMULAS

Multiply	by	to obtain	Multiply	by	to obtain
inches	25.4	millimeters	millimeters	0.039 370	inches
feet	304.8	millimeters	millimeters	0.003 281	feet
feet	0.304 8	meters	meters	3.280 8	feet
yards	914.4	millimeters	millimeters	0.001 093 6	yards
yards	0.914	meters	meters	1.093 613 3	yards

Multiply	by	to obtain	Multiply	by	to obtain
square inches	645.16	square millimeters	square millimeters	0.001 550 0	square inches
square feet	92 903.04	square millimeters	square millimeters	$1.076\ 391 \times 10^{-5}$	square feet
square feet	0.092 903 04	square millimeters	square millimeters	10.763 910	square feet
square yards	836 127.36	square millimeters	square millimeters	$1.195\ 990 \times 10^{-6}$	square yards
square yards	0.836 127 36	square millimeters	square millimeters	1.195 990	square yards

LINEAR CONVERSIONS

Inches	Millimeters (mm)	Centimeters (cm)	Meters (m)
0.25	6.35	0.635	0.00635
0.5	12.7	1.27	0.0127
0.75	19.1	1.91	0.0191
1	**25.4**	**2.54**	**0.0254**
1.25	31.8	3.18	0.032
1.5	38.1	3.81	0.038
1.75	44.5	4.45	0.045
2	50.8	5.08	0.051
3	76.2	7.62	0.076
4	101.6	10.16	0.102
5	127.0	12.7	0.127
6	152.4	15.24	0.152
7	177.8	17.78	0.178
8	203.2	20.32	0.203
9	228.6	22.86	0.229
10	254.0	25.4	0.254
11	279.4	27.94	0.279
12	304.8	30.48	0.305
24	610.0	61.0	0.610
36	914.5	91.45	0.915
48	1 219.2	121.92	1.219
60	1 524.0	152.4	1.524
72	1 828.8	182.88	1.829

Inch-to-Millimeter Conversions (to scale)

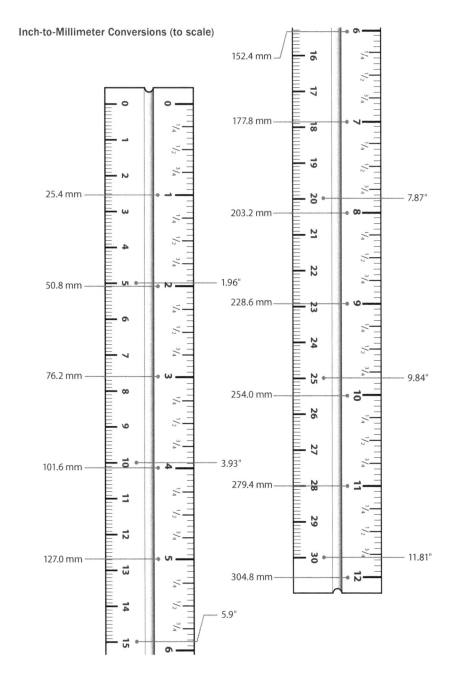

152.4 mm
177.8 mm
25.4 mm
203.2 mm
50.8 mm — 1.96"
228.6 mm
76.2 mm — 9.84"
254.0 mm
101.6 mm — 3.93"
279.4 mm
127.0 mm
304.8 mm
7.87"
11.81"
5.9"

Construction Calculators

Construction calculators provide easy access to a full range of conversions needed in the construction-related industries. They can quickly convert feet and inches to their metric equivalents, as well as translate units of weight and volume. Many models also calculate other data that is useful to the interior designer, such as stair length and riser height, stringer length, stud spacing, and material calculations, such as paint or wallpaper quantities.

Every attempt has been made in this book to represent accurately the relationship between customary and SI units. Except where noted, soft conversions are used throughout—rounding up 12 inches to 305 millimeters rather than 304.8—and, due to constraints of space, are usually written as follows: 36" (914).

MANUAL DRAFTING TOOLS

Although the computer has taken over as the primary method of drawing in most interior design practices, manual tools continue to be a part of the design process. Manual drafting is often used for developing quick ideas and details and is still employed quite frequently for final perspective drawings.

DRAWING TOOLS	
Lead Holders	Device that hold leads of 2 millimeters diameter; a spring-push action increases the length of lead for sharpening.
Mechanical Pencils	Leads, in various diameters up to 0.9 millimeter, that do not require sharpening.
Other Pencils	Standard wood-encased pencils; good for freehand drawing and sketching.
Lead Pointers	Manual sharpener whose blades give leads a specified sharpness.
Graphite	Leads in various hardnesses; good for drawing or sketching on tracing papers and vellum.
Colored Leads	Nonprint and nonphoto varieties do not show up on certain reproduction machines.
Plastic Leads	Leads designed for use on drawing films such as vellum and Mylar.
Technical Pens	Pens of specific widths designed for drafting; used exclusively on drafting films and vellums; tips can dry out and require frequent cleaning.

PARALLEL TOOLS	
T-squares	Plastic straightedges with a perpendicular attachment at one end to ensure that vertical lines on the page remain perpendicular to horizontal lines.
Parallel Rules	Plastic straightedges whose system of cables, rollers, and springs provides an edge that can move in one direction on a drawing surface.
Triangles	Clear plastic triangles that come in 45/90-degree and 30/60/90-degree variations.
Adjustable Triangles	Clear plastic triangles that can be set to any angle.
Templates	Wide variety of plastic sheets whose cutouts simplify drawing repetitive elements such as circles, polygons, and furniture.
Flex Curves	Measurable rulers that can flex to a user-defined curve or arc.
French Curves	Plastic guides that offer many curved radii.

Paper	Description	Sizes	Best Use
Tracing Paper	thin, transparent paper that comes in white or yellow	rolls in standard drafting sizes (12", 18", 24", and 36")	sketching and drafting details; overlay work; pencil, ink, and marker
Vellum	thicker than trace; available in various weights (16, 20, and 24 lbs); transparent and smooth finish	sheets and rolls	construction documents; hard-line detail drawings; perspective drawings; pencil, ink, and marker
Drafting Film	often referred to as Mylar; one- or two-sided drawing surface; of its various weights .003 and .004 are the most common	sheets (in standard drafting sizes) and rolls (36" and 42")	construction documents; plastic lead and ink; erases well and is resistant to tearing
Bond	opaque paper that comes in a variety of thicknesses and finishes of which hot- and cold-pressed are the most common	sheets of varying sizes	final drawings; pencil, though ink and watercolor can be used on certain papers
Illustration Board	finish paper laminated to a cardboard backing; comes in single ply ($^1/_{16}$") and double ply ($^3/_{32}$")	sheets of varying sizes	finish presentation drawings; model making
Foam Core	polystyrene core faced with clay papers; comes in a variety of thicknesses	sheets up to 48" x 96"	quick model studies; dry mounting presentation boards

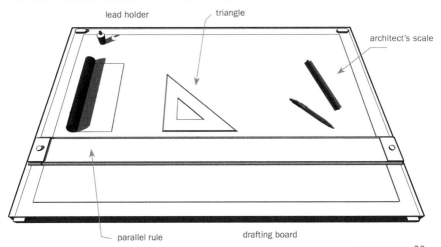

lead holder triangle architect's scale

parallel rule drafting board

UNDERSTANDING DRAWING CONVENTIONS

For legibility and comprehension, designers employ a number of *graphic conventions* in their drawings that communicate the designs equally to clients, consultants, and contractors. In a necessary abstraction, lines, symbols, and text all combine to convey the designer's vision.

LINE WEIGHTS AND TYPES

Lines are essential to the communicative language of an interior designer. Lines convey a project's intended plan, demonstrate the sectional quality of the space, and visually cue the reader to matters of hierarchy, type, and intent. Line weights and types can be created through various media, both manually and digitally.

Line types have many functions in an interior drawing. The designer determines the relative meaning for different weights; however, heavier lines are typically reserved for plans and section cuts, while lighter lines form the outlines of surfaces and furniture within a room.

0.05" (1.27)	▬▬▬▬▬▬	**Heavy**
0.04" (1.02)	▬▬▬▬▬▬	Used for borders of drawings, profiles of objects, and cut lines in plans and sections.
0.03" (0.76)	▬▬▬▬▬	
0.025" (0.64)	▬▬▬▬	

0.014" (0.36)	————————	**Medium and Light**
0.007" (0.18)	————————	Used for dimensions, lines on objects that are not in the cutting plane, and objects hidden from view.
0.003" (0.08)	————————	

Dashed	— — — — — — — —	**Dashed**
Dashed .5x	– – – – – – – – – –	Used for hidden objects, either above or below the cutting plane.
Dash-dot-dash	– — – – — – — – — –	

Dashed lines represent many different elements, from objects that are hidden from view to objects above the cut plane (e.g., cabinets above kitchen counters), from the type of wall construction to changes in level. They can also be tied to consultant trades, showing, for example, structural grids, electrical wiring, lighting and switching, or mechanical routing.

Hierarchy *in a plan drawing is established through the careful use of line weights and types.* Here, the walls that are cut are the most heavily rendered; furniture and built-ins are lighter; and hidden elements such as shelving and cabinetry are expressed with dashed lines.

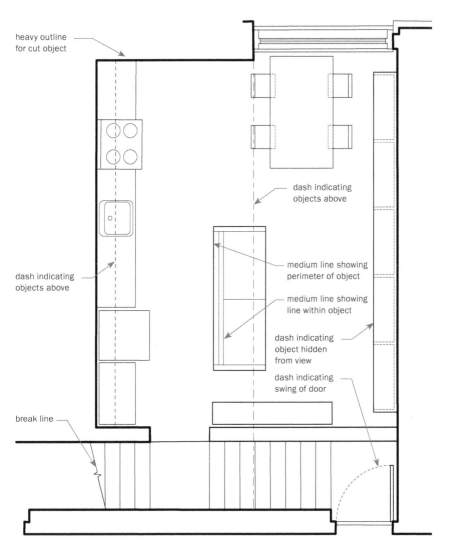

heavy outline
for cut object

dash indicating
objects above

dash indicating
objects above

medium line showing
perimeter of object

medium line showing
line within object

dash indicating
object hidden
from view

dash indicating
swing of door

break line

DRAWING SYMBOLS

Drawing symbols provide a *codified language* by which to specify the essential elements in drawings across a set. Below are some of the symbols typically used for an interior set.

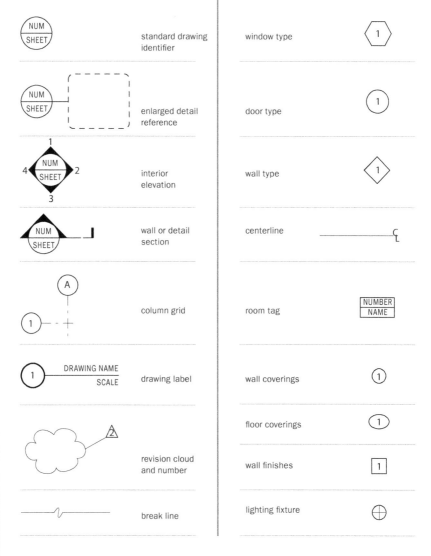

standard drawing identifier		window type	
enlarged detail reference		door type	
interior elevation		wall type	
wall or detail section		centerline	
column grid		room tag	
drawing label		wall coverings	
revision cloud and number		floor coverings	
break line		wall finishes	
		lighting fixture	

Symbols on a plan drawing are keyed to other drawings in the set, including reflected ceiling plans, elevations, sections, and details. Elements needed to implement a design are thus easily read from drawing to drawing, and revisions are readily coordinated. Dimensions are indicated in strings around the plan, or in some cases, within the plan itself. Legibility of text and numbers is crucial to reading a plan.

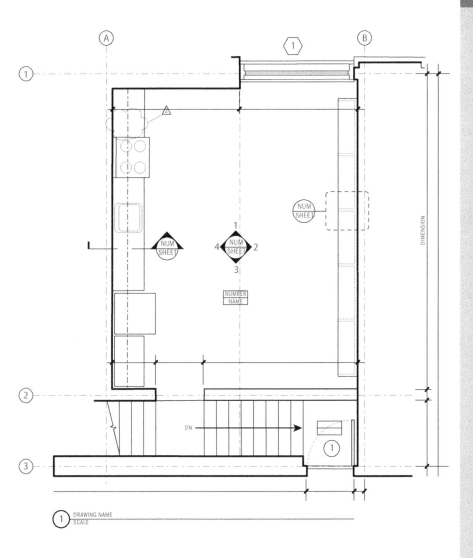

TYPES OF DRAWINGS IN INTERIOR DESIGN

Drawings are the main communicative tool in an interior designer's arsenal. Some drawing types will overlap with those of other disciplines, such as architecture or electrical engineering, while others are unique to interior design. The following pages *demonstrate the typical drawings with which an interior designer should be familiar.*

Floor Plans

Floor plans establish the limits—from demising partitions to exterior walls—that will frame the project. Walls are indicated by their dimensions, and doors by their centerline, for easy location within the floor plate. Plans are drawn at a scale that allows them to be comprehensible in one view.

Reflected Ceiling Plans

Reflected ceiling plans (RCPs) *depict the upper surface of a room as viewed through a mirror.* All light fixtures, soffits, transoms, and other ceiling data such as heights and materials are noted on RCPs. Standard symbols are used to describe fixture types and location and are keyed to a legend on the drawing sheet.

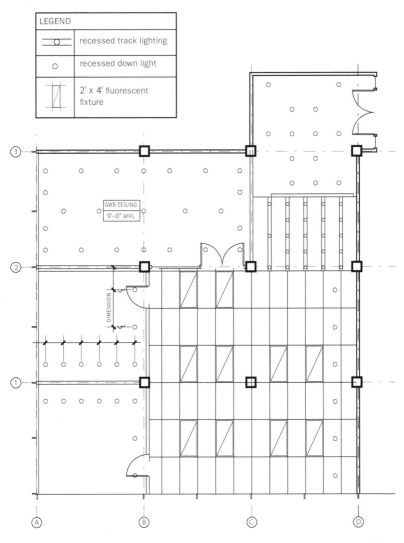

Furniture Location Plans

Interior designers often specify furniture—both custom and purchased—for their projects. These items are indicated on many other plans, but *furniture location plans specifically dimension their placement within the project.*

Floor Finish and Wall Finish Plans

Floor finish and wall *finish plans describe the various finishes used in a project.* The finishes are dimensioned as necessary. Standard symbols that identify finish types are tied to a legend that accompanies each plan.

Floor Finish Plan

Floor finish plans set the type, location, and dimensions of any pattern that is within the scope of the design, including, if necessary, a start tile.

Wall Finish Plan

Wall finish plans, with a simple tagging system, provide the data for start and stop points of color, for materials such as wallpapers and other wall coverings like wood paneling, and for acoustic treatments.

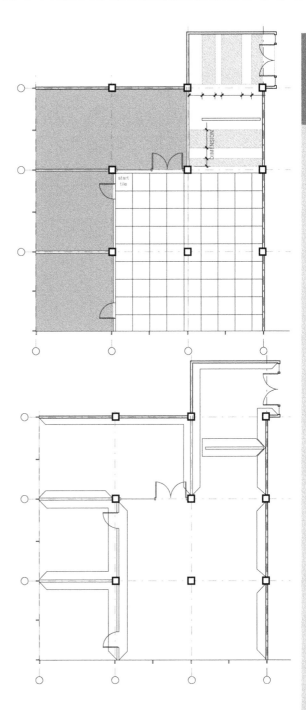

Interior Elevations

Elevations are typically drawn at a larger scale than the plans of a project. This allows for the inclusion of more detail, such as specific information about the dimensional and material qualities of objects in the interior. Elements on elevational drawings are cross-referenced to section and plan details that further develop the design. Here, cabinets, transoms, door and glazing details, and custom fixtures are highlighted.

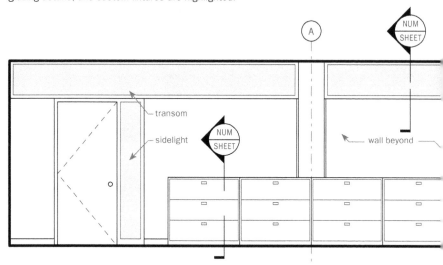

Details

Details indicate how the design is to be fabricated and range from wall sections to mechanical coordination details to millwork construction. They are produced at a larger scale than all other drawings in the set. Scales for details can be as small as $1/4$" = 1" (1:2) through to full scale. Occasionally, details are drawn at larger than full scale to transmit clearly the intent of the designer to the fabricator or contractor. In detail drawings, materials are rendered symbolically, and annotations specify the material and fabrication methods to be used.

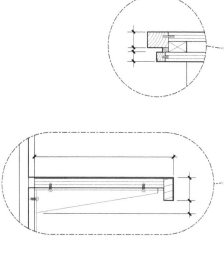

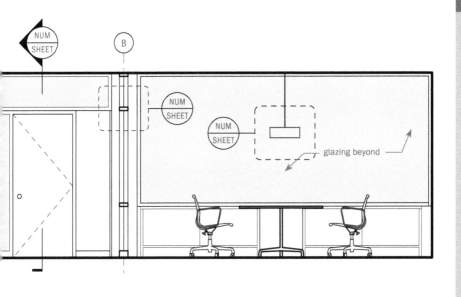

NUM
SHEET

B

NUM
SHEET

NUM
SHEET

glazing beyond

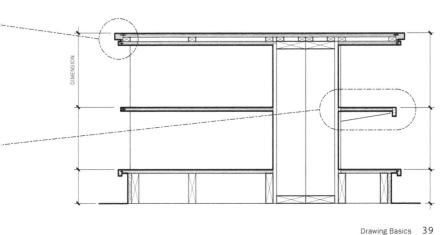

DIMENSION

DRAWING NAVIGATION

Single sheets are often used for overall plans, whether complete or partial. Multiple drawing sheets are typically used for elevations, details, and millwork drawings that require greater elaboration of the design intent and at a larger scale than plan drawings. These types of drawings are numbered by a coordinate system outlined at bottom.

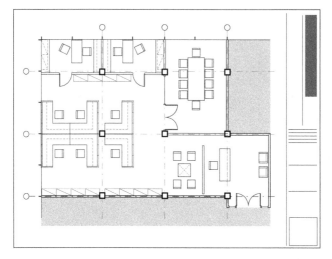

In interior practices, all floor plans, RCPs, and coordination plans that can fit on one sheet are drawn at the same scale, typically $1/16$", $1/8$", or $1/4$" (1:200, 1:100, or 1:50).

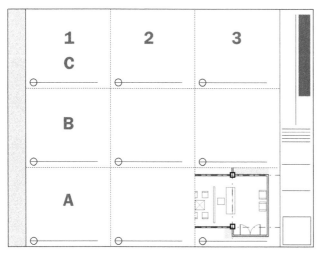

When many types and scales of drawings are contained on a single sheet, their arrangement flows from bottom left to top right, and they are numbered in the manner shown. Cells, which contain single drawings, can be added to the sheet, but legibility is key to how many can fit comfortably on a sheet.

Chasing the Details

A typical sequence for following the links in a drawing set is illustrated below. A plan drawing (A) contains information regarding, among other things, an enlarged plan. Navigating to the cross-referenced sheet (B) indicates a further link to room elevations (C), which are marked with sectional information found on yet another sheet (D). As with the multidrawing sheet, the gridded coordinate system allows for more details to be easily added as necessary.

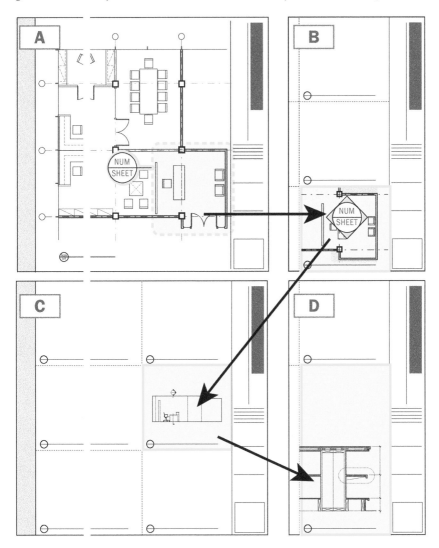

DRAWING ORDER

The order of drawings may vary from one design firm to another. For clarity and organization, the types of drawings that comprise an interior design set are numbered in sections that generally move from overall plans to specific details. After these drawings, consultants' sets should follow in a sequence similar to that listed below.

Section	Drawings	Purpose
	Cover Sheet	Gives project name and location and firm informatio
	Index Sheet	Outlines drawings in the set, abbreviations, etc.
	Site or Location Plan	Provides context for project
100	Demolition Plans	Outline extent of demolition (if required)
200	Floor Plans	Delineate new wall and opening locations
300	Reflected Ceiling Plans	Locate lighting and ceiling fixtures
400	Finish Plans	Specify finishes and finish locations
500	Furniture Installation Plans	Indicate furniture type and placement
600	Elevations	Locate heights of details and finishes
700	Wall Sections	Detail wall construction and classification
800	Millwork	Develop custom furniture designs
900	Details	Provide construction information
S	Structural	
Q	Equipment	
F	Fire Protection	
P	Plumbing	
M	Mechanical	
E	Electrical	

PAPER SIZES

Various paper sizes are used for the presentation of a working set of drawings. In the United States, the common format is the architectural classification. Other formats include the engineering format ANSI (American National Standards Institute) and in Europe and elsewhere, the A-Series ISO 216 (International Organization for Standardization).

ANSI			Architectural			ISO 216		
	Inches	Millimeters		Inches	Millimeters		Inches	Millimeters
A	8.5 × 11	216 × 279	ARCH-A	9 × 12	229 × 305	A0	$33^{1}/_{8} × 46^{3}/_{4}$	841 × 1 189
B	11 × 17	279 × 432	ARCH-B	12 × 18	305 × 457	A1	$23^{3}/_{8} × 33^{1}/_{8}$	594 × 841
C	17 × 22	432 × 559	ARCH-C	18 × 24	457 × 610	A2	$16^{1}/_{2} × 23^{3}/_{8}$	420 × 594
D	22 × 34	559 × 864	ARCH-D	24 × 36	610 × 914	A3	$11^{3}/_{4} × 16^{1}/_{2}$	297 × 420
E	34 × 44	864 × 1 118	ARCH-E	36 × 48	914 × 1 219	A4	$8^{1}/_{4} × 11^{3}/_{4}$	210 × 297

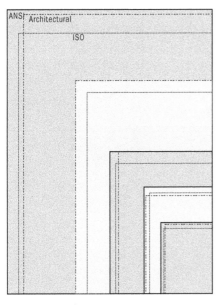

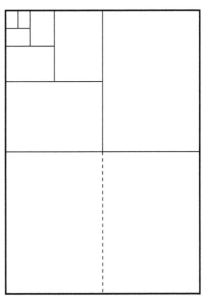

Relative Paper Sizes

The drawing above illustrates all of the paper sizes overlaid. The various ratios and sizes can be seen clearly.

The ISO 216 Series

Each smaller paper size in the ISO series is derived by dividing in half the previous paper size parallel to its smaller side.

THREE-DIMENSIONAL DRAWING TYPES

Three-dimensional drawings are used in interior projects to demonstrate aspects of the design that cannot be readily understood through two-dimensional representations. In general, three-dimensional drawings should clarify the intent of the design. In interiors, they can demonstrate and explain many aspects of a project: furniture details, color, finish, light, and shadow. Numerous types of three-dimensional drawings can be incorporated into a project, including paraline drawings—where all lines in the image remain parallel to each other—and perspective drawings—where lines converge to points on a horizon.

Paraline Drawings

Also known as axonometric, isometric, and oblique, paraline drawings are extremely useful to the designer as they represent the third dimension in ways that are parallel and measurable and combine plan, section, and elevation into a single drawing. The choice of angle will emphasize certain parts of the object; choosing the correct angle and projection method is essential to the success of the drawing as a communicative tool.

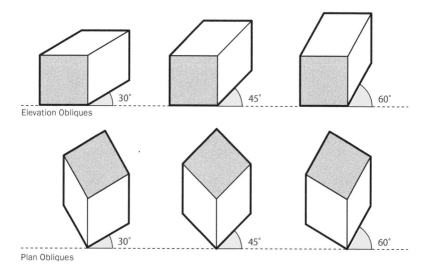

Elevation Obliques

Plan Obliques

Oblique Projections

Oblique projections can be either plan- or elevation-based. Plan obliques allow for a true plan to be used in the construction of the drawing. The angle of view is also higher than in other projections. Elevation obliques draw a true elevation in the picture. For both, an angle is chosen to represent the volume of the object (usually 30 or 45 degrees), and the depth of the object is extruded from the picture plane. Oblique drawings often appear distorted and are compressed by a third or a half to restore proportion to the object.

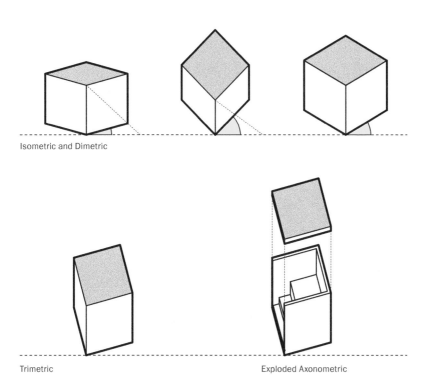

Isometric and Dimetric

Trimetric Exploded Axonometric

Isometric, Dimetric, and Trimetric Projections

Isometric, dimetric, and trimetric projections constitute the second classification of paraline drawings, and all are referred to as axonometric drawings. In these, the angles from which the object is viewed is lower than in obliques. Often, plans and sections cannot be used as the basis of the drawing, as there is inherent distortion in each projection. In an isometric projection, the three axes of the object are equal in angle to the picture plane and are foreshortened equally. Because of this equality, isometric projection is the most popular of the axonometric types. A dimetric projection foreshortens two axes and the third is either elongated or shortened to prevent distortion. In a trimetric drawing, all axes are foreshortened by different amounts.

On occasion, designers may prefer the exploded axonometric, a technique of pulling individual faces away from the object to reveal elements within. Key to the exploded axonometric drawing is the ability for the eye to reconstitute the complete object. Dashed lines are added to this drawing to indicate the direction and length to which the drawing has been taken apart.

Perspective Drawings

Interior perspective drawings do not differ in construction from their architectural counter-parts, though their obvious focus on the interior makes the choice of reference point much easier. Care must be taken, however, not to distort the image by making the cone of vision too large an angle or the picture frame too wide.

Picture Plane (PP): Flat surface, always perpendicular to the viewer's center of vision, on which the image in perspective is projected.

Station Point, or eye point (SP): Locates the position and height of the viewer.

Horizon Line, or eye height (HL): Locates the horizon as established by the viewer's height; it is typically projected from the vertical measuring line (ML).

Ground Line (GL): Represents the intersection of the ground plane and the picture plane.

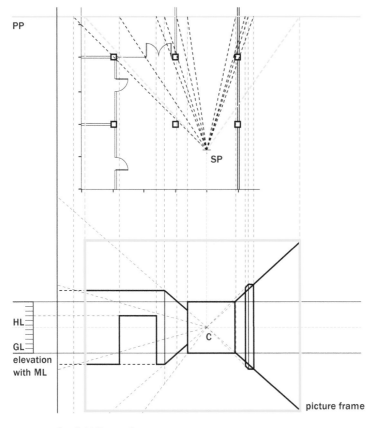

One-Point Perspective

Center of Vision (C): In a one-point perspective, a line perpendicular to the horizon line is drawn from the center of vision to establish the point to which all lines converge.

Vanishing Point (VP): Vanishing points in a two-point perspective are found by projecting lines parallel to each axis of the plan until they meet the picture plane. Lines are then projected perpendicular to the horizon line.

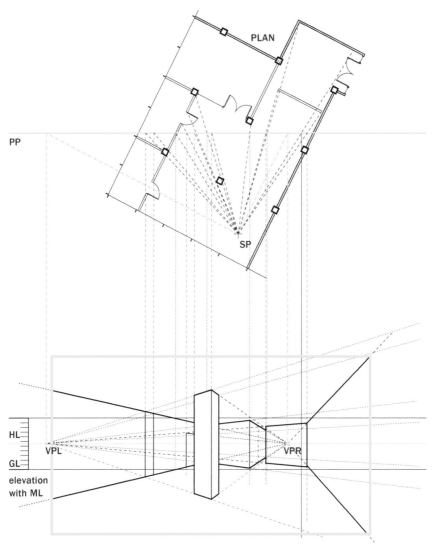

Two-Point Perspective

DIGITAL DESIGN SOFTWARE

Perhaps the most challenging and important decision any interior designer can make is the choice of computational software. Certainly, the design industry acknowledges and encourages particular standards; simultaneously, emerging technologies will always affect the way in which the design process is conceptualized, represented, and produced. Although many applications are now capable of multiple modes, they have been categorized into the groups that follow to provide a framework for selecting the best software to suit an individual or group practice.

IMAGING SOFTWARE

An important tool for the interior designer, imaging software allows renderings, photographs and other drawings to be manipulated by collaging images of materials, colors, and other elements (such as furniture, fixtures, or entourage). Imaging software is typically used for adding details to perspectives, highlighting important areas of a plan or section, or emphasizing details on plans and elevations. All of these applications encourage the use of layers, which help facilitate exploration of different aspects of the design, and the exploration of multiple alternative schemes.

A visual depiction of layers in a raster image. Layering in 2-D software allows for the isolation of specific parts of a drawing, whether it is a schematic image or a working construction document.

Raster Images

A raster image is a collection of pixels (or points of color) that depend on their resolution for their integrity. The more pixels in a given image, the greater its resolution, providing more information about the image displayed on screen. Resolution also determines the size of the printed image: the greater the resolution, the higher the quality, which allows for a larger print. A raster image is very memory-intensive, as each pixel and its combination of colors must be considered in the document. To be saved at smaller sizes, raster images employ compression techniques that can effect the quality of the image. Such formats are often referred to as "lossy" because they lose information in the compression of the original.

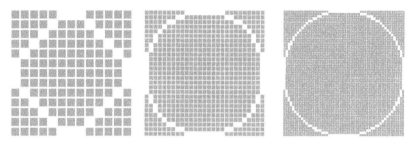

Raster File Types

TIFF, JPG, GIF, PNG, and RAW are all examples of raster file types. Each has its advantages and use. TIFFs are not as compressed as JPGs and result in larger files. JPGs and GIFs are useful for displaying images in an on-screen presentation, in apps or online. PNGs are used when saving images with delicate linework, such as plans, and RAW files are digital negatives used in documenting finished work.

Raster Image Processing

Several applications exist for processing and editing raster images, the most popular of which is Adobe's Photoshop. These programs allow users to correct mistakes in an image; add material content to perspectives, plans, and sections; and create images entirely from scratch.

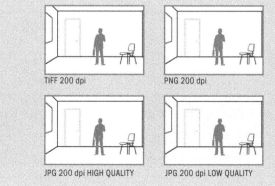

TIFF 200 dpi

PNG 200 dpi

JPG 200 dpi HIGH QUALITY

JPG 200 dpi LOW QUALITY

The images adjacent demonstrate the loss in quality—occasionally referred to as artifacting—as raster compression increases.

Vector Graphics

A vector graphic is the opposite of a raster image. Vector files are translations of mathematical data into a visual format in the form of points, lines, curves, and polygons. Each of these shapes is defined by a series of coordinates, which a computer application then translates into a visible graphic. Vector files have the advantage of being resolution independent. This independence allows them to be printed at very small or very large page sizes without any loss of information. Moreover, compared to raster images, the file size can be quite small, as it is essentially a sequence of numerical relationships.

Vector files maintain their resolution regardless of how large they are scaled. Curves are maintained, though line weights may need to be adjusted if the image is made too large.

Vector File Types

Several types of files can contain vector information. The most common of these is SVG, which is an open-source format and can be written and read by most vector-based applications. Other, more proprietary formats include EPS, AI, DWG, and DXF.

Vector Graphic Processing

Computer applications allow users to create vector-based graphics and edit them by the three most common topological levels: object, segment, or point. By default, computer-aided design software is vector-based. The advantage of vector drawing is both in its resolution-independence (which allows images to be blown up for close examination without losing any image quality) and in the user's ability to snap to points within the drawing. A number of raster applications can work with and edit vector files, including Adobe's Photoshop and Affinity Photo, but they are most productive in drawing applications such as Autodesk's AutoCAD, Adobe's Illustrator, and Affinity Designer, among others.

Vector Development

Pierre Bézier, working as an engineer at the Renault car company in the 1960s, developed a computational method for representing curves both in 2-D and 3-D space. The curve is connected by two end points, or anchors, and the shape of the curve is made by control points. The position of the control points in relation to the anchors defines the nature of the curve.

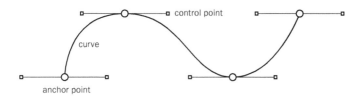

A Note about PDFs

Adobe developed the Portable Document Format (PDF) as a way to transmit documents, drawings, and other types of information. The benefits of this format are that it allows for the preservation of document type, the correct printing of line weights, and the inclusion of both raster and vector images within the same document. PDF files can also contain links, multi-media files, and forms that facilitate ease of movement through a set of documents—ranging from specifications to construction documents or even a presentation to a client. Numerous applications can create PDF files, but Acrobat is the most widely used for editing, appending, and organizing them.

PDF files that contain vector art can be opened in vector applications like AutoCAD, Illustrator, and Affinity Designer or can be rasterized upon import to a raster image editor like Photoshop. Files can also be password-protected to prevent unwanted editing, and with the introduction of digital signatures, they have become increasingly accepted as legally binding documents.

Choosing the Right Image Type

The choice of file type is ultimately up to the designer. For clarity and scalability, technical drawings such as plans and sections should remain vector-based. Raster images should be reserved for scans, perspectives, and any renderings that include entourage—people, trees, and other elements.

COMPUTER-AIDED DESIGN

Computer-aided design, or CAD, has been available to the design profession for several decades and has become the standard by which interior designers produce work. The computer has changed the practice of interior design in many ways—from facilitating communication within a project team to tracking and handling changes among the full project team in incredibly accurate ways to translating design ideas directly into custom-fabricated pieces. The first decision a designer must make is which application to use, a choice that takes into consideration many factors, including the computer platform (Macintosh or PC) and the complexity of the work being produced.

TWO-DIMENSIONAL DRAWING APPLICATIONS

While most projects will require exploration in three dimensions, smaller studies, such as elevations and detail drawings, can be developed through two-dimensional drawings. These applications enable a designer to replicate digitally the ink-on-Mylar process of developing a design. The benefits of computer drafting are many: the precision that the software enables, collaborative possibilities, the ability to share information with consultants, and the efficiency of repetitive output. The information in most two-dimensional applications is essentially without context: a line is just a line, and a complex set of details are a collection of lines representing the idea of the designer.

In the digital environment, drawings are created at full scale (that is, at the scale at which they are expected to be constructed) and then organized and scaled down for output. Because two-dimensional applications replicate the manual drafting environment, they require the same coordination of working drawings and construction documents. Close attention is needed to ensure that cross-referencing, schedules, and annotations are revised as a project progresses.

The dominant drawing application continues to be AutoCAD, but others include Rhinoceros by Robert McNeel & Associates and Vectorworks by Nemetschek.

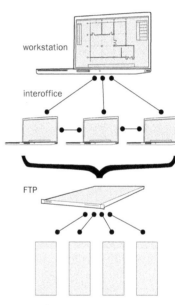

workstation

interoffice

FTP

consultants

Collaborative Drawing

Typically, CAD drawing is a collaborative process; plans and sections are referenced so that they can be worked on by many people within an office. Drawings for consultants are uploaded to an FTP server for retrieval.

Layering and Standards

The sharing of information across users, both within an interior design office and among consultants, requires a close agreement on how layers are named and organized. Several organizations have developed strategies for systems that facilitate information interchange. The National CAD Standard and the AIA Layer Guidelines are two prominent ones, though several other layering systems exist. A strategy for layer use and formatting is usually agreed upon during the contract negotiation phase of a project.

The National CAD Standard also covers the annotation of drawing sets, model files, and sheet files. The drawing below demonstrates the system as deployed by the NCS:

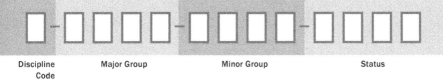

| Discipline Code | Major Group | Minor Group | Status |

Any combination of a discipline code and a major group constitutes an acceptable layer naming convention. For example, a typical layer breakdown could be as follows:

A-WALL-INTR-DEMO to indicate a layer for interior walls that are to be demolished
A-WALL-INTR to identify a layer for new interior walls

Typical layer formats within the interior design profession include, but are not limited to:

A-CLNG	I-ANNO-TEXT	I-EQPM
A-WALL	I-ANNO-SYMB	I-EQPM-MOVE
A-DOOR	I-ANNO-LEGN	I-FURN
A-FLOR	I-ANNO-DIMS	I-FURN-CASE
A-GLAZ	I-ANNO-TTLB	I-FURN-POWR

(Note: The A designation is typically used for architecture layers, but as there is a lot of overlap among disciplines, it is best to keep the standard consistent.)

THREE-DIMENSIONAL DESIGN SOFTWARE

Three-dimensional design applications enable designers to imagine the space and details of their design as volumetric projections. These models can be used for analytic study in the development of details and as representations of the project as it evolves—complete with accurate material, lighting, and atmospheric qualities. Three-dimensional design programs offer great potential for engaging directly with a design as it is being created, though they are not without their limits.

Three-dimensional modeling applications are often categorized by the types of objects they create; that is, as either surface modelers or solid modelers. While several applications can produce both solid and surface types, most specialize in one or the other. Not all available applications are designed for interior visualization, and any decision to purchase software should be considered carefully alongside issues of licensing and training.

Surface Modelers

Surface models are constructed by drawing two-dimensional splines, or surfaces and using modifiers to create volumes; by making meshes that are lofted and translated into objects; or by creating a parametric surface that responds to changes in control points and control polygons. In a surface model, faces and segments can easily be transformed, attached, and accumulated to create complex forms. Surface modelers are especially useful in rapid prototyping scenarios, where the designer desires the direct translation of the model to a physical object.

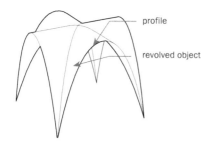

profile

revolved object

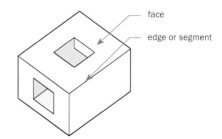

face

edge or segment

Surface Model

An example of a surface model shows the profile line and the surface object. Surfaces have no implicit volume.

Solid Model

Solid models have volume and must have all faces of the object closed along their connecting edges.

Solid Modelers

Solid modeling applications create objects that have closed geometries; a cube, for example, can only be solid if it has six sides whose segments coincide with each other. Such an object is considered to be well formed and therefore solid. Solid models are well suited to architecture and interior design practices because they function in a way similar to the construction process: Objects are decided on, created, and accumulated to form the intended design. This cumulative approach is ideal for the creation of spaces that have a lot of detail and tectonic qualities. In addition, various functions (copy, rotate, scale, etc.) can be used to alter the solid after it has been created to reach a desired outcome.

Boolean Operations

Solid models can also be affected by subtractive and additive functions known as Boolean operations. Boolean operators can subtract solid volumes from each other, add volumes together, and split volumes into their component pieces, so that from an original object come a number of resultant objects. Booleans depend on the order of objects picked. In the following diagrams, the lower rectangular volume was picked first.

Algorithmic and Node-based Modelers

Algorithmic and node-based modeling functions have emerged to challenge the way designers think about developing multiple iterations of a facade, building form, or custom elements. These applications apply a visual programming language to 3D modeling, where graphic connections between the building blocks of the design process are explored within formal constraints, which quickly produces almost infinite variations on a design problem. Typically offered as plug-ins or extensions to existing applications, the most used is Grasshopper for Rhinoceros.

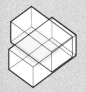 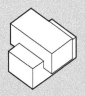 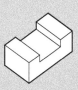

Original Objects **Union: One Solid** **Difference: One Solid** **Intersection: One Solid** **Split: Two Solids**

Building Information Modelers

The limits of solid and surface modelers are similar to those of two-dimensional technologies in that the information (except for some parametric data control in NURBS objects) cannot represent the exact nature and process for construction. By contrast, building information modelers, or BIMs, are now an established technology in the architecture, interior design, and construction management worlds that enable the designer—or team of designers—to create a complete, functional, and representative model of a space as it is being designed.

In a BIM system, all of the elements of a building are modeled using objects specific to the construction industry (walls, floors, finishes, and furniture) that have parameters (materiality, width, height, mass, or cost) that can be closely monitored as the design develops. The result is a precise simulation of the design in terms of aesthetics, cost, and building performance. All typical two-dimensional drawings, schedules, and details are derived from an active three-dimensional model, and any changes made to the base model are instantly reflected in the documentation required for the project. This technology allows for more time spent designing and less time documenting, maximizing the opportunity to explore the design in full.

File Interchange

All drafting applications write data to their own file types, yet it is essential to be able to share the information created with consultants and collaborators on the project. The most common formats for this are DWG and DXF files. Although these formats are proprietary to Autodesk, most, if not all, of the applications used in the industry are able to export to them with varying levels of success.

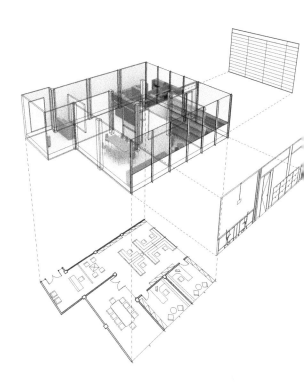

Translation and Limitations

Most three-dimensional modeling applications write files in a format native to their application; however, several file export types are available for translation to other platforms and programs. As with two-dimensional applications, the most common are DXF and DWG, which, being proprietary to Autodesk, are susceptible to change with each new release. Other formats include XML, OBJ, and 3DS.

BIM models are increasingly being shared through the open format Industry Foundation Class (IFC) to transmit the data commonly associated with the complex objects a BIM file manages.

A Note about Tablet-based Applications

With the rise of portable devices, many drawing and preliminary 3D modeling applications have become available to the designer. These applications have many of the benefits of their desktop equivalents, including layering, vector and raster drawing, and export options. The inclusion of a stylus has made both beginning the design process, hand sketching, markup, and communication viable away from the constraints of a desktop machine.

3-D MODELING SOFTWARE

Application	Solid	Surface	Animation	Operating System	Price
AutoCAD	✗	✗		Windows	* 2D only **** Full 3D
3D Studio Max	✗	✗	✗	Windows	****
Blender 3D		✗	✗	OS X, Windows, Linux	Free
Cinema 4D	✗	✗	✗	OS X, Windows	****
Rhinocereos		✗		OS X, Windows	**
SketchUp	✗	✗	✗	OS X, Windows	Free for personal use, ** for pro use

BUILDING INFORMATION MODELERS

Application	Solid	Surface	Animation	Operating System	Price
Revit	✗	✗	✗	Windows	****
ArchiCAD	✗	✗	✗	OS X, Windows	****

ONLINE

Application	Solid	Surface	Animation	Operating System	Price
TinkerCAD	✗			Browser	Free
OnShape	✗			Browser	Free
My.Sketchup	✗	✗	✗	Browser	Free for personal use

(REFER TO THE RESOURCES CHAPTER FOR FURTHER INFORMATION AND LINKS TO SOFTWARE VENDORS.)

Chapter 4: Presentation and Communication

Drawings perform multiple tasks for the interior designer. They help communicate ideas to the client at the beginning stages of a project; they present the image and content of the design at strategic points in the process; and they are integral to the construction documentation. Their effectiveness, however, depends on the manner in which they are presented. Designers have a variety of presentation methods available to them, all of which have specific functions in the design process. Anything that an interior designer transmits to the public should be considered a reflection of the design practice. Referred to as *branding,* it is a name, term, sign, symbol or design, or a combination of them intended to identify the goods and services of a design firm and to differentiate them from others. Letterheads, business cards, proposals, brochures, design boards, models, and projected images all serve to communicate the designer's ideas. It is thus important to develop a clear and graphically cohesive program regardless of how the work is being presented.

DEVELOPING A PRESENTATION

A key skill for the designer is the ability to develop an appealing and successful presentation that translates the ideas and processes that led to specific design decisions. Creating a narrative, outlining and *storyboarding* the presentation, and determining the appropriate medium for the content are but a few of the interior designer's tasks.

The designer must also grasp how drawings—used as graphic elements—function within different types of presentations and how the principles of graphic design can influence the presentation. It is a good idea to keep an updated library of graphic design references that not only offer inspiration, but also provide strong examples of article layout and narrative development. The design award issues of graphics magazines are an excellent starting place.

Keep in mind that the relatively recent appearance of high-quality color prints—even from fairly inexpensive inkjet printers—has expanded the resources available for presenting ideas in printed form. It is important that the interior designer take a look at how the format of a print can affect the translation of design ideas and also how to draw on graphic skills to support this communication.

DESIGN BOARDS

Design boards set up a sequential and ordered structure in which the intent of the proposal is illustrated. For boards to succeed, the principles of storyboarding must be applied to the information being presented; this entails the hierarchy of the elements on the board itself and the sequence in which the narrative unfolds. Design boards allow the client to spend as much time with the work as possible, and thus elements should be paced to allow for further discovery the longer they are examined. Numerous issues need to be considered when designing presentation boards.

Number of Boards: In determining the number of boards in a presentation, several questions must be asked: What is the size of the project? How many drawings will be needed to adequately describe the project? Are there going to be perspectives? Will samples be attached directly to the board or scanned and added to a perspective?

Narrative Development and Outlining: Developing a narrative for the presentation means, essentially, telling the story of the design process. A well-conceived narrative structures what and when to include in the presentation. Narratives provide a framework that can allocate emphasis and importance to certain aspects of the process. Maintaining an outline of the design intent, and developing it as the project itself evolves, will focus the narrative.

Spacing, Scale, and Speed: When developing the layout for a presentation, it is important to consider how the boards will be viewed. Some viewers will quickly scan the boards, and others will pause to look at the work in depth. By anticipating this, layout strategies regarding the spacing and scale of objects can begin to address the speed at which they are examined.

Orientation: Boards arranged with their length in the vertical dimension are said to be in portrait format and those with a width longer than height are referred to as landscape. Each has its benefits: Portrait-oriented boards have a visual resonance with the printed page and when displayed in sequence, allow for more information in less horizontal space. Landscape-oriented boards enable a more natural cropping of views for perspectives, and their width encourages a more relaxed sequencing.

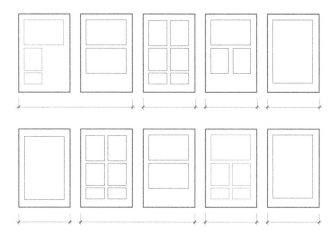

White Space: The surrounding white space can be used to increase the relative importance of any drawing, sample, or text on the page. Designers should avoid over-complicating the layout of the presentation by crowding too few boards with too much information. Adding another board is always an option.

Storyboarding and Thumbnails: A useful method for developing the presentation is to create several variations as mock-ups. These mock-ups gather the information to be presented and then explore several sequencing strategies.

Labeling and Annotation: Often overlooked, one of the most important factors in determining how a layout is perceived is the choice of fonts that will translate the designer's text. Clear, legible type, used at varying type sizes, can add another layer to how a board is read; it also offers another graphic element for the design of the board. Establishing a good hierarchy of fonts early in the process allows annotations to be placed in relation to the graphics in precise ways. At the very least, decisions should be made with regard to the following label types in a document: title font, label font, and caption font.

Grid Development

To establish the structure and placement of objects on a presentation board, the designer must develop a template that provides rules in the form of grids. Grids, set up correctly, can clarify the distribution of the design elements. If uncertain where to start, interior designers can draw from the world of the graphic arts, from which the following examples come, to fashion their own grid systems.

Single Column

Emphasizes singular content, such as a rendered plan or perspective.

Multi-Column

Allows for multiple images and text.

Anchored

Content, including images and titles, anchors the page.

Modular

More comprehensive grid that allows for variation in placement of elements.

Layout Strategies

The following examples illustrate two of the ways in which a modular grid system can be deployed in a larger set of design boards.

MATERIAL AND MOOD

The careful development of a material palette is an integral part of the interior design process. The presentation of each design element poses a challenge to the designer, as their representation conveys important ideas about the project. Typically prepared during design development, sample and mood boards—both physical and digital—function as a representative palette of the materials that will be used as reference during the development of an interior project. Ideally, materials should be proportionally represented to give the client a clear understanding of the ambiance, fixtures, furniture, and finishes that comprise the elements of a proposal.

Element	Material
Floors	wood, tile, cork, stone, carpet, etc.
Ceilings	acoustic tile, paint, panels, etc.
Walls	paint, wall coverings, plaster finishes, etc.
Furniture	wood, metals, plastics, etc.
Fabrics	drapes, shears, upholstery, etc.
Hardware	actual pieces or representative finishes (stainless steel, bronze, anodized aluminum, etc.)

Regardless of type, presentations should include material samples for each of the major elements in a project. They may also contain clippings of furniture products—chairs, tables, lamps, and so on—that are relevant to the design.

Such presentations will not only serve as a reflection of the designer's ideas for the space, they should also represent the care and attention that will be taken throughout the project. If physical, strands of hot glue, fabric threads, and general messiness can undermine the effectiveness of a presentation, therefore it should be finished in a professional manner: Digital presentations should also be developed with careful attention to sequencing and content. Also, any digital presentation about materials and furnishings should always be supplemented with physical samples so that consistency of color, variations in presentation mediums, and approval can be controlled.

It is good practice when ordering materials for presentations that interior designers obtain three copies of each material that they intend to use: one for the sample board, one for the designer's library, and one for the clients, should they request it at any time.

Sample Board Presentation Types

There are many ways in which samples can be presented to reflect the professionalism of the designer. Looking to trade magazines, books, and other publications to see how manufacturers are displaying their products can be a good way to keep sample boards looking current.

Informal

Allows samples to be evaluated by touch; organization is not so important, although a tray or box can be used to give order to schemes.

Sample Book

Allows for integration of images of furniture, hardware, textiles, and paint colors.

Volumetric

Arranges samples on a hard surface, such as foam board, with an overlap of materials.

Formal

Mixes samples and images in a rigorous, gridded system.

Tablet

Allows for on-site visualizations and a variety of samples to be presented at once.

Typical Sample Board

1 Sheer fabrics for drapery
2 Upholstery fabrics
3 Paint colors
4 Stone for counters/flooring
5 Carpet
6 Wood for millwork
7 Tiles for restrooms
8 Cork flooring

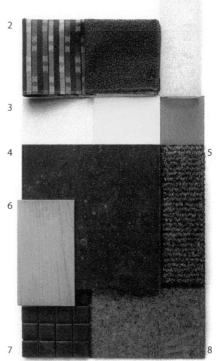

DIGITAL PRESENTATIONS

Digital presentations offer a different set of design problems and opportunities. The most striking difference is the digital presentation's greater flexibility for the development of a well-developed narrative. Although a projected or tablet presentation is a less interactive medium than boards—viewers cannot casually flip back and forth among the material, nor allow their eyes to absorb information—the medium offers a more comprehensive presentation of the design. Because of this, the designer must take care to script the content of what is being communicated.

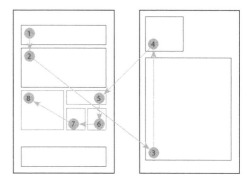

Projection versus Design Boards

A projected presentation is developed as a linear narrative, in which elements of importance are reiterated to ensure that the audience comprehends the work. A design board, on the other hand, has elements that are read at different times and out of sequence.

With the ever-increasing use of screens in the design profession, more presentations and other methods of design communication are being made to potential clients digitally. What was typically a series of slides that show previous work, ideas for a particular design solution, and project organization has become a much more immersive set of content, delivered through online webinars, shared collections of inspirational images, and customized applications. In order to make each type of presentation as useful to the presenter as it is to the audience—it is essential to keep the content focused and for the designer to be aware of the potential that such a collaborative process offers.

Many applications are involved in creating a digital presentation. Apple's Keynote, Google Slides, and Microsoft's PowerPoint are among those that can facilitate presentations, while online collaborative sites offer a less formal way to develop design decisions. In either case, the designer should become familiar with the techniques and strategies that are most effective.

(SEE THE RESOURCES CHAPTER FOR LINKS TO PRESENTATION AND COMMUNICATION SOURCES.)

Constructing Effective Digital Presentations

The variables in designing for a digital presentation are many: and the size of the screen onto which the work will be displayed or projected may not be known; the light levels in the space in which the presentation will be made cannot be predicted; and the manner in which people will react to the delivery cannot be anticipated. The designer can use the recommendations below to focus the attention of the audience:

Increase the size of your fonts

Fonts used in printed layouts may be illegible when projected on a screen. Add a few point sizes to captions and headings.

Limit the use of serifs

Although useful for reading long passages of text, the variety of thicknesses in a serif font can dissolve when projected.

Separate content into smaller pieces

Placing as much content on a slide as you would on a large board will result in too many images; separate them.

Do not use bulleted lists

· bullets simplify

· reduce complexity

· incomplete sentences

Avoid clip art

Clip art can often call into question the content of the presentation. Rely on your own drawings.

Increase the contrast of your color palette

Projectors have limited control over color management. Increasing contrast will ensure your work is legible.

Avoid showing samples and sample boards

Color accuracy changes from projector to projector. If you are going to talk about samples, have the real ones with you.

Create summary slides at significant moments

If you have talked about a number of ideas, include them all on a pros-and-cons summary page.

Know your data

Review any significant—or insignificant—numbers and facts so that you can recite them at any moment.

Pace your delivery

Having a timer function in presentation software is a good thing, but it can make you rush. Practice prior to presenting.

Pace your content

Develop your presentation so that all of the elements balance out. Don't spend fifteen minutes on dull content.

Pace yourself

The presentation is yours. Relax and take the time you need to get your ideas across.

RENDERING TECHNIQUES FOR PRESENTATIONS

Renderings play an important role in any presentation of an interior project. The ability to render a simple drawing—that is, to add textures, shadows, and other material qualities to a drawing—greatly enhances its readability. Moreover, good rendering techniques allow a drawing to operate as a visual guide to how an interior is organized and how decisions that have been discussed are being deployed. Typically, designers reserve sketching for process drawings, not just for internal sessions with the project team, but as a collaborative tool for communicating ideas quickly at a meeting or presentation with the client, consultants, or contractor. Today, most presentation renderings are computer generated.

Shadows and Texture

When used in nonperspective drawings such as plans or sections, shadows provide an easy way to read the elevational heights of various objects and add depth as well. Computational rendering packages can make shadow plans a quick and effective way of demonstrating information to the client, but care should be taken in determining the angle of a shadow so that design elements are not obscured.

Material and Shadow Plan

Material plans and sections—onto which the material palette of a project has been collaged—can demonstrate the location, proportion, and effect of materials within a space. Materials can also be desaturated, or transparencied down, to allow the space of the plan or section to remain visible. Material plans are more effective when combined with shadow plans, as the abstraction of the plan is given a specific sense of space. They are also best presented in combination with sample boards.

PERSPECTIVE RENDERING TECHNIQUES

Hidden Line and Shadows

Like perspective drawings done by hand, hidden line images essentialize the space through the use of lines. Shadows and textures in a hidden line image can deepen an image, give clarity to certain elements of the design, and express more fully the designer's intent. As with plans and sections, shadow position and intensity should be chosen carefully. These drawings can be produced within a three-dimensional application, but are more easily assembled as collages within a two-dimensional raster image program.

Line and Color

Adding color to a line drawing emphasizes aspects of the interior environment in a clear and minimal way.

Line, Color, and Shadow

Adding shadows to a line drawing gives greater depth and drama to an image.

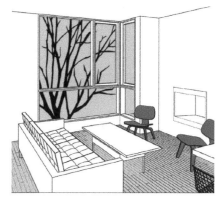

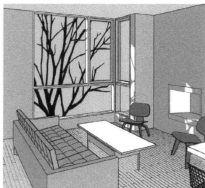

Light

Key to any understanding of space is light. Computers can simulate light within interior space through a variety of algorithms, including surface renderings and ray trace renderings. The former do not adequately represent light or materials, however, and the accuracy of the latter is not as rich as other solutions. Recently, two alternative algorithms have been introduced: global illumination and physically accurate solutions. Global illumination calculates both direct and indirect light that enters a space. Color from reflected surfaces is bounced into the scene. Physically accurate rendering software simulates the precise physics of light in an environment; it allows for careful evaluation of both natural light entering a space and artificial light within a space. These calculations are computationally intensive and can take many hours to complete. Designers should familiarize themselves with the complex factors that influence the efficiency of any solution.

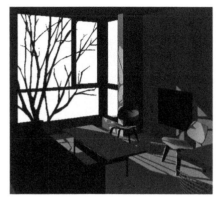 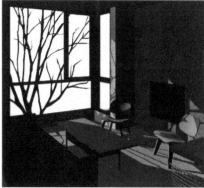

Surface Rendering

Surface renderings are simple representations of the space.

Ray Trace Rendering

Ray trace renderings add reflections and traced shadows to a scene.

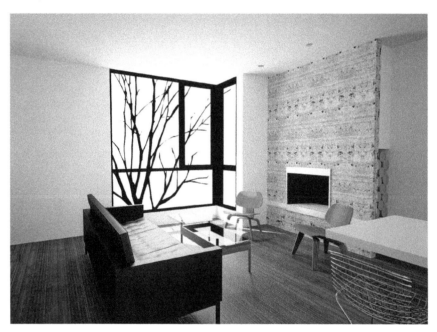

Accurate Lighting Solutions

Computers are now powerful enough to use complex algorithms, such as global illumination and physically accurate solutions, to represent how light interacts with color and space.

Three-Dimensional Rendering Software

Three-dimensional renderings are typically generated through whatever specific program the model was created in. Recently, a number of alternative rendering systems have emerged that offer a wide range of representational opportunities. Realistic materials, complex lighting techniques, atmospheric effects, and the ability to render soft, pliable surfaces are now available to the designer at all levels of the rendering spectrum. In addition, renderers have begun to harness the power of a computer's GPU for quicker and in some cases, real-time imaging. These systems allow for a variety of modeling programs to be used to create form, while the rendering takes place either within that platform or as a stand-alone application.

PLUG-IN SYSTEMS

Application	Material System	Complex Lighting	Physically Accurate	Operating System	Price
VRay	✗	✗	✗	OS X, Windows	**
Corona	✗	✗	✗	OS X, Windows	**
Maxwell	✗	✗	✗	OS X, Windows	**
Arnold	✗	✗	✗	OS X, Windows	**
Thea	✗	✗	✗	OS X, Windows	**
Octane	✗	✗	✗	OS X, Windows	**
Unity	✗	✗	✗	OS X, Windows	**

INTEGRATED SYSTEMS

Application	Material System	Complex Lighting	Physically Accurate	Operating System	Price
Cinema 4D	✗	✗	✗	OS X, Windows	****
Revit		✗	✗	Windows	****
Form·Z	✗	✗		OS X, Windows	***

(REFER TO THE RESOURCES CHAPTER FOR FURTHER INFORMATION AND LINKS TO SOFTWARE VENDORS.)

Deborah Berke, could you describe yourself and your practice?

I've been practicing architecture for more than twenty years. The practice has grown from being a desk in the middle of my studio apartment to a thirty-five-person office that provides services that include master planning, urban design, traditional architecture as it's understood, interior design, and actually even decorating; we offer a full range of services. Some of our clients elect to take only one and others elect to take advantage of more.

Who were your mentors in teaching you about design?

Judith Wolin, who was my teacher at the Rhode Island School of Design, was my literal, most direct mentor. I was at RISD in the 1970s—it was very much an artsy environment. What Judy made appreciable to me was the idea that your work was good if you brought an intelligence to it and if you brought to it the idea of revisiting and editing and reconsidering; in other words, a rigorous form of self-critique.

I then taught at the Institute for Architecture and Urban Studies. Spending five years in the company of Peter Eisenman, Anthony Vidler, Kenneth Frampton, Mario Gandelsonas and Julia Bloomfield—in an environment that valued intelligence and inquiry—was the next chapter of mentoring. After that, I took a radical departure from that kind of straightforward education and it became about taking what I had learned in that environment and applying it to the things that I have always intuitively cared about, which is the found and not the consciously created. Now, I would rather wander the back part of the city to discover the decrepit oddities. I'm taking the word "mentoring" and morphing it into inspiration.

At what point in your life did you feel confident about starting your own company?

When I got out of school there wasn't any work for architects, so my first job was in the graphic design department of an enormous multinational engineering firm that had its headquarters in New York. This job was not intellectually challenging, and I started hanging out at the IAUS (Institute for Architecture and Urban Studies), taking courses. Eventually, I got a job as administrator of the educational programs under Mario Gandelsonas and then became a teacher there. Augmenting that salary, I taught in two elementary schools; the NEA in those days put artists and architects into public schools—they paid $100 a day, which was a lofty sum. The courage to open my own practice came less from a sense that I finally have a job and I can open the doors, than I finally have enough other kinds of jobs. I can print up some business cards, put a straightedge on my coffee table, and say that I'm in practice. That's how it worked for me.

I think it's very cyclical, to the extent of depending on the coincidence of when you are ready in terms of confidence, experience, and opportunity, and when the natural cycles of the economy give you the sense that you can sustain it—that doing the garage addition for your cousin's next-door neighbor is not going to be your one and only chance to design something, that there will be a job after that. When those two things are in sync, then you are ready.

What phase of a design project do you find to be the most satisfying? The most educational? The most challenging?

I love the very, very beginning. I love seeing the site for the first time, whatever the site might be. I love talking to people in the very beginning, and I love schematic design. I love study models. I like sketching. I like thinking. I like falling asleep with forms in my head as I doze off.

I find the well-executed detail or the exquisite piecing together of a large set of documents interesting, but it's not my thing. There are terrific people in my office who do that well, and I can work with them to make sure that I feel there is the kind of wholeness and integrity to the project that I want it to have. But I do that more as a critic, whereas in the early stages of the project, I'm the creator. Is it the most educational? Yes, in that it's the most challenging and forces me to think.

What is your approach for starting a project?

I don't arrive at a project with a preconceived notion. I try to educate my clients about the fact that they should have no preconceived notions either. If somebody comes to you and they want a house, there's clearly going to be some place where food is stored and prepared and some place where people are going to sleep, but beyond that there are many notions you dispense with when you begin to examine the program and the forms that people automatically associate with the program.

I think that, for me, all design processes are reiterative processes, and for how I work, the client needs to participate in that process. I'm not the kind of designer who says, "Here it is, take it or leave it." What I become in the reiterative process is a salesman, to ensure that the result I see is the result I can get them to agree to. There's the candid truth: At a certain point, you get the client to embrace the idea and form as enthusiastically as you are embracing it.

What is the role of technology in your practice? Is it a tool for design, or does software allow for a more creative exploration of the design process?

One of my partners lives in Reykjavik, Iceland. He spends one week of each month in New York, and the rest of the time he's on our server from his office there. That has proven to be

wonderful, superbly productive. Most of our clients don't know where he is when he's talking to them. The isolation he can achieve there actually allows a kind of productivity that's very different from the kind of productivity that I have in the course of a day, when I might sit down with ten people on six different projects, half an hour checking out the interior elevations of this, half an hour looking at the window details on something else. He can spend extremely focused time, whether he's writing an agreement at one extreme, sifting through an entire set of construction documents, making sure that every piece is there and that we like it, or developing a design.

Are you engaged in building information modeling?

We just started a new project, and at the developer's insistence and to our excitement, we are going to be embracing BIM on this project. We needed a project on which it made sense and also to work with somebody from whom we could learn, so that we can take the leadership role the next time. This first time, we will be the student of somebody else.

How do you program your residential projects? Is it different from programming your institutional projects?

Programming, whether it's a large institutional building or a residence that's only an interior—here are four walls, it's a blank loft where someone's going to live—I think involves the same skill set and the same series of questions and distillations. You need to treat it like data, and in a sense, assure your client that you are taking their data—whether it's a house, "I have six linear feet of hanging," or an institutional facility, "We need to seat thirty-six children in each classroom"—and that you are engaging, hearing, and understanding that data. But then you allow yourself, critically and without preconceptions, to assemble the relationships among those pieces of data as the design starts to coalesce. You question it as you go.

Do you reveal that questioning process to your client?

Not always, not when it would lead them to think that you didn't trust them or didn't believe them or anything like that. You use that questioning to help yourself both understand the data and perhaps slice it in ways that the client can't imagine it being sliced.

There are two different situations. There are projects in which the program is handed to you. Whether because it's a big enough or wise enough or institutional enough client, the programming was done separately by another firm, at another time, for a different reason, and really needs to be questioned. We pull apart those programs and in their reassembly, get vastly better results. When the program is handed to you, you have a critical distance from it and look at it with a different set of eyes and without preconceived notions. It's really different when you do the program yourself and then you go ahead and make the space. You have to be so deeply

careful of not reinforcing your own preconceptions. For instance, I ask you a question about your house and I already know what I want it to look like, so I might phrase the question in a way that is dishonest. In the long run, I think that is self-defeating. You can get better results if you are more critical in your own process.

How important is understanding the business of design? In what way did you design your business?

My design education did not prepare me at all for my business. I think as the company grows, you begin to design the business, to the extent that you say yes to certain jobs, and if you have your wits about you, you say no to other work. People imagine that they'll never have that luxury, but that is in part how you are designing your business—by what you agree to do and at what price you agree to do it.

Could you name two or three contemporary spaces that have recently impressed or affected you, and say why?

As an object here in New York, I like Norman Foster's Hearst Tower. Of all the towers going up, I appreciate the sort of elegance and simplicity and the structural out-front-ness about it. I was awestruck by Richard Roger's Madrid Barajas Airport. I thought it was extraordinary. It's one of the few truly contemporary spaces I've visited recently where I went, Wow. But I questioned my own "wow"—to ask whether part of the feeling wasn't just its sheer size, whether I could have a similar experience walking into something quite small—and to parse from that what was impressing me.

We recently did a project out in Columbus, Indiana. The last time I was there, we had some extra time and went to Eliel Saarinen's church—the first one. You walk into the sanctuary and you think, Wow, this is truly an extraordinary space. Part of the appeal to me is its asymmetry, which is subtle and reinforced by certain decorative moves and surface moves. But it's masterful; it's a masterful building and a masterful space.

Overleaf Left 21c Museum Hotel Oklahoma City, Oklahoma. Photos by Chris Cooper.
 Right 21c Museum Hotel Lexington, Kentucky. Photo by 21C Museum Hotels.

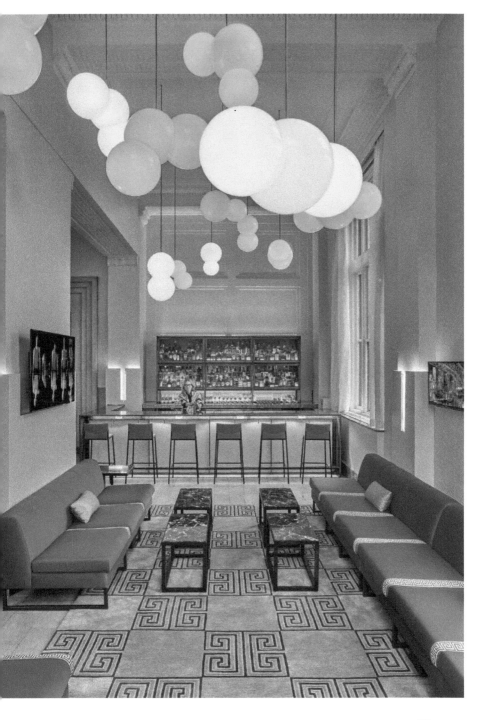

2.

SPACE

The shaping of space into rooms of specific configurations is the primary art of the interior designer. Several issues impact the proportion of rooms and their location in plan, including the intended functions of rooms, the way furniture and accessories will fill out the space, and the limitations imposed by accessibility and building codes. The best designers can juggle these myriad issues while developing an overarching concept for the character of a room. At a more sophisticated level, spaces and rooms can be knitted together in a sequence of spaces that provoke discovery and incite delight.

Chapter 5: Proportions of a Room

In the disciplines of art and design, proportion is concerned with one of the funda-mental characteristics of shape: the aspect ratio of width to length. Significantly, the qualification of the proportion of a shape does not concern itself with dimensions. When designers speak of the proportions of a shape, they are usually discussing the relative width and length of a rectangle, but they can also address the proportion of an oval or even complex and irregular forms such as the proportions of a kidney-shaped swimming pool. Most typically, proportions are considered when making de-sign decisions about a series of related elements. For example, the designer should consider the proportion of the wall space between windows as well as the proportion of the windows themselves when designing an interior elevation. The relative propor-tion of the shape of the wall and the shape of the window can be construed as a more complex proportional relationship. Proportion is considered in two dimensions in drawing and painting and when composing a plan or an elevation.

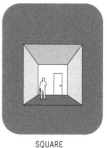
SQUARE

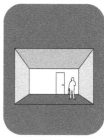
RECTANGULAR

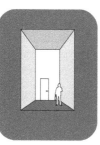
TALL

INFLUENCE OF PROPORTION

Rooms of Different Shapes

For interior design, the proportion of a space or an object is qualified by the relative length of three variables: width, length, and height. The character and use of a room is strongly influ-enced by the proportion of the space. A room that is relatively long, narrow, and tall is much different in character than a room that is square in plan with a low ceiling. The relative propor-tion of a room qualifies whether a space is primarily meant as a path or a place. Square rooms are the most geometrically stable, but are difficult to furnish and thus used for ceremonial functions when large or as threshold spaces when small. Rectangular spaces with proportions of less than 1:2 are the most common shape of place-rooms since they can accommodate a variety of furniture arrangements and can be easily aggregated along circulation armatures. Long, narrow rooms are typically circulation spaces, whether functional corridors or spaces for processional rituals and ceremonies.

The pure geometry of a square room can demand a symmetrical arrangement of furnishings.

M + M Creative Studio, Edmunds. Photo by Benny Chan.

A rectangular space can be broken up into different zones to accommodate distinct seating areas.

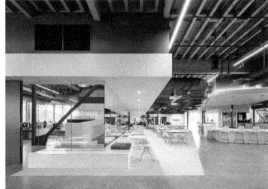

Architecture + Information, Canvas Worldwide. Photo by Michael Wells.

The formality of a tall and long room is ideal for both work and entertaining.

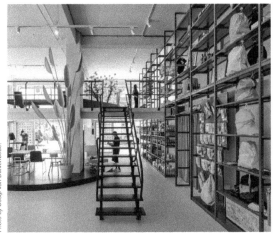

MVRDV, The Groos Store. Photo by Ossip van Duivenbode.

Rooms in a Choreographed Sequence of Spaces

Rooms can be arranged as a proportional related sequence of spaces. The richest sequences of rooms typically contrast rooms of different but related proportions to create visual variety and to provoke a sense of discovery. Strategies that consider contrasting proportions of rooms also seek contrasting qualities of light to enliven the itinerary.

Tusen Takk, Leland, Michigan.
Photo by Matthew Millman.

DETERMINING PROPORTION

Proportions are determined and appreciated in one of two ways: either through the informed intuition of the designer or through a rule system established by the designer. When designers use a rule-based proportioning system, they typically employ it opportunistically—following the proportioning system when helpful and ignoring it when other design criteria prove to be more important.

An Intuition for Proportion

Talented designers have an innate sense of proportion. In fact, this is one of the essential skills that every artist and designer needs to develop. When proportions are considered intuitively, expressions such as "relative weight," "balance," and "designing the space in-between" may capture the synthesis of visual choices during design. Appreciating proportions can also be an act of connoisseurship. To speak of a "beautifully proportioned façade" suggests a recognition of an overall balance among the proportions of the windows, the spaces between the windows, and the proportion of the wall itself. When proportions are designed and appreciated intuitively, the visual tastes of the creator and observer play an important role. Some designers prefer dynamic compositions with strongly contrasting proportions, while others may seek stasis and balance. The history of visual styles is partly the history of the changing tastes for proportional and compositional strategies.

Whole-Number Proportions

Rule-based proportioning strategies, by contrast, begin with a geometric system that associates the various lengths of an object or space with mathematical ratios. The most common of these systems relates the length, width, and height of a room in simple whole numbers. For example, a rectangular room can be qualified as a room that is twice as long as wide with a ceiling as tall as its width. Such a room can be defined as a simple whole-number proportion: 1:2:1.

Andrea Palladio famously used a whole-number proportioning system to design and organize the rooms for his palace and villa commissions in the sixteenth century. The plans of the rooms in Palladio's buildings are typically organized in whole-number ratios of 1:1 (the square) or rectangles of 1:2, 2:3, and 3:5. Significantly, he avoided other ratios such as 3:4 or 4:5 because the resulting shapes sit uncomfortably between the stable square and the directionality of the rectangle.

Plan and section of Villa Capra by Palladio

The Golden Rectangle

More complex rule-based systems exploit the relationship among a class of rectangles that can be generated from the geometric properties of the square. The most noteworthy of these is the golden rectangle (also known as the golden section, the golden mean, and the magic rectangle). To construct a golden rectangle, a square must first be subdivided into two rectangles, each with 1:2 proportions. If the hypotenuse of one of the rectangles is drawn and then rotated to follow the radius of a circle with its center at the pivot point, a golden rectangle will result. The golden rectangle has a proportion of 1:1.618.

This rectangle is golden and magical not just because of how it is generated, but also because of its inherent geometric properties: It is the only rectangle that comprises a square and another similar (equally proportioned) rectangle. The logic of this characteristic means that a golden rectangle can be endlessly subdivided, with each smaller golden rectangle begetting its own square and smaller golden rectangle.

The golden rectangle can be a helpful proportion in interior design, best used for relating asymmetrical subdivisions of wall surfaces and/or rooms. Whenever the golden rectangle is applied to an overall room proportion, the component square of the rectangle should also be present, whether as the ceiling height or as some stable subset of the larger directional space. Guiseppe Terragni, an Italian modernist working in the 1920s and 1930s, used the golden rectangle to organize the plans and elevations of many of his projects, most notably the Danteum, an unbuilt monument to the poet Dante, designed in 1938.

Photo by Alinari, Art Resource, New York.

Leonardo de Vinci, drawing of ideal proportions
of the human figure, 1492

The Golden Rectangle: Ratio of 1:1.618

The Radical Two Rectangle

Another common rectangle in proportioning systems is the radical two rectangle (also known as the root two rectangle). Its geometric construction is similar to the golden rectangle. In this case, however, the full hypotenuse of the generating square is drawn and rotated. The resulting proportion is thus less attenuated than that of the golden rectangle. The ratio of the radical two rectangle is 1:1.414. Henri Labrouste used the radical two rectangle to organize the proportions of the plans, sections, and façades of the Bibliothèque Ste. Geneviève in Paris.

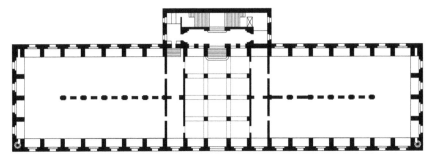

Plan of Bibliothèque Ste. Geneviève by Labrouste, 1843

In the 1940s, the French architect Le Corbusier used the generating logics of both the golden rectangle and the radical two rectangles to generate a complex proportioning and dimensioning system called the Modular. Le Corbusier used the system to compose and dimension all of his subsequent projects until his death in 1963.

Le Corbusier's Nautilus

Photo by Erich Lessing, Art Resource, New York.

Le Modular by Le Corbusier

Chapter 6: Sequencing Spaces

Although the art of composing a plan would seem to be the province of the architect, the interior designer must be involved in choreographing the sequence of spaces, so that a project reflects a single design approach. Acknowledging the necessary collaboration between architects and interior designers, it is important to understand the two primary vehicles for organizing the relationship between rooms: the plan and the cross section.

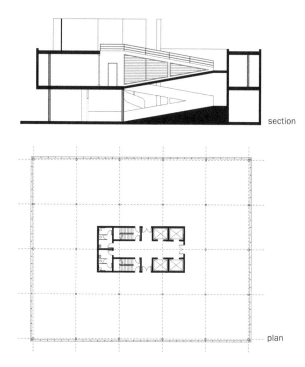

section

plan

COMPOSING A HOUSE IN PLAN

Through-Room and Independent Circulation

Interior design typically begins with the plan. Fundamental to the logic of the plan is the distinction between rooms that can serve as both places and as routes for through-circulation—such as the living room, dining room, and kitchen—and rooms that, because of issues of privacy, require a separate circulation space or network of spaces to access them—such as bedrooms and bathrooms.

Servant Spaces

A third type of space comprises closets, storage rooms, pantries, fireplaces, and powder rooms. Spaces of this category should be consolidated into systemic *"thick-wall"* zones to create acoustical privacy between larger rooms and to generate a logic for the plumbing, ventilation, and mechanical systems and overall structure of the house. When composing a plan, it is useful to consider these consolidated smaller spaces as solid masses, in opposition to the open spaces of major rooms. In the late 1950s, American architect Louis Kahn qualified this as an opposition between "servant" and "served" spaces. In the 1980s, the consolidated zones of servant spaces came to be called the *"poche,"* a term borrowed from a drawing technique used in the nineteenth century at the École des Beaux Arts in Paris (from the French *pocher* "to fill in").

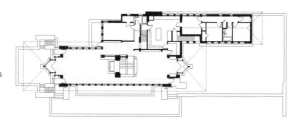

The plan of the Robie House is composed of two distinct wings that separate the public from the private space.

Frank Lloyd Wright, Robie House

Relationships between Rooms

Networks of rooms can be conceived by aggregating rooms, with the gap between each room functioning as both a thick-wall poche zone and a threshold space. Rooms can also be created by subdividing a space with thick-wall zones or chunks of poche, as the Farnsworth House illustrates below.

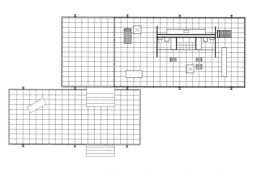

The plan of the Farnsworth House is a modern example of poche; the kitchen, bathroom, and storage areas are collected into one single volume in the open plan.

Mies van der Rohe, Farnsworth House

Plan Types in American Domestic Architecture

The differences among *vernacular* housing types, designed based on localized needs, construction materials, and reflecting local traditions is the result of climatic variations (the need to conserve heat versus the need to encourage cross ventilation), security concerns, and the density of development. The American single-family house is generally organized into five plan types.

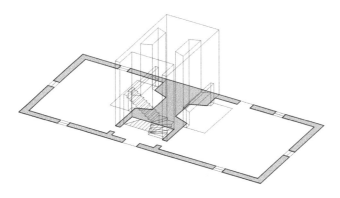

Freestanding house organized around a central fireplace core (the American Northeast and Midwest)

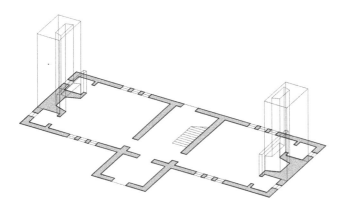

Freestanding house with a through-house central stair hall with fireplaces on the end walls (the American South)

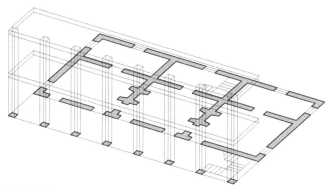

Freestanding house with rooms organized along a south-facing double-story portico (Charleston, South Carolina)

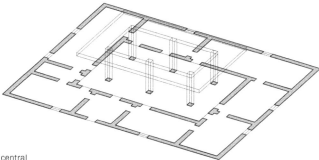

Attached or freestanding central courtyard (California and the American Southwest)

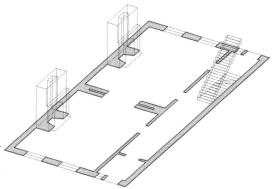

Attached row house with a stair and corridor along one of the common walls or in the middle of the plan sandwiched between exterior-facing rooms (the American Northeast and Midwest)

COMPOSING A HOUSE IN SECTION

If a house is conceived as a series of independent floor levels, then every room on each floor will share the same ceiling height. Ideally, however, a house should have rooms whose ceiling heights differ in proportion to the overall size of each space. The height of the living room should be greater than that of the powder room or a coat closet, for example. Opportunities for such a house of interlocking rooms with different ceiling heights are best explored in *section*.

The simplest way to organize a mixture of ceiling heights is to make one or several rooms double-height spaces, with the potential that rooms on the second level can look onto these taller spaces. Le Corbusier organized houses around double-height living rooms at every stage of his long career: The Villa Schwab of 1916 and the units in the Unité d'Habitation of 1949 are but two such housing designs.

Another strategy for varying spatial heights in a house is to connect one-and-a-half-story rooms to adjacent one-story rooms via short stairs. Separating sections of the house by partial-level stairs rather than the full-floor stairs of conventional house designs offers numerous psychological and functional advantages.

As a variation on this strategy, in the 1920s, Adolf Loos designed a series of houses that organize the rooms of the main living level with a common ceiling plane, but allow the floor levels to shift, creating rooms with a mix of ceiling heights. As a result, the interiors of Loos's houses resemble a terraced landscape. In houses with these complex sectional relationships, the interconnecting stair needs to be carefully designed to take full advantage of views into taller spaces and beyond to the exterior.

Le Corbusier, Villa Baizeau

The section of the Villa Baizeau has interlocking double-height spaces that become single-height spaces when joined.

A series of intimate, terraced spaces along the sides of a triple-height space, exemplified in the section of the Müller House, is another strategy for varying spatial heights.

Adolf Loos, Müller House

REDEFINING THE OFFICE SPACE

The majority of contemporary office spaces are designed for the logic of preexisting flat-floor-plate office buildings. In recent years, however, the idea of a core with perimeter open office cubicles and enclosed private offices has been replaced by ideas of open collaborative environments, team rooms, shared work surfaces, and informal meeting spaces. As workplaces evolve, the lines between work and play and where creative spaces for work happens have shifted. In addition, many elements from residential and hospitality design have become commonplace in office space. Softer furnishing elements—places that encourage gathering, communal conversation areas, and informal eating and social spaces—have replaced the traditional emphasis on spatial efficiency.

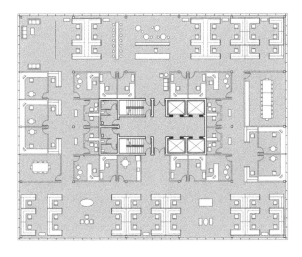

Traditional Office Layouts

Private Office at Window Wall

This layout is typically organized in three layers of functions, starting with a zone of private offices at the window wall, followed by a zone of circulation, then a zone of back-to-back partial-height cubicles for assistants, and a second zone of circulation against the building core.

Natural light typically reaches the middle of the plan through clearstory windows in the wall that separates the private offices from the rest of the office space. This layout results in a conventional dimension from building core to window wall of approximately 45 feet (13.7 m), which has become the ideal industry standard for the minimum width of American office buildings.

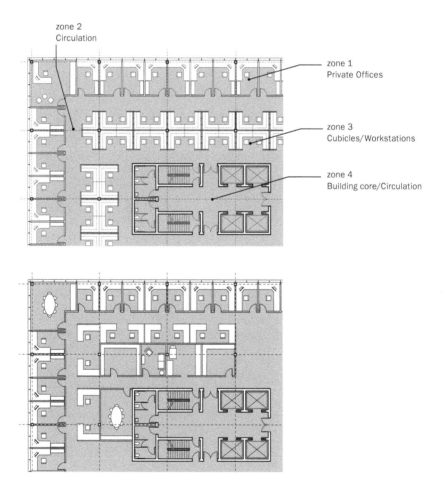

zone 2
Circulation

zone 1
Private Offices

zone 3
Cubicles/Workstations

zone 4
Building core/Circulation

Open Workstations at Window Wall, Private Offices in Center

Related to the open plan opposite, this layout places enclosed offices on the inside of the plan, typically against the core. Private offices in this plan configuration have mostly glass walls to benefit from the natural light in the open office area.

The Evolved Plan

The dynamics of the contemporary workplace involve rapid changes in demographics, technologies, and multiple work styles that combine focused work with multiple collaboration models. With less focus on traditional efficiencies in favor of making ideal work environments, the evolved plan incorporates ideas from the residential and hospitality industries, with areas that support focused work, social spaces, and communal gathering areas.

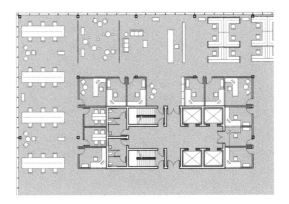

Chapter 7: Types of Rooms

There are a wide variety of room types in domestic, office, and commercial environments, each requiring specific design strategies. Interior designers should, at a minimum, be familiar with the design issues and potential solutions outlined below. The best configuration for a room depends on how it will be inhabited and the potential circulation patterns through its space. Good interior design seeks to balance issues of character, such as comfort and harmony, with these practical considerations.

KITCHENS

The kitchen is the most difficult space in the house to design because appliances, equipment, working surfaces, and storage spaces must be carefully organized into a visually coherent and functional whole. To ensure a smoothly functioning kitchen for more than one occupant, it is necessary to synthesize a wide range of working and circulation scenarios. Fundamental to kitchen planning is the placement of three elements: the refrigerator, the sink, and the stove. These elements define the preparation zone, the washing zone, and the cooking zone. Together, the zones define the three points of the "working triangle." In addition to mapping out a safe and efficient working triangle, interior designers must also consider storage requirements for the countless number of kitchen gadgets, dishes, and other accessories that are found in the contemporary kitchen.

Working Triangle

The ideal total length of the segments that comprise the working triangle is 12 to 22 feet (3 658 to 6 705 mm). The layouts that follow describe how the working triangle might be best arranged for the size and shape of a particular room.

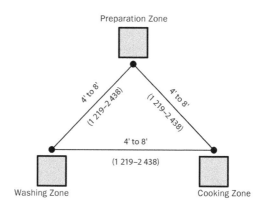

Preparation Zone

4' to 8'
(1 219–2 438)

4' to 8'
(1 219–2 438)

4' to 8'
(1 219–2 438)

Washing Zone

Cooking Zone

Kitchen Layouts

Single-Wall Kitchen

The simplest kitchen organization is a single row of appliances and counter space arranged against a wall. This layout is ideal for long narrow rooms or one wall of a studio apartment where the kitchen can either be screened off or made the central focus of the space. The most practical plan should include counter space on both sides of each major appliance. The refrigerator should be placed at one end of the kitchen wall since it only needs counter space to one side—remember to specify a refrigerator with doors that open in the direction of the adjacent counter space.

Galley Kitchen

A galley kitchen has two parallel runs of counters. The sink, dishwasher, and stove should be located on the same side of the kitchen (cooking and washing zones) and the refrigerator (the preparation zone) should be located on the opposite wall. The counters should be at least 4 feet (1 219 mm) apart to provide adequate room for more than one cook; if the kitchen is designed for only one cook, the space between counters can be reduced to 3 feet (914 mm). This layout is not recommended if other rooms are accessed through the kitchen.

L-shaped or U-shaped Kitchens

In these layouts, the counters and appliances are organized around two or three walls. This arrangement can work in either small or large spaces; however, in larger rooms, the working triangle should be kept within the optimal range of 12 to 22 feet (3 658 to 6 705 mm). Often in these arrangements, one leg of the L or the U forms a counter, which is ideal for casual meals. In this scenario, it is best to design a higher counter to separate the cooking zone from the eating zone.

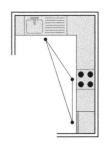

Island Kitchen

A central workstation provides extra space for performing various culinary tasks. Depending on the preferences of the cook, the island can be designed for either preparing or cooking a meal. Of all the layouts, this arrangement encourages the most socializing in the kitchen. It is best used in large rooms that allow enough space between counters and island.

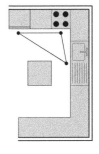

Kitchen Zones

Washing Zone

The washing zone is primarily made up of the sink and dishwasher. Ideally, the sink has two compartments for washing and rinsing. The dishwasher should be placed immediately adjacent to the sink but carefully located so that there is enough room to wash dishes in the sink while the dishwasher is open. If the kitchen does not have a dishwasher, a drying rack should be located above the counter so that it does not take up critical counter space.

It is also important to have a waste bin close to the sink for disposing of trash prior to washing dishes. Trash receptacles are often located behind a cabinet door and underneath the sink to avoid visual clutter. Lay out the cabinet for the trash can so that the cabinet door, when open, does not block the open dishwasher. To avoid this conflict, incorporate the trash cabinet on the opposite side of the sink from the dishwasher.

Preparation Zone

The preparation zone consists of the refrigerator and an adjacent counter-height workspace for preparing food. The refrigerator should be placed in close proximity to the pantry so that perishable and nonperishable foods are both easily accessible from the food preparation workspace. There are many refrigerator/freezer combinations, each suitable for particular spaces and types of users. The size of the refrigerator should be directly proportional to the size of the kitchen.

Different types of tasks are best performed on different types of surfaces: For instance, marble slabs are best for rolling out pastries, while wood counters are best for chopping. These surfaces can be incorporated into the countertops or not, depending on the size of kitchen, the preferences of the cook, and the budget. Other common counter surfaces include granite, engineered quartz, concrete, stainless steel, wood, tile, acrylic solid surfacing, and plastic laminate.

STANDARD DIMENSIONS

	W	D	H
Double Sink	28"–54" (711–1 372)	14"–21" (356–533)	7"–8" (178–203)
Sink	14"–32" (356–813)	14"–21" (356–533)	7"–8" (178–203)
Dishwasher	24" (610)	24"–25" (610–635)	33"–35" (838–889)
B. Freezer	29"–36" (787–914)	25"–33" (635–838)	66"–84" (1 676–2 134)
Side-by-Side	30"–36" (762–914)	29"–33" (737–838)	64"–69" (1 626–753)

Cooking Zone

The cooking zone consists of the stove or a combination of a cooktop and wall oven. In smaller kitchens, a stove is the most efficient choice. In larger kitchens, a separate cooktop and wall oven is more desirable. In either arrangement, there must be sufficient heat-resistant counter space on both sides of the cooktop. Pots and pans should also be stored immediately adjacent for easy access while cooking. A minimum aisle clearance of 36 inches (914 mm) is required in front of the cooktop.

It is important to select the appropriate type of cooktop ventilation system: either a system that recycles air through a charcoal filter or a system that removes smoke through a duct vented to an exterior wall. Ventilating exhaust directly to the exterior is preferred but may not be practical in multifamily residential buildings.

STANDARD DIMENSIONS

	W	D	H
Cooktop	24"–37" (610–940)	21"–27" (533–686)	3"–8" (76–203)
Range	21"–40" (533–1 016)	24"–28" (610–711)	36"–46" (914–1 168)
Wall Oven	22"–30" (559–762)	22"–24" (559–610)	28"–48" (711–1 219)

Vertical Considerations

Standard kitchen appliances are 35 inches (889 mm) high and typically have adjustable feet to help align them with adjacent countertops. Most appliances have a built-in toe space that ranges from 2 to 4 inches (51 to 102 mm) from the floor to accommodate the front of the feet when reaching to the back of the appliance. Adjacent cupboards should be designed with these basic dimensions in mind.

A minimum clear vertical height of 16 inches (406 mm) is recommended between the work surface and bottom of wall cabinets. On upper cabinets, doors should have 180-degree hinges so that no one bangs their head on the doors when open. Lift-up doors can also solve this problem.

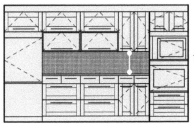

16" (406) min.

DINING ROOMS

The configuration of the dining room is predicated on the size and shape of the dining table. Otherwise, the dining room allows for a great deal of design flexibility. Once a formal room occupied primarily on special occasions, the dining room today lends itself to a wide range of interpretations and can accommodate a variety of lifestyles. The dining room can be an extension of the kitchen, a zone within a large living room, or a separate room organized around the specific rituals of enjoying a meal. Regardless of the configuration, the dining room should be immediately adjacent to the kitchen work areas for easy delivery and cleanup of meals.

Dimensional Criteria

Place Settings

The dimensions of a dining table relate directly to the area required for a place setting. The approximate area of a place setting is 24 inches (610 mm) wide by 15 inches (381 mm) deep. Although the standard dimension for a placemat is 18 inches (457 mm) across, additional area is allocated for serving dishes, wine bottles, and elbow room.

24" (610)

15" (381)

Dining Tables

The average table manufacture allows 24 inches (610 mm) per person; however, other elements must be considered when selecting the right table for a specific number of guests. For instance, a dining chair with arms increases the amount of space required for an individual by 4 inches (102 mm) on average. The location of table legs may also determine the number of people that can sit comfortably at a table. A variety of table configurations are shown here.

To determine the size of a round table, multiply number of seats by width of place setting (26" [660] +/-) and divide by 3.14.

A square table for four can be expanded lengthwise in 24-inch (610 mm) increments for additional seating.

Dining Room Layouts

The size and shape of a room can help to determine the best table configuration for a specific situation. The diagrams that follow look at dining rooms combined with a living room or kitchen as well as dining rooms of minimal dimensions. In addition to tables and loose furniture, interior designers must consider the ambience of a room by including adjustable lighting above the table and near the serving area.

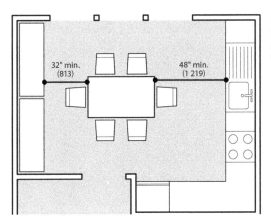

Combined Dining and Kitchen

Kitchens with an eat-in dining table require additional space adjacent to the work zones.

Combined Dining and Living Room

When space is at a premium, combining the dining and living rooms may be better than isolating them into separate smaller rooms.

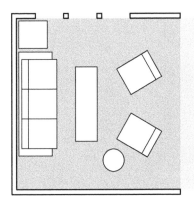

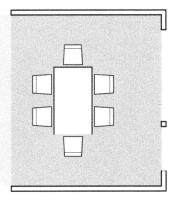

Minimal Dining Room: Rectangular Table

The minimum size of a dining room is based on the size of a rectangular table with 36 inches (914 mm) of clearance on all four sides.

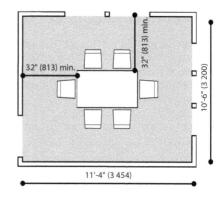

Minimal Dining Room: Round Table

A round table in a square room allows space for cupboards or built-in cabinets in the corners.

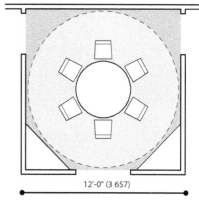

Dining Room with Additional Furniture

An ideal dining room allows space for two additional chairs and a buffet table in the room.

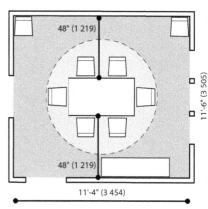

LIVING ROOMS

Of all the rooms in a house, the living room has the fewest constraints since it requires neither appliances, nor plumbing fixtures, nor storage. As a result, interior designers have a great deal of freedom in terms of the character and configuration of the space. The living room should be designed to reflect the particular lifestyle of a family.

Typical Furniture Dimensions

Specific functional requirements and the size and shape of the room will help set the agenda for selecting and arranging the most appropriate furniture. Below are the dimensions of typical living room furniture. Be mindful that the dimensions of specific pieces may vary from the typical sizes. Furniture that diverges widely in dimension from these examples may be uncomfortable and impractical, however.

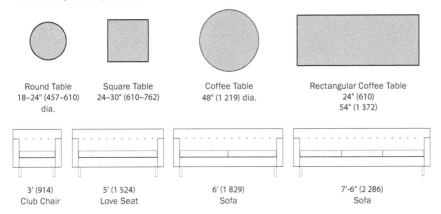

| Round Table 18–24" (457–610) dia. | Square Table 24–30" (610–762) | Coffee Table 48" (1 219) dia. | Rectangular Coffee Table 24" (610) 54" (1 372) |

| 3' (914) Club Chair | 5' (1 524) Love Seat | 6' (1 829) Sofa | 7'-6" (2 286) Sofa |

The distance between chairs and sofas can influence the behavior of the occupants of a space. Two people sitting across from each other must be within a specific dimensional range for conversation to be comfortable. The behavior of larger groups of people around and across a coffee table is also affected by the relative intimacy of the furniture arrangement.

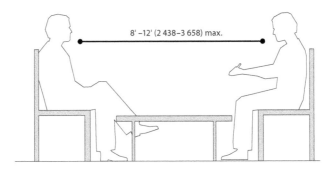

8' –12' (2 438–3 658) max.

Living Room Layouts

A typical living room can function well when arranged according to several alternative principals.

Symmetrical

Using the natural center of a room, furniture is placed around a common axis.

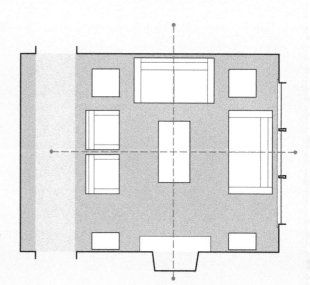

Dual Axis

A cross axis will focus attention toward the center of a room, while other features become a backdrop.

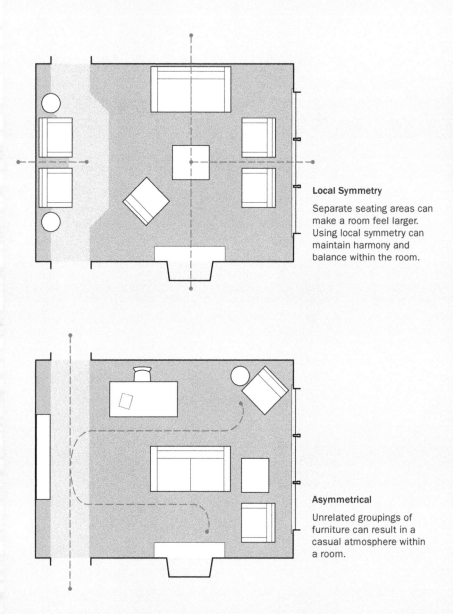

Local Symmetry

Separate seating areas can make a room feel larger. Using local symmetry can maintain harmony and balance within the room.

Asymmetrical

Unrelated groupings of furniture can result in a casual atmosphere within a room.

BEDROOMS

The most important goal in designing a bedroom is to establish a comfortable relationship between the occupants and their bed and between the bed and the room at large. Because people spend an average of six to eight hours a day in the bedroom, the space must engender feelings both of relaxation and security. The design of bedrooms should also accommodate activities such as reading and functions such as storage for personal belongings.

Crib

Furniture

Beds

The bed is the only indispensable piece of furniture in the bedroom; many other functional require-ments can be accommodated by built-in furniture. Examples include built-in window seats and closets. The standard dimensions for beds below will be helpful when selecting the right size bed for a specific room.

Twin Twin XL

Full Full XL

Queen King

STANDARD DIMENSIONS

Type	Inches	Millimeters
Crib	24 × 54	610 × 1 372
Twin	39 × 75	990 × 1 905
Twin XL	39 × 84	990 × 2 134
Full	54 × 75	1 372 × 1 905
Full XL	54 × 84	1 372 × 2 134
Queen	60 × 84	1 524 × 2 134
King	76 × 84	1 930 × 2 134

Additional Furniture

Depending on the size of the room, bedside tables, lounge chairs, side tables, and even writing desks can be added to a bedroom to promote quiet activities during waking hours. Augmenting built-in closets, pieces such as dressers, armoires, and vanities provide other forms of storage in larger rooms.

Bedroom Layouts

Bed Centered in Room

The most typical and practical configuration is to place the bed in the center of the room against one wall. The dimensions recommended below provide ample space for two people to get into and out of bed.

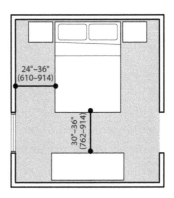

Twin Beds in a Room

A minimum of 30 inches (762 mm) between beds is recommended; this allows for a shared night table and ample room to get into and out of bed.

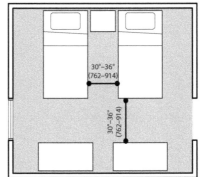

BATHROOMS

Options for bathroom configurations range from two-fixture powder rooms to five-fixture master bathroom suites. The diagrams below include the average sizes for bathrooms based on the number and position of fixtures. For all bathroom layouts, comfort and privacy are top priorities.

Bathroom Layouts

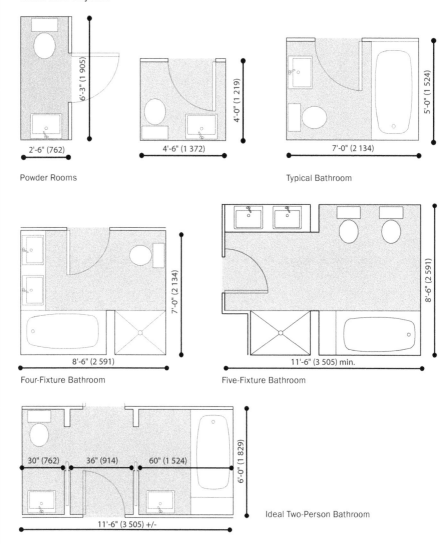

Powder Rooms

Typical Bathroom

Four-Fixture Bathroom

Five-Fixture Bathroom

Ideal Two-Person Bathroom

Design Considerations

Two-Person Use

Placing lavatory, bath, and toilet in a single space is not ideal when the bathroom is shared. When two people commonly use a bathroom suite at the same time, an enclosed toilet or a separate toilet room should be considered if space allows.

Wall and Floor Finishes

Numerous options are available for floor and wall finishes for a bathroom, from ceramic tile to glass tile to stone. Wall finishes need to be water-resistant with a waterproof substrate to 72 inches (1 829 mm) above finish floor and floors need to be slip-resistant.

Lighting

Bathrooms should include both general room lighting and task lighting at the mirror and over the shower. The best mirror lighting is at the sides via wall sconces, which prevents shadows on the face. Wall sconces should be placed approximately 66 inches (1 676 mm) above the floor and minimally 30 inches (762 mm) apart. Avoid using ceiling-mounted fixtures as the sole source of light. If the bathroom is too small and there is not enough room for side lighting, consider introducing a light cove above the mirror.

Shower Controls

The many recent advances in shower design can make the selection of shower controls confusing. Here basic elements are defined:

Spray Showerhead: Traditional showerhead that can be used in a shower enclosure or as part of a tub-shower combination. Mounted to the wall, it comes in a variety of spray patterns. Supplemental handheld showers allow for more flexibility.

Shower Diverter: Valve that redirects water from a spout to a showerhead or handheld shower. A two-way diverter is for a bathtub and shower combination. These diverters can be as simple as a pull-tab on the tub spout that redirects the water flow from one function to the other. A three-way diverter, which redirects the water flow among tub, showerhead, and handheld shower, is a separate control value mounted on the wall.

Thermostatic-controlled Valve: Valve that allows the water temperature to be set, while controlling the amount of water coming through the system at a precise temperature.

High-flow Valve: Valve that controls custom designed showers with multiple spray heads. At this end of the spectrum, the various manufacturers offer many features that are unique to their system.

OFFICE ENVIRONMENTS

Elements

The contemporary office contains a multitude of furniture types and other elements that facilitate new modes of work and interaction. This new thinking encourages collaboration and engagement and as a result, presents unique design challenges. The following is a brief overview of these spaces:

Furniture Systems

Traditional systems of core-perimeter workstations still have a presence in spaces where independent work occurs. The design of these systems have also evolved to embrace the nomadic and more collaborative workspace. Often not tied to a single person, or even a type of work, they are deployed with various levels of privacy and separation. They remain based around surfaces for work and storage and can accommodate varying positions of the body, from seated to standing.

Common Spaces

Whether incorporated into a semiprivate meeting rooms or integrated into an open plan, common spaces offer flexibility and opportunities for informal collaboration. Various types such as pods, bleachers, conversation nooks, and low tables with seating provide many opportunities for chance encounters. Many of these spaces also incorporate features needed for productivity and connection, while retaining the casual feeling of a lounge.

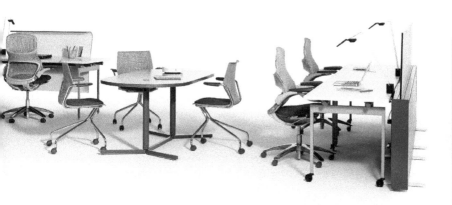

Focus Rooms

Focus rooms provide areas
where quite conversations, phone
calls, and client meetings occur,
with higher levels of acoustic and
visual separation.

Acoustics

As office spaces become more flexible,
open, and collaborative, the need for
acoustic control has increased. Con-
versations, phone calls, and meetings
often overlap and reverberate.

RESTAURANT ENVIRONMENTS

Restaurant types range from utilitarian fast-food purveyors to full-service restaurants with elaborate themes. Restaurant design encompasses a great number of issues regarding adjacencies, kitchen layouts, lighting, acoustics, and so forth. The interior designer must be familiar with each, especially with the dimensional criteria for seating layouts.

Before planning the seating layout, the designer must understand the restaurant concept. The concept should define the type of dining experience offered, the intended clientele, the hours of operation, and the menu. If the restaurateur's idea is to put the workings of the chef on display, for example, then the seating should be arranged so that the kitchen is visible from every table. Equally, the spacing between tables can have a substantial impact on the character of a restaurant. Tables closely packed will result in a loud and lively space, since patrons need to compete with their neighbors to be heard. Conversely, tables spaced far apart tend to separate diners into quieter pockets of conversation.

Types of Seating

Restaurant seating falls into three general categories: loose chairs, built-in seating (for example, banquettes), and bar seating. Seat height is typically 17 to 18 inches (432 to 57 mm) at a table or low counter. Bar seating typically ranges from 30 to 34 inches (762 to 864 mm) in height. All seats should be a minimum of 16 square inches (406 mm²). For the full-service dining experience, consider the use of padded seats and armchairs for ease of getting in and out of the seat.

Tables and Counters

In the restaurant trade, tables are known as tops. The most common sizes are two tops (seating two people) and four tops (seating four people). Beyond these sizes, tables are typically combined or expanded. Some tables have flip-up corners, which convert a square table seating four to a round table seating six people. Table height is typically 30 inches (762 mm). A square table with a minimum dimension of 36 inches (914 mm) across can accommodate four people. A square table with a minimum dimension of 24 inches (610 mm) across is acceptable for two; however, 30 inches (762 mm) is preferable. Smaller tables are acceptable when only drink service is provided. Counters range in height from 28 to 36 inches (711 to 914 mm); however, the Americans with Disabilities Act (ADA) requires that 60 linear inches (1 524 mm) of a counter be no more than 34 inches (864 mm) high to accommodate patrons in wheelchairs.

MINIMUM TABLE DIMENSIONS

Shape	Seats	W	L
Square	2	24", 30" (610, 762)	24", 30" (610, 762)
Square	4	36" (914)	36 (914)
Round	4	36"–42" (914–1 067) dia.	
Round	6	42"–48" (1 067–219) dia.	
Round	8–10	66" (1 676) dia.	
Rectangular	4 (2 per side)	30" (762)	42"–48" (1 067–219)
Rectangular	6 (3 per side)	30"–36" (762–914)	72"–84" (1 829–2 134)
Rectangular	8 (2 per side)	36" (914)	90"–106" (2 286–692)

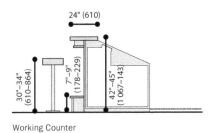

Working Counter

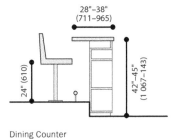

Dining Counter

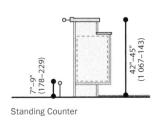

Standing Counter

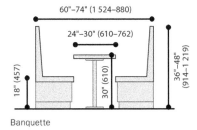

Banquette

These sections describe ideal vertical dimensions. Please note that all vertical dimensions are subject to local building code and accessibility regulations.

Typical Restaurant Layout

A Banquette

B Table Setting

C Bar Seating

D Wall Seating

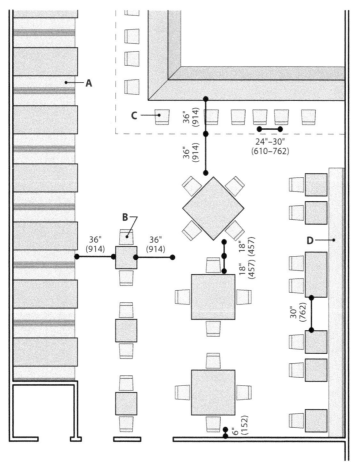

The plan notes minimal dimensions for access aisles, limited-passage, and no-passage aisles. Wheelchair-accessible aisles are required from the restaurant's entry to the accessible seating and restrooms.

Design Considerations

Spacing between Tables

As long as the spacing between tables meets the minimum dimensions required for an access aisle, the spacing is subjective and driven mostly by the restaurant concept. Full-service restaurants provide more space between tables for a comfortable dining experience, while fast-food restaurants maximize the number of seats. The access aisle dimension is determined by the local building code and by the ADA, which specifies a minimum width of 36 inches (914 mm) in the access aisles and also requires that all accessible tables be located adjacent to an access aisle.

Interior Finishes

Interior finishes are the most tangible elements that a designer can use to describe the type and quality of the restaurant. Certainly, materials appropriate for the public areas will differ from those appropriate for the kitchen; but in both areas, fire-retardant materials must be utilized. In addition to the quality of the materials specified, it is important to consider their maintenance standards to ensure their suitability for the type of restaurant.

Lighting

The ambiance of a restaurant will be informed by the lighting design. Low-level mood lighting is typical of fine dining, while bright lighting offers a more casual dining experience. Over the course of a day, restaurants can change the lighting to suggest different moods. Most restaurant lighting is incandescent because of the warm tones that the lamps provide; however, fluorescent lighting is more energy efficient and may be more appropriate in the kitchen areas.

Acoustics

The acoustics in a restaurant go hand-in-hand with the concept. In some restaurants, for example, the reverberation of hard surfaces adds to the desired effect of the dining experience. There are a number of ways to control the acoustics in an environment, as long as the desired effect is understood. The simplest way to control acoustics is through sound-absorptive materials. These can range from carpet on the floor to fabric paneling on the walls to sound-absorptive tiles in the ceiling. Another strategy worth considering is to compartmentalize the restaurant into different types of rooms with different noise levels to suit the various patrons.

Chapter 8: Code and Accessibility

Building codes and the Americans with Disabilities Act (ADA) are the two basic standards with which the interior designer needs to comply. The building code is specified by the jurisdiction in which a project will be built. These codes can be defined by a state, county, township, or city and are typically based on a national model such as National Building Code (BOCA), International Building Code (IBC), International Residential Code (IRC), and Uniform Building Code (UBC). The main focus of these codes is to secure the public's life safety. Codes are frequently amended, and designers need to know which edition the jurisdiction is adhering to during the permitting timeframe of a specific project.

ADA was passed in 1990 to secure civil rights protections for people with disabilities. Unlike the building code, ADA includes design guidelines and requirements based on the principle of equality for people with disabilities. Compliance with the building code thus does not mean compliance with ADA, and vice versa. ADA is the national accessibility code, and as with the building code, jurisdictions have interpretations of the guidelines that are specific to the governing municipality. It is reasonable to assume that these guidelines are written for public facilities and not for private use.

The terminology of the building code and accessibility guidelines are not always the same. While interpreting a code or guideline, it is important to reference the correct definitions.

KEY TERMS AS DEFINED BY ADA

Access Aisle: Accessible pedestrian space between elements such as parking spaces, seating, or desks that provides appropriate clearances per the ADA guidelines.

Accessible: Site, building, facility, or portion thereof that complies with the ADA guidelines and that can be approached, entered, and used by persons with disabilities.

Accessible Route: Continuous, unobstructed path connecting all accessible elements and spaces within or between buildings or facilities. Interior accessible routes may include corridors, floors, ramps, elevators, lifts, and clear floor space at fixtures.

Accessible Space: Space that complies with ADA regulations and can be used by persons with disabilities.

Adaptability: Ability of certain buildings, spaces, and elements (e.g., kitchen counters, sinks, grab bars) to be added to or

altered so as to accommodate the needs of persons with or without disabilities or with different types of degrees of disability.

Adaptable: Able to readily be made accessible to, functional for, and safe for use by persons with disabilities without structural change.

Area of Rescue Assistance: Area with direct access to an exit, where people who cannot use stairs may remain temporarily in safety to await further instructions or assistance during an emergency evacuation.

Automatic Door: Door equipped with a power-operated mechanism and controls that open and close the door automatically. The switch that begins the automatic cycle may be a photoelectric device, floor mat, or manual switch.

Bathroom: Space or series of interconnected spaces that contain a toilet, sink, and bathtub or shower.

Change of Use: Varying the use of a building from a private to a public one.

Clear: Unobstructed.

Clear Floor Space: Minimum unobstructed floor or ground space required to accommodate a single, stationary wheelchair and occupant. Unless otherwise stated, the dimensions of clear floor space shall be 30 by 48 inches (762 by 1 220 mm).

Common Use: Refers to those interior and exterior rooms, spaces, or elements that are made available for the use of a restricted group of people.

Detectable Warning: Standardized surface feature built into or applied to walking sur-faces or other elements to give warning of hazards on a circulation path.

Dwelling Unit: Unit providing living facilities for one or more persons.

Egress, Means of: Continuous and unob-structed path of travel from any point in a building or structure to a public way, consist-ing of three separate and distinct parts: the exit access, the exit, and the exit discharge. A means of egress comprises the vertical and horizontal means of travel and should include intervening room spaces, doorways, hallways, corridors, passageways, balco-nies, ramps, stairs, enclosures, lobbies, horizontal exits, courts, and yards.

Entrance: Any access point to a building or portion of a building or facility that is used for the purpose of entering. An entrance in-cludes the approach walk, stairs, lifts, ramp, or other vertical access leading to the en-trance platform; the entrance platform itself; vestibules; the entry door(s) or gate(s); and the hardware of the entry door(s) or gate(s).

Ground Floor: Floor of a building closest to the level of the exterior grade and any floor within 36 inches (914 mm) of an exterior grade at some or all of its perimeter. Build-ings on sloped sites may have more than one ground floor.

Half Bathroom: Space with a toilet and a sink.

Loft: An intermediate level between the floor and ceiling of any story, located within a room or rooms of a dwelling.

Mezzanine or Mezzanine Floor: Intermediate level between the floor and ceiling of any story with an aggregate floor area of not more than 33 percent of the floor area of the story in which the level is located.

Occupiable: Room or enclosed space designed for human occupancy in which individuals congregate for amusement, education, or similar purposes or in which occupants are engaged in labor and which is equipped with means of egress, light, and ventilation.

Ordinary Repairs: Any maintenance that does not affect structure, egress, fire protection systems, fire ratings, energy conservation provisions, plumbing, and sanitary, gas, electrical, or other utilities.

Power-assisted Door: Door with a mechanism that helps to open the door or that reduces the opening resistance of the door, on the activation of a switch or a continued force applied to the door itself.

Ramp: Walking surface that has a running slope greater than 1:20 but no greater than or equal to 1:12.

Reasonable Modification: Physical changes to multiple dwellings requested by persons with disabilities or their agents to enable full use and enjoyment thereof.

Remodeling: Modification beyond an interior decoration or involving any structural changes or the redecorating of a public building for which the cost of such refurbishing, updating, or redecorating equals or exceeds 5 percent of the full and fair cash value of the building.

Repair: Reconstruction or renewal of any part of an existing building for the purpose of its maintenance.

Sleeping Accommodations: Rooms in which people sleep; for example, dormitory and hotel or motel guest rooms or suites.
Space: Definable area; for example, a room, toilet room, hall, assembly area, entrance, storage room, alcove, courtyard, or lobby.

Story: Portion of a building between the upper surface of a floor and the upper surface of the floor or roof next above. This portion of the building must include occupiable space to be considered a story. There may be more than one floor level within a story, as in the case of a mezzanine.

Structural Changes: Major reconstruction of walls or partitions or relocation of bearing walls or partitions. Minor alterations, including the opening of wall sections and/or the relocation of equipment or fixtures, are not considered structural changes.

Tactile: Describes an object that can be perceived using the sense of touch.

Tactile Warning: A surface texture applied to or built into walking surfaces or other elements to warn visually impaired persons of hazards in the path of travel.

Unassisted Access: Condition that enables a person with a disability to obtain information about and to maneuver a path of travel without the assistance of another person, except at those points and under those conditions in which individuals without disabilities would need assistance from another person. This definition does not restrict the right of a person with a disability to request and receive assistance.

Use: Purpose for which a building is designed, used, or intended to be used.

Walk (Walkway): Interior or exterior pathway with a prepared surface that is intended for pedestrian use, including, but not limited to, general pedestrian areas such as plazas, courts, and crosswalks.

DOORS

Clear Opening

The minimum clear opening width is 32 inches (813 mm) measured with the door open in a 90-degree position. The measurement should be taken from the face of the door to the stop on the strike jamb. For bifold, accordion, and pocket doors, the clear widths are measured when the doors are in a fully opened position. No projections are allowed in clear opening space, with the exception of door hardware.

For double doors, one leaf must comply with the minimum clear opening. Shallow closets that are less than 24 inches (610 mm) deep are exempt from the minimum clear width. Doors that are recessed more than 6 inches (152 mm) from the door opening need to comply with pull- or push-side requirements.

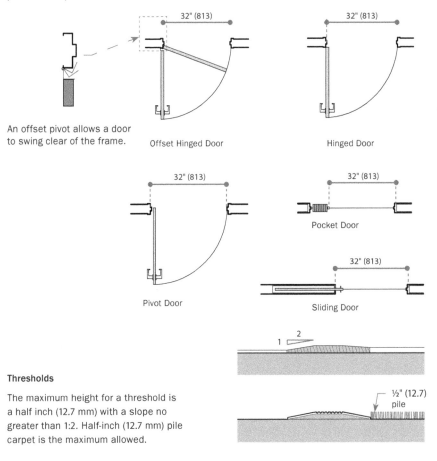

An offset pivot allows a door to swing clear of the frame.

Offset Hinged Door

Hinged Door

Pivot Door

Pocket Door

Sliding Door

Thresholds

The maximum height for a threshold is a half inch (12.7 mm) with a slope no greater than 1:2. Half-inch (12.7 mm) pile carpet is the maximum allowed.

Door Hardware

Handles, pulls, latches, and locks must be easy to grasp with one hand. Door hardware should be operable with a closed fist or loose grip. All operating devices should be mounted between 34 and 48 inches (864–1 220 mm) above finished floor.

Opening Force

The opening force for an interior hinged, sliding, or folding door should not exceed 5 pounds (2.26 kg). The opening force does not consider the force required to operate a latch or the initial force to open the door; it is a measure, rather, of the continuous application of force.

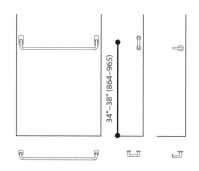

Pull-Side Clearance

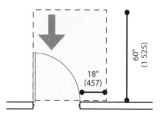

Front Approach

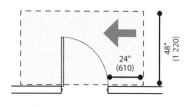

Latch-Side Approach

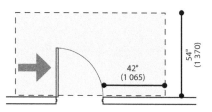

Hinge-Side Approach

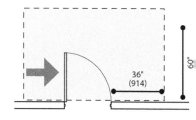

MANEUVERING CLEARANCES AT MANUAL DOORS AND GATES

Approach Direction	Door or Gate Side	Perpendicular to Doorway	Parallel to Doorway
Front	Pull	60" (1 525)	18" (457)
Hinge-side	Pull	60" (1 525)	36" (914)
Hinge-side	Pull	54" (1 370)	42" (1 065)
Latch-side	Pull	48" (1 220)[1]	24" (610)
Front	Push	48" (1 220)	0" (0)[3]
Hinge-side	Push	42" (1 065)[2]	22" (560)[4]
Latch-side	Push	42" (1 065)[1]	24" (610)

[1] Add 6" (150) if closer is provided.
[2] Add 6" (150) if closer and latch are provided.
[3] Add 12" (305) if closer and latch are provided.
[4] Beyond hinge side.

Push-Side Clearance

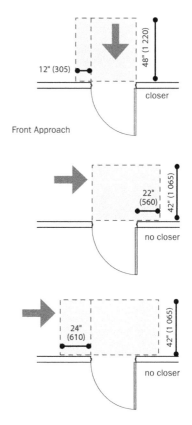

Front Approach

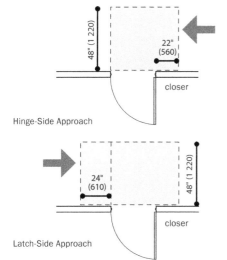

Hinge-Side Approach

Latch-Side Approach

VERTICAL CIRCULATION

Stairs

ADA requires that all steps in a flight of stairs have uniform riser and tread dimensions. The minimum riser height is 4 inches (102 mm) and the maximum riser height is 6 inches (152 mm). The minimum depth of a tread is 11 inches (280 mm); however, these dimensions should be verified with local building codes. ADA does not permit open risers.

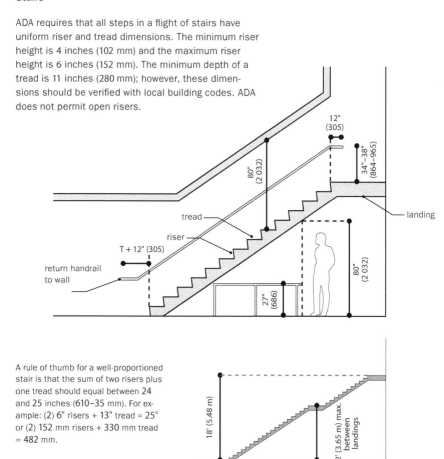

A rule of thumb for a well-proportioned stair is that the sum of two risers plus one tread should equal between 24 and 25 inches (610–35 mm). For example: (2) 6" risers + 13" tread = 25" or (2) 152 mm risers + 330 mm tread = 482 mm.

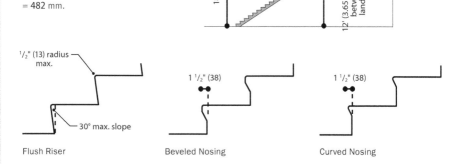

Flush Riser

Beveled Nosing

Curved Nosing

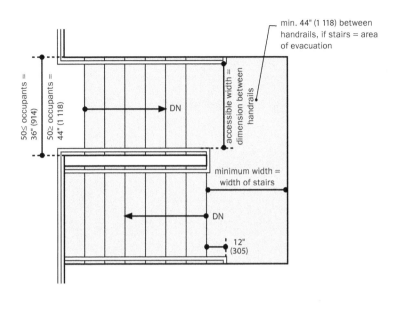

min. 44" (1 118) between
handrails, if stairs = area
of evacuation

50≤ occupants =
36" (914)

50≥ occupants =
44" (1 118)

accessible width =
dimension between
handrails

DN

minimum width =
width of stairs

DN

12"
(305)

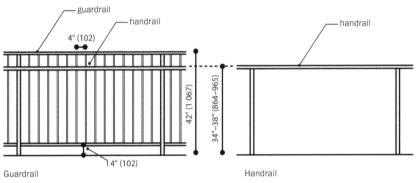

guardrail

handrail

4" (102)

42" (1 067)

34"–38" (864–965)

handrail

4" (102)

Guardrail

Handrail

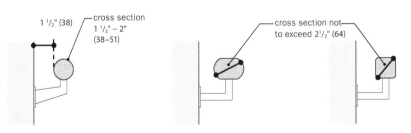

1 ¹/₂" (38)

cross section
1 ¹/₂" – 2"
(38–51)

cross section not
to exceed 2¹/₂" (64)

Handrail Cross Sections

Ramps

The maximum rise of a ramp cannot exceed 30 inches (762 mm) in height without a landing. Ramps must have landings at both top and bottom. The maximum slope of a ramp is 1:12. A slope that is 1:20 or less is not considered a ramp and does not require handrails. Ramp runs that exceed a 6-inch (152 mm) vertical drop require handrails on the sides, as well as vertical edge protection or a 12-inch (305 mm) horizontal surface extension beyond the handrails. The minimum clear width of a ramp is 36 inches (914 mm).

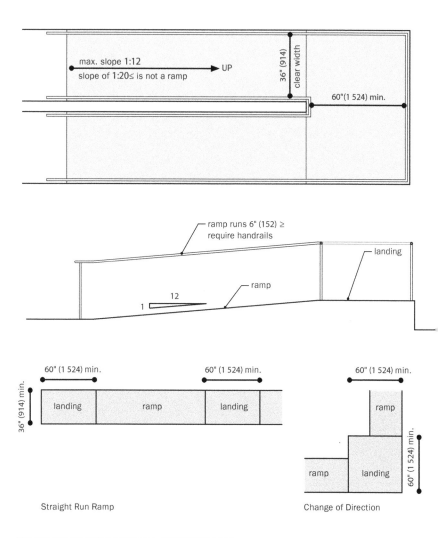

Straight Run Ramp

Change of Direction

Elevators

Visible, tactile, and audible displays are required at and around elevators to allow disabled persons to function independently in elevators. Hall signals at each elevator should announce the arrival of an elevator audibly and visually. Audible signals sound once for cars traveling up and twice for cars traveling down; for new elevators, they must verbally announce each floor at each stop. Tactile designations are required at jambs and should be mounted 60 inches (1 524 mm) above finished floor. Hoistway key access and elevator call buttons must be mounted 35 to 48 inches (889 to 1 220 mm) high, as should all interior control buttons unless the building exceeds sixteen floor levels.

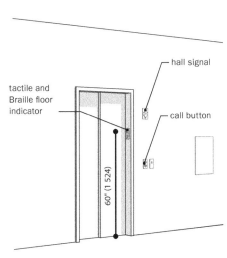

tactile and Braille floor indicator

hall signal

call button

60" (1 524)

80" (2 032) min.

51" (1 295) min.

Centered Door

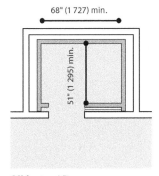

68" (1 727) min.

51" (1 295) min.

Off-Centered Door

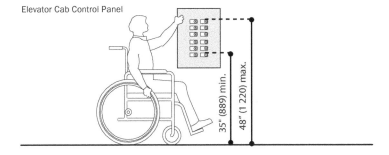

Elevator Cab Control Panel

35" (889) min.

48" (1 220) max.

BATHROOMS

Toilet Stalls

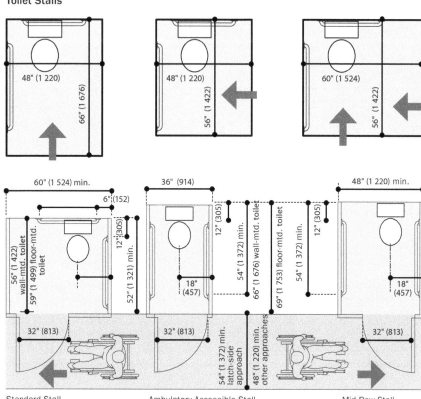

48" (1 220) 66" (1 676)

48" (1 220) 56" (1 422)

60" (1 524) 56" (1 422)

60" (1 524) min. 6" (152) 12" (305) 12" (305) 56" (1 422) wall-mtd. toilet 59" (1 499) floor-mtd. toilet 52" (1 321) min. 32" (813)

Standard Stall

36" (914) 12" (305) 54" (1 372) min. 66" (1 676) wall-mtd. toilet 69" (1 753) floor-mtd. toilet 54" (1 372) min. 18" (457) 32" (813) 54" (1 372) min. latch-side approach 48" (1 220) min. other approaches

Ambulatory Accessible Stall

48" (1 220) min. 12" (305) 18" (457) 32" (813)

Mid-Row Stall

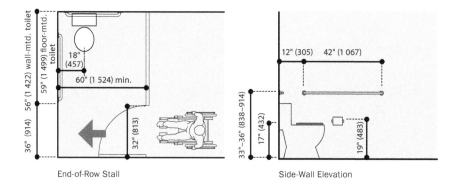

56" (1 422) wall-mtd. toilet 59" (1 499) floor-mtd. toilet 36" (914) 18" (457) 60" (1 524) min. 32" (813)

End-of-Row Stall

12" (305) 42" (1 067) 33"–36" (838–914) 17" (432) 19" (483)

Side-Wall Elevation

Lavatories

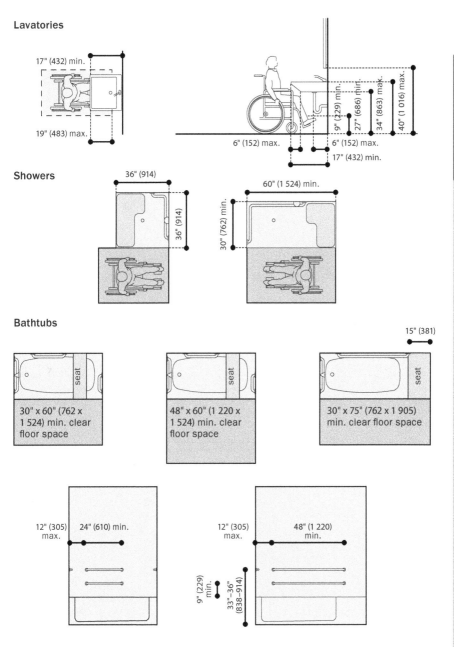

17" (432) min.

19" (483) max.

9" (229) min.

27" (686) min.

34" (863) max.

40" (1 016) max.

6" (152) max.

6" (152) max.

17" (432) min.

Showers

36" (914)

36" (914)

60" (1 524) min.

30" (762) min.

Bathtubs

15" (381)

seat

30" x 60" (762 x 1 524) min. clear floor space

seat

48" x 60" (1 220 x 1 524) min. clear floor space

seat

30" x 75" (762 x 1 905) min. clear floor space

12" (305) max.

24" (610) min.

12" (305) max.

48" (1 220) min.

9" (229) min.

33"–36" (838–914)

KITCHENS

When designing a kitchen for a multifamily dwelling, interior designers must determine the jurisdictional requirements for their specific project because they can vary depending on the type of project and the number of units. The layout for an accessible kitchen follows the same principles as that of a standard kitchen, with additional criteria regarding maneuverability. In general, clear floor space is required at fixtures and appliances, and the shape and size will depend on whether the approach is parallel or perpendicular.

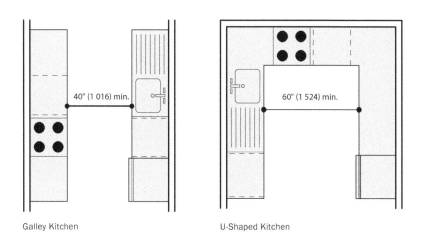

Galley Kitchen U-Shaped Kitchen

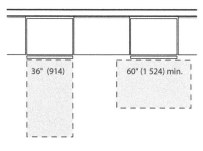

Front Approach

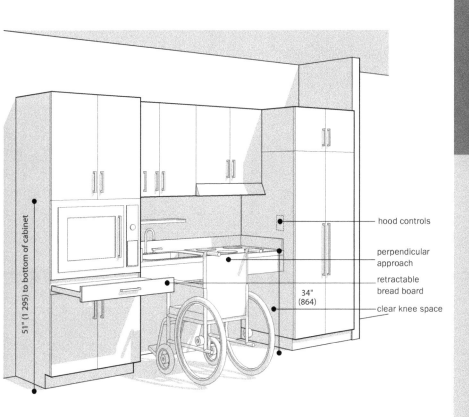

51" (1 295) to bottom of cabinet

hood controls

perpendicular approach

retractable bread board

34" (864)

clear knee space

Adaptable Kitchen Design

Depending on the specific project, a kitchen might be designed as "adaptable," meaning that certain features can be adapted for persons with or without disabilities. Examples of adaptable features are removable base cabinets for clear knee space and adjustable counter heights.

SEATING

Minimum aisle widths must connect all occupiable areas, such as seating, bar areas, restrooms, and exits. Accessible seating should be evenly distributed around the dining room and should be able to accommodate parties of all sizes. Disabled patrons should have access to all sunken or raised areas of a restaurant; however, certain exceptions may be granted in a specific jurisdiction.

Typical Layout for
Accessible Seating

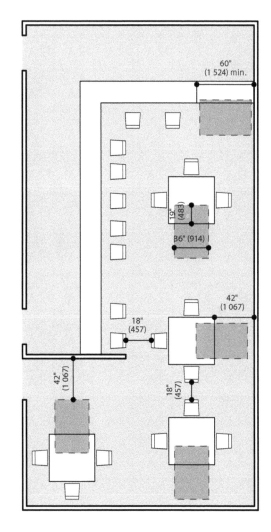

Furniture

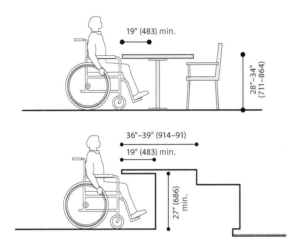

Table tops and counters should range between 28 and 34 inches (711–864 mm) in height for accessible patrons. The clear knee space must be 27 inches (686 mm) high, 30 inches (762 mm) wide, and 19 inches (483 mm) deep underneath tables and counters.

Counters

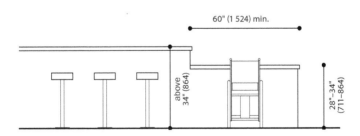

At dining counters that exceed 34 inches (864 mm) in height, at least 60 inches (1 524 mm) of the counter length must be 28 to 34 inches in height (711 to 864 mm), or accessible seating must be provided within the same area.

Michael Gabellini, describe yourself and your practice.

My firm is an interdisciplinary design studio specializing in architecture and interior design. We operate as a kind of high-octane design shop, generating concepts and assembling teams of designers and artists to cross-pollinate a project. The practice was founded in 1990, after I returned from living in Italy for a while, which offered a unique vantage point from which to initiate my own work.

Who were your mentors that taught you about design? At what point in your life did you feel confident about designing?

My father was an artist and interior designer. Growing up in Pennsylvania, in an area with rich art and industry traditions, design was a constant undercurrent, a way of seeing the world. This initiated a fascination with design as something that can enhance your daily life, from spatial geometry and movement to better lighting or furnishings.

Until I arrived at RISD (Rhode Island School of Design), however, I thought I was going to be a sculptor. This sculptural sensibility percolated into my architectural studies and gave me an interesting counterpoint to work from. The program was very rigorous and conceptually oriented, which suited me well. It was at this point that different influences and interests converged into the desire to become a designer.

I was also infused with purpose while studying at the Architectural Association in London during a very intoxicating period with mentors such as Rem Koolhaas, Bernard Tschumi, and Zaha Hadid.

Who or what do you look at for inspiration?

In terms of pure architecture, I look to the modern masters like Mies, Neutra, and Barragán. I also love the early modern French designers Paul Dupré-Lafon and Jean-Michel Franc. But equally important for me is the work of contemporary artists and specific artistic sensibilities: for example, arte povera, the California light artists, and American land art, such as Robert Smithson's landfill projects.

How do you refresh your creativity?

It percolates down through art and travel and those rare moments of solitude. I find the visual conversations among artists to be quite stimulating, a feast for the senses and the mind. And there is no substitute for the fresh perspective and insights you

gain from immersing yourself in different cultures and places, each with its own vocabulary of public and private space.

Many of your projects "dematerialize" the corners of a room by incorporating reveals and light conditions at the intersections of ceilings, walls, and floors. Does that serve to emphasize planes rather than volumes? Please describe your intent.

It's about creating a sense of floating planes that affect and help sculpt the volume in order to create a seductive interplay between light and space, and to convey a sense of weight and weightlessness to blur the distinctions between indoors and outdoors. Ultimately, I want to elevate the essential acts of perception and deepen the awareness of space and the body moving through it.

Lighting seems to be very important in your work. How do you develop your lighting strategies, and how does this affect your reading of space? Is there a lighting designer with whom you collaborate?

We wouldn't be the first designers to consider light as the prime animator of space, but we really have to think about the cycle of illumination from daylight to moonlight and how it relates to the lives of our individual clients. We seek a balance of natural and artificial light to mold the space, creating a functional and alluring frame to the activities of viewing art, shopping, lounging, bathing, or whatever the program may be. Over the years, we have collaborated with a handful of talented lighting designers such as William Armstrong and Ross Muir.

The East Hampton residence that you designed is unlike any of your other projects in that it places the existing house on a minimalist plinth and creates an exterior room. In the context of the rest of your work it could be considered a landscape project. What is your opinion about the differences and similarities among interior design, architecture, and landscape architecture?

The Bellport House was indeed a special project, but actually I have always been very interested in the spatial crossover from outdoors to indoors. Our first project for Jil Sander, the Paris flagship, was conceived as an interior "courtyard" within the Beaux-Arts mansion. More recently, we designed the louvered ceiling and lighting concept of Bergdorf Goodman's fifth floor to evoke something of a sun-lit afternoon.

The notion of "exterior rooms" also came into play at the Rockefeller Center observation decks, where we designed the terraces with optical glass screens to offer the purest possible viewing experience. Whether we are designing a piece of furniture or an urban square, we consider the discipline of design to be the master mediator of scale and use.

Your color palette is predominantly white. Other architects like Richard Meier and Philippe Starck also use a lot of white. How would you say you distinguish the use of "white" in your work?

The point of distinction might be the depth and number of whites we use. In any one of our purer environments, regardless of site, there are as many as five to eight shades of white to highlight or shadow a space, much the way women apply cosmetics to strengthen or diminish certain natural features.

Ultimo Boutique in San Francisco has a very bold color palette. What inspired your use of color?

Ultimo was conceived as a red chinoiserie box and as a dramatic performance space for entering into a sculpted, graphic world in miniature. Like falling through a looking glass—à la Alice—and discovering a saturated world of bespoke women's collections with tantalizing objects shaped by veils of ambient light.

Is there a building or project type that you haven't done that you wish you could do?

We have honed our obsession with art, and spaces for viewing art, over the years. So it would be natural for us to design a museum from the ground up. This would help nurture our obsession.

Could you name two or three contemporary spaces that impressed or affected you, and explain why?

James Turrell's *Roden Crater Project* in Arizona. A celestial connection between earth and atmosphere, his ultimate perceptual cell.

Walter De Maria's *Lightning Field* in New Mexico. A heightened field of perception hovering above the iron ore beneath, also a place that has a peculiar effect on ants.

Robert Smithson's *Spiral Jetty* in Utah. An enduring gesture that shows it's possible to do something man-made that is meaningful.

Overleaf Left Top of the Rock, Grand Atrium, New York, NY. Photo by Paul Warchol.
 Right Ultimo, San Francisco; Jill Sander, Paris. Photos by Paul Warchol.

3.

SURFACE

Of all the tools that interior designers use to define space, surfaces are perhaps the simplest and, at the same time, most provocative. The impact of the detailed, behind-the-scenes work that allows an interior to function effectively will be lost unless the finished surfaces are well integrated into the project.

Theories abound about how surfaces affect mood, atmosphere, comfort, and the basic ways a space is inhabited. The different ways in which designers approach these ideas have created some of the most challenging and thoughtful expressions of what an interior is.

Surface is often discussed in terms of its depth, its relative thinness, and the appropriateness of a particular surface to function, space, and durability. The more the designer understands how color, material, texture, and pattern have developed, how choices of finish translate into ideas of taste, and how surface variation can impact a space, the greater, and richer, the opportunities will be for the design practice.

Chapter 9: Color

Color remains one of the most challenging and contentious aspects of interior design. As the painter and color theorist Josef Albers noted, "colors present themselves in continuous flux, constantly related to changing neighbors and changing conditions."

The application and mixing of color has long been an intense area of study for scientists, artists, and designers. At the same time, color can be an extremely subjective topic: Everyone has their favorite colors—colors that remind them of a place or time or that have specific emotive qualities. The role of color in interior design resists dissemination into simple rules and ideas, and yet understanding the complexities of using color in a space is fundamental to creating a successful interior. Thus, interior designers must learn the characteristics of color and how it can act as a focusing and organizing agent.

FUNDAMENTALS OF COLOR

Color, fundamentally, is the result of the way in which an object absorbs or reflects the visible light in the color spectrum. An object that the eye perceives as red absorbs every color except red, which it reflects. White is often described as the reflection of all colors, while black is described as the absorption of all colors.

Seeing Color

Color is a physical phenomenon, and the range of colors stretches far beyond what the human eye is capable of perceiving. At either end of the visible spectrum of light are the imperceptible infrared and ultraviolet lights. In between is "human color space." This model is best observed when light is refracted in a prism and the eye identifies the resultant color wavelengths—whose number is considered to be around 10 million—as a rainbow.

Additive and Subtractive Color Mixing

To think about color relative to light and its effect leads to a discussion of how color mixes, either in additive or subtractive systems. Light that is emitted to create color is often referred to as additive. Combinations of red, green, and blue primary colors produce other colors; all three combined produces white. Using this color mix are monitors of all kinds, from computer screens to television sets to flat-panel display systems. Subtractive color mixing exists in two forms: combinations of cyan, magenta, and yellow and combinations of red, yellow, and blue. In these systems, the base colors are added to each other on an opaque medium such as paper, and their mixing changes the way colors are absorbed and reflected. CMY provides the model for the printing industry, and RYB is the model for both fine art training and color theory.

Additive Color

Starting from the primary group of red, green, and blue, an additive color model occurs when colored lights overlap and mix to produce a visible spectrum. The mixing of the primaries results in the color white.

Subtractive CMY and RYB

In a subtractive system, colors are used to filter out the red, green, and blue from white light. In this model, color is added to paper through the mediums of ink and paint, and colors are produced through the absorption the wavelengths other than what the eye sees. The two color models of subtractive systems are defined by their use in the printing industry—which combines cyan, magenta, yellow, and black to create a visible spectrum of color—and the fine arts—where red, yellow, and blue form the basis for mixing colors.

THEORIES OF COLOR

Many attempts have been made to establish methodologies to evaluate the advantages of certain color combinations. Very early on, color wheels or color spheres were engaged to visually communicate the associations and range of colors and their relationships to each other. In his *Opticks* of 1706, Isaac Newton split white light into seven colors—orange, yellow, green, blue, indigo, violet, and red—arranged on a disk in proportionate slices such that the spinning of the disk would result in the color white. Newton's objectification of color into a mathematically understandable system allowed for quantifiable experimentation.

The German poet Goethe along with the romantic painter Philipp Otto Runge further expanded color theory (in, respectively, *Theory of Color* of 1807 and *Color Sphere* of 1810) to include research into the subjective effects of colors: the contrast of complementary colors, the visual illusion of afterimages, and the contrasting.shadows seen in colored light. They also associated color with emotion—speaking of certain colors as warm and others as cool.

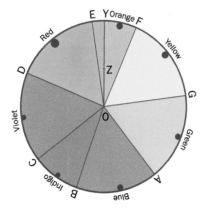

Newton's Hue Circle

In his attempt to develop a theory of color, Newton was the first to understand that colors did not lay on a linear chart, but rather existed in a continuum. The hue circle is represented by white at the center (O) and the hues arranged in order around the disk. Each hue is given a weight, or proportion, that balances it within the system. Newton closed his system through a mix between red and violet that did not appear in his natural primary spectrum.

Itten's Color Wheel

Johannes Itten developed his color wheel based on primary colors of red, yellow, and blue. From this simple starting point, two steps of mixing result in a 12-hue color circle. Itten did not believe in further expanding the wheel to 24- or 100-hue wheels, as the dilution of the naming system he established made it difficult to easily identify color distinctions.

Itten and Albers

In the early twentieth century, two supportive theories of color emerged from the Basic Studies curriculum at the Weimar Bauhaus that continue to influence the way we comprehend color today. The first emerged out of the teaching of Johannes Itten, who developed the 12-hue color wheel. He identified seven rules of contrast that examined, in a scientific way, the subjective effects of color combination, proportion, and harmony. Itten's philosophical and mystical beliefs influenced his understanding of the use of color and have led some to dismiss the importance of his discoveries. His *Art of Color*, however, is still in publication. Josef Albers, who developed his *Interaction of Color* after he had begun to teach at Yale University, expanded on the instructional exercises of Itten to further emphasize the notion that color and the interaction of colors were a discipline to be learned.

The Munsell Model

In the early 1900s, the American Albert Munsell developed a system of color analysis based around hue, value, and chroma. These elements form a three-dimensional model: Starting with a circular relationship of hues, Munsell established a decimal notational system to describe the transitional relationship as one color is identified from another.

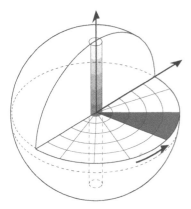

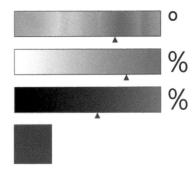

Munsell's Color Sphere

In Munsell's system, hue is arranged around the perimeter of a sphere, value as it moves from the top pole (light) to the bottom (dark), and chroma as it moves toward the center. Munsell also developed nomenclature that made it easy to identify any color in his system. R 5/10 would be red, value 5, chroma 10.

Hue, Saturation, and Brightness

In most software applications, color can be chosen using the Hue, Saturation, and Brightness (HSB) model (also referred to as Hue, Saturation, and Value). Hue is measured in degrees from 0 to 360; saturation determines the vibrancy as the color moves toward white; and brightness changes the darkness of a color. Saturation and brightness are measured in percentages.

Munsell also limited the nomenclature of his color system, referring to orange as red-yellow to avoid confusion. His second term, value, describes the light or dark qualities of a color, on a scale from 1 (dark) to 10 (light). His final term, chroma, identifies a color as it moves inward from the hue band to the value pole. Other color models refer to this as saturation. To account for the variation in strength of a color (red is considered to be twice as strong in chroma as blue-green), Munsell developed what he called the color tree.

These systems serve as a starting point in understanding the complex relationships of balance, proportion, harmony, and effect that combinations of colors can produce. Each has its merits and applications for an interior design practice. Furthermore, their translation to a three-dimensional design space needs to be tested in-situ to observe the results. The following pages examine how one of these systems—that elaborated by Itten—functions as a model for developing a deeper understanding of color.

RELATIVE COLOR

Color Temperature

Color, inherently, has temperature. Color can be described as being warm (reds, oranges, yellows) or cold (blues, greens). Neutrals (whites, grays) also have ranges of temperatures. Whites can shift in tone from cool to warm, and the change in temperature can enhance and tie together a color scheme. Grays, too, have temperature. In the Pantone color system, cool grays tend toward blue, while warm grays gradate toward brown.

Warm and Cool Colors

Color and Material

The role of color in interior design is further complicated by its association with materials. Materials have qualities of absorption, reflectance, and luminance that the abstract systems of color do not take into account. Materials might contain many layers of color, and often variations of color can occur within a single material sample. The proportional use of material within a three-dimensional space also affects how color is experienced. Through the complex interaction of color and material, an interior designer can create atmospheres of intimacy or freshness, vibrancy or muteness, and even begin to affect other senses such as sight and hearing.

Color in interior design can, moreover, be divided into two distinct categories: color as an applied surface and color as integral to a material. Paint, lacquer, specialty finishes, certain laminates, and other applications of color to the finished surface of an object are efficient and modifiable strategies for color use. There are many instances where paint and applied finishes should be avoided, however: Adolf Loos's aphorism "Do not paint concrete gray, or wood brown" holds true here. Materials with integral color—which require no finish other than a sealer—have greater depth of surface, which allows more complex, precise color relationships to be developed.

(OTHER, RELATED ASPECTS OF COLOR WILL BE EXAMINED IN THE CHAPTERS DEDICATED TO MATERIAL, TEXTURE, PATTERN, AND LIGHT.)

Color Schemes

Color schemes are the result of turning color combinations into a set of rules for an interior palette. Grounded in color theory, the designer can creatively select and organize color in harmonious combinations. In the abstract—that is, when color is not tied to a material—there are six "classic" combinations of color: monochromatic, analogous, complementary, split complementary, triadic, and tetradic. The examples below use a full-saturation color wheel, but the designer can vary both saturation and brightness.

Monochromatic

Uses a single color in a variety of saturations and lightnesses to unify a scheme.

Analogous

Uses colors directly adjacent to the chosen color. The prime color serves as the dominant color in the scheme.

Complementary

High-contrast scheme developed by paring the chosen color with that directly opposite on the color wheel.

Split Complementary

Variation on the complementary scheme that pairs the chosen color with two adjacent colors.

Triadic

Uses colors equally spaced around the color wheel. Produces high-contrast schemes.

Tetradic

Uses two complementary color pairs. Proportions of colors must be chosen carefully to maintain balance.

APPLYING RULES OF CONTRAST TO INTERIOR SPACE

In the seven variations on color contrast that Itten identified, contrast was considered as a range of differences between the compared effects of color interaction. The projects that follow explore the practical application of Itten's system to an interior project—whether at the scale of a room or a building. As with any system, continued exposure to and examination of the effects of each set of relationships will deepen understanding.

Contrast of Hue

The simplest of the rules, contrast of hue, functions at the extremes of undiluted colors at the greatest luminosity. Solutions that use contrast of hue have a visual vibrancy and playful intensity. This contrast always requires three colors, and it is important to note that the effect lessens as the colors move away from Itten's three primaries.

For the interior of the SRK Legal Assistance, the Dutch firm eijkingdelouwere use contrast of hue to great effect. Colors playfully interact through the space; lime-yellows, blues, and reds in the felt poppy figures lift the environment from staid office to a lively series of colored spaces.

eijkingdelouwere. Photo by Eric Laignel.

Light-Dark Contrast

Light-dark contrast exists in the relationship between black and white—as well as in the range of grays that exist between them. Itten saw gray as an essentially achromatic color, shifting in relationship depending on the colors that surround it. The key to this contrast is a deeper understanding of shading and its effects.

A showroom for the textile manufacturer Kvadrat in Stockholm eschews the typical neutral background for display in favor of an innovative tile system developed by the designers Ronan and Erwan Bouroullec. The move from light to dark symbolizes a shift in function—from open showrooms to more intimate meeting spaces and offices.

Ronan and Erwan Bouroullec. Photo courtesy of Maharam.

Cold-Warm Contrast

Particular colors can affect the relative comfort
of a room at a specific temperature. In fact, a
perceptual change in physical temperature occurs
in spaces when they are painted in cold versus
warm colors. For Itten, cold-warm contrasts were
highly versatile in their expressive powers.

For a lounge in the André Balazs Hotel QT,
Lindy Roy uses a cold-warm contrast to dis-
tinguish the different zones of the space.
The bar is surfaced in a cool blue that acts
as a functional highlight against the warm,
intimate spaces that surround it.

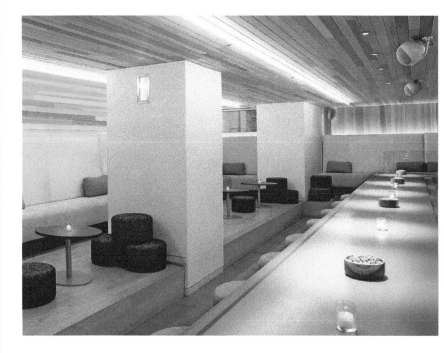

Complementary Contrast

Complements occur when two hues are mixed and the result is a neutral gray-black. (In additive color systems, the result will be white.) Every color within a color system has its complement; finding a complementary color is a simple matter of selecting opposite colors on Itten's wheel. In complementary contrasts, colors balance each other.

For a hotel in Milan, designer Patricia Urquiola uses complimentary contrast with a vibrant pallet of material and light to draw attention to specific moments within the room.

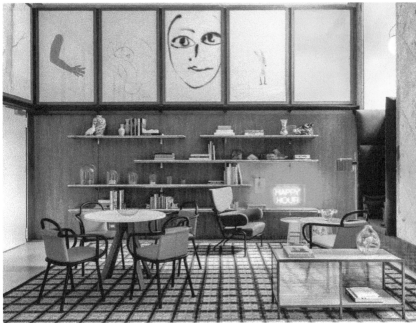

Patricia Urquiola, Milan hotel Room Mate Giulia. Photo by Ricardo Labougle.

Simultaneous Contrast

Simultaneous contrast occurs as an optical illusion: The complementary color of an applied color is not itself objectively present, but appears to be visible. Simultaneous contrast requires an adjacent neutral color or any other color that is not complementary. The longer a background is viewed, especially with more luminous colors, the greater the intensity of the simultaneous effects.

Simultaneous contrasts are difficult to capture photographically. In the Montréal Convention Centre, Saia Barbarese Topouzanov playfully uses light against painted color to suggest additional colors. As the sun changes position and color over the course of a day, new combinations appear.

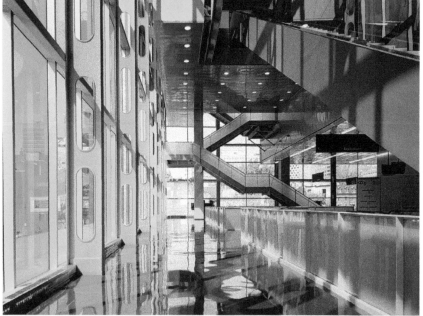

Saia Barbarese Topouzanov Architectes: Tétreault Parent Languedoc et Associés

Contrast of Saturation

Color can be diluted via four methods to obtain different results: Adding white makes a color cooler; adding black reduces the overall vitality of a color and renders it more subdued and, in the absence of light, quite dark; adding gray reduces the intensity of a color and tends to neutralize it; adding the complementary color produces various effects, depending on the intensity of the colors being mixed, their relative temperature, and their hue.

A library at the Rhode Island School of Design by Office dA uses a natural palette that lends itself to a contrast of saturation. Various shades of browns and yellows allow this intervention to fit nicely within the classical architecture it occupies. Accents of cooler colors in the existing architecture also contribute to the scheme's success.

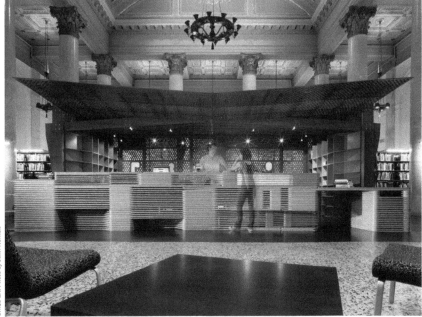

Contrast of Extension

Contrast of extension refers to the relative force that a color exerts in relation to the other colors in a system. Depending on the hue and value of a color, careful consideration must be taken to balance the addition of another color. The result is a ratio that harmonizes the colors in play. Of all the contrast rules, this is perhaps the most subjective.

Balance is the fundamental principle behind the contrast of extension. In this maisonette apartment, Ippolito Fleitz Group uses color balance effectively—mixing strong contrasting colors, intense graphic elements, and textiles in a complex sequence that achieves a sense of equilibrium.

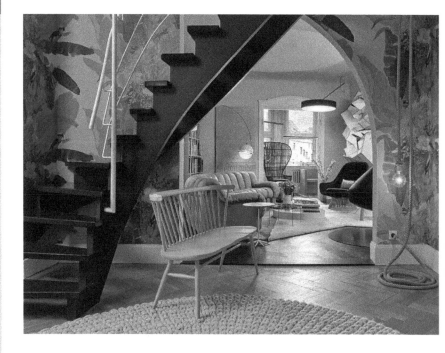

COLOR TERMINOLOGY

Although it is difficult to talk about specific color through the use of nomenclature, it is important to develop a vocabulary that can objectively evaluate the specific ways a color or set of colors is being used. When discussing the effects of color, the following terms can serve as the start of a common vocabulary.

Color Space: Refers to the final output of a color. RGB is typically used for illuminated color, while CMYK is used for absorptive colors.

Color Temperature: Temperature of a light source, measured in Kelvins. Lower temperatures are considered warmer (adding a yellow cast to objects), while higher temperatures are considered cooler (adding a blue cast to objects).

1800K 5000K 16000K
Color Temperature

Hue: Gradation of color within a visible spectrum.

Pantone: A color management system that is used to specify consistent color for prints, textiles, and paints.

Hue

Primary Colors: Group of colors that, when mixed, can produce all other colors. Primary colors cannot be made by other colors.

Secondary Colors: Colors that result from a 50 percent mixing of any two primary colors.

100 90 80 70 60 50 40 30 20 10 0
Saturation

Saturation: Intensity of a color, expressed as the degree to which it differs from white.

Schemes: Method of organizing color in harmonious combinations.

0 10 20 30 40 50 60 70 80 90 100
Shades

Shades: Result of adding more black to an existing color.

0 10 20 30 40 50 60 70 80 90 100
Tints

Tints: Result of adding more white to an existing color.

Tones: Result of mixing a color with its complement. An equal mix will result in a gray.

COLOR AND SPACE

The process by which color is chosen and utilized in a design has a profound effect on interior space. The designer's decisions can drastically change the spatial understanding of a project and also influence how it is navigated. When used with knowledge and intent, color can add perceived weight to surfaces, alter the basic proportions of a room, and variously be a calming or exciting factor. As the designer begins to explore and understand the surface effects of color, it will become the basis of a rich visual and material palette.

Volumetric Approaches to Color

Painting all aspects of a room the same color has the effect of volumizing the space. This method of using color can be particularly effective in making small spaces appear larger or more intimate depending on the color choices. Volumetric approaches work best in situations where they can be referenced in sequence, such as an enfilade, or series of rooms connected through doors.

Elements such as furniture can emphasize the volumetric reading of a room. Here, the chairs, matched with the red walls, draw attention to the room's dimensions.

Planar Approaches to Color

Color can be used to emphasize the planes in a given sequence of rooms or the vertical connection of spaces, as in a double-height room or loft. Painting a length of wall regardless of interruption can lead the eye though the spaces of a design and highlight elements at the end of the wall—be it a light fixture, art, or furniture piece. Planar color can also make surfaces that are perpendicular to the occupant appear closer or further away.

Painting a continuous length of a space with a single color emphasizes the planar elements within an environment.

Adding color to a sequence of parallel walls also reinforces the planar elements in a space.

Emphasizing Design Elements

Emphasizing the elements of a design—door and window trim, reveals at the ceiling, or the connection of materials—can draw the viewer's attention to aspects of the design. Painting elements such as reveals in the ceiling a darker color than adjacent objects can make the objects appear to float. Emphasizing the color of a door in a wall can cue the viewer to its importance. A red door in a white wall will seem more present in the room than a door within a wall of the same color.

Color can be employed to make certain aspects of a design stand out. For instance, elements such as trim, moldings, and structure take on more significance when they are colored in stark contrast with their surroundings.

Connections emphasized between spaces can use very bold, bright hues or be made to recede when matched to the color of an adjacent surface.

Changing the Proportions of a Room

Color can change how the proportions of a room are perceived. Adding color to a certain datum, altering paint sheen, or darkening a room's upper portions are some of the strategies by which the designer might play with spatial perception. Through the careful application of color, spaces can be made to appear smaller or larger, or an eccentric volume can be proportionally controlled. Using color in geometric and abstract patterns can further enhance a space.

Adding color to lower parts of a space can provide a demarcation line for elements such as furniture and art.

Adding color to the upper regions of a space can reduce the perceived height of a room.

Chapter 10: Material

Materials are the essence of the interior designer's palette. They immediately signal the designer's vision and inform almost every decision in the process of developing an interior. *Materials have a direct bearing on issues of color, light, texture, and pattern* that the designer will need to address with every project. To make these decisions well, designers must learn the myriad qualities inherent in materials, from the purely *functional to the aesthetic.*

Needless to say, the range of materials available to interior designers is expansive. Only those materials essential to an understanding of how to treat the basic components of a room can be considered here. This book's space limitations mean that many other important materials are not covered—from the varieties of glass and metal to solid surfacing and engineered plastics—although the resources section provides references for further research. Indeed, a designer's ability to choose the best materials for a particular interior space must be founded on an ongoing process of research. Equally important is to build a library—of both materials and literature— to keep current on the latest developments in material and product design.

WALL TREATMENTS

Walls define the space of a room or the sequence of movement through an interior. Because they are, in many ways, the primary spatial tool of the designer, their finish is of great importance. The variety of finishes available for wall surfaces ranges from simple paints to more complicated paneling and stone veneers.

PAINTS

Paints are used to add color, durability, and decoration to many elements in an interior, but they are especially appropriate for walls, as they offer a lot of impact for relatively little expense. All paints are composed of four main ingredients: pigment, binder, drier, and solvent. *Pigment* forms the color of the paint. The *binder*, typically a resin, surrounds the pigment and, when dry, creates the paint film. The *drier* speeds up the drying time of the binder. Lastly, the *solvent* allows the paint to flow from the brush or roller onto the surface, where it evaporates, leaving only the dried pigment and binder. Coverage—the area that a paint can conceal—is defined by the amount of solvent in the mix: the less solvent, the better. Other additives to the paint can also aid in the durability of the product.

Paint Type	Description
Primer Paints	With all finish paints, the success of the final surface depends on the preparation of the wall or object being painted. It is common practice to prime a wall prior to painting; adding a few drops of the paint color into the primer allows for better concealment and coverage. Primers are also often necessary when changing from one sheen to another. Primers should be used for the following conditions: all uncoated surfaces, wallpaper, patched/repaired areas, paneling, stained areas, existing oil-based paint, and dramatic changes in color.
Latex Paints	Latex paints are made with a synthetic polyvinyl material that is water soluble, allowing for easy clean up. Latex paints dry more quickly than oil-based paints and release less off-gassing odor as they dry. Their fast-drying properties permit quicker recoating. Latex paints are also more elastic than oil-based paints and, as such, are less prone to substrate cracking.
Alkyd Paints	Oil paints tend to be more durable and resistant to wear and tear. Made with an alkyd base, they dry much more slowly than latex paints. Consequently, they produce smoother finishes since brush strokes and other discrepancies tend to disappear as the paint layer levels itself.
Enamel Paints	Enamel paints dry to an extremely hard and durable finish. This finish is usually made by adding varnishes and other hardeners to a base paint. Enamels are used on walls, but also on appliances, signage, and other items that need a waterproof coating.
Stains and Varnishes	Stains, an alternative to paint, are color finishes that absorb into the material they are being applied to—usually wood. Stains come in a range of transparencies, controlling how much of the substrate remains visible once the stain is applied. Stains are unsuitable as finishes alone and need to be varnished to create a durable surface. Varnishes are transparent films and are available in several sheens.

Paint Sheen

The finished surface of paint is often referred to in relation to its sheen—the level of gloss the paint has when dry. The choice of a paint sheen for a particular application will affect how it performs, its durability, and the extent to which it can be cleaned and maintained. Sheens also affect the way light and color are reflected from a painted surface, and they can serve to highlight various aspects of a room.

Paint Sheen	Description
Flat	not reflective; hides surface imperfections, but makes it difficult to remove stains; good for low-traffic areas
Eggshell	more reflective than a flat paint; hides surface imperfections and stains can be scrubbed out; ideal for medium-traffic areas
Satin	minimal gloss, but more reflective than eggshell; provides a durable finish that is easier to clean than flat or eggshell; good for most spaces
Semigloss	slightly glossy appearance; highly durable and easily cleaned, also moisture-retardant; good for wet areas
Gloss	very reflective; good for highlighting detail such as trim and moldings; ideal for doors and cabinets
Ceiling Flats	spatter-resistant; designed especially for painting ceilings

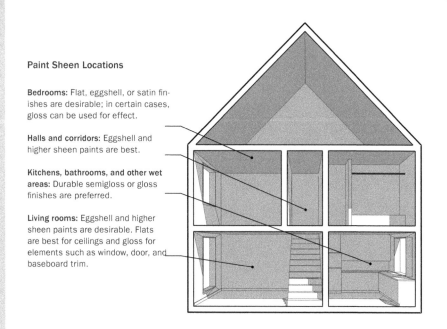

Paint Sheen Locations

Bedrooms: Flat, eggshell, or satin finishes are desirable; in certain cases, gloss can be used for effect.

Halls and corridors: Eggshell and higher sheen paints are best.

Kitchens, bathrooms, and other wet areas: Durable semigloss or gloss finishes are preferred.

Living rooms: Eggshell and higher sheen paints are desirable. Flats are best for ceilings and gloss for elements such as window, door, and baseboard trim.

WALLPAPERS AND VINYLS

Whether paper or vinyl, wall coverings—by their simplest definition—are composed of a printed face adhered to a backing. The front face is treated as a decorative surface that is then applied to a wall in vertical sections. Papers and vinyls offer the interior designer many advantages, from their durability to their ability to hide surface imperfections to their pure aesthetic appeal.

Compared to commercial papers, residential wall coverings are designed for significantly less wear. They do, however, offer a wide range of patterns and ideas that can add significantly to the atmosphere of the room in which they are placed. They typically come in two varieties:

Wallpapers

Residential wallpapers come in widths between $20^1/_2$ inches (typically found in the metric equivalent of 520 mm) and 27 inches (685 mm). Often sold in double rolls, which have a length of 9 yards (8 230 mm), wallpapers are rarely durable enough for commercial applications.

Wall Vinyls

Wall vinyls are similar to papers, but receive a plastic coating that makes them more durable and easily cleaned. They are typically recommended for the wet areas of a house, but are also suitable for other high-traffic zones and are most often used in commercial applications. Commercial wallcoverings typically come in widths of 54 inches (1371 mm).

Surface Preparation

Regardless of where papers are being applied, the surface they are covering will require as much preparation as with a painted wall. There are several ways to prepare a surface for wall coverings.

Surface Prep	Description
Primers	As with paint preparation, a primer coat provides a clean surface for the application of the covering.
Sealers	If the subsurface has been water damaged, an oil- or water-based sealer should be applied to the wall. Sealers also allow for easier removal of the covering.
Wall Liners	In some cases, such as where cracking and other surface imperfections appear, a wall liner may be applied prior to installing the covering.

Types of Patterns

Random Match

Random matches are the most efficient of the wallpaper or vinyl types. There is no pattern match horizontally, therefore the covering can be cut wherever necessary.

Straight Match

Straight matches repeat at regular intervals across papers. On installation, the pattern is cut at the same height from the ceiling line to assure alignment.

Drop Match

Drop matches have the most potential for waste, as the pattern does not match at the same distance from the ceiling, but rather at regular diagonal intervals.

Flocked

Flocking is a process through which small fibers are adhered to the surface of the paper or vinyl. Originally created to imitate cut-velvet hangings, flocked papers are typically very ornate, and their soft textural qualities can enhance the intimacy of other materials in a room.

Other Types of Wall Coverings

Technical advancements and new expressiveness in wall coverings have changed the way that interior designers approach them. These coverings experiment with graphics and play with scale, dimension, and material.

Commercial-Grade Wall Coverings

Commercial-grade wall coverings can no longer be easily categorized. The types of materials that they comprise, including their mixing of different materials on the same surface, have produced a range of surfaces that are technologically sophisticated, while increasing their sensual and aesthetic qualities.

Environmental Graphics

Wayfinding, placemaking, and directional graphics are often integrated with a design project. The range of materials and illumination technologies, ranging from playful to sophisticated solutions, aid in the joy of moving through a space.

Photo courtesy of Overunder.

Acoustics

As designs become more sophisticated, the need for acoustic control is becoming more of important in the range of materials a designer must incorporate. Relying on porous surfaces that have many small pockets to absorb sound, their acoustic benefits are measured by how much sound a material mitigates.

Green Wear. Photo courtesy of Designtex.

Textiles

Textile coverings are a special class of fabrics that have been engineered for surface installation. Textiles are adhered to a backing paper to provide the dimensional stability required during installation and to prevent glue absorption.

FLOORING

Flooring is as integral to an interior project as any wall treatment. The many ways in which a floor can be constructed or covered provide the designer with a template that influences color, acoustics, and reflectance. Floor finishes can be continuous or designed with a combination of hard and soft surfaces. In addition to integral floors, area rugs and carpet tiles allow for a carefully strategized design.

Radiant Floor Systems

Whenever a floor is being installed in an interior, the designer has the opportunity to include a radiant floor system to aid in the *environmental heating of the space*. Radiant floors offer multiple advantages: They operate silently, eliminate visible sources of heat (such as vents and louvers) that need to be coordinated with the design, are energy efficient and thus reduce overall heating costs, and generate none of the dust and other particles spread by forced-air systems. Additionally, radiant floor systems provide an even distribution of heat throughout a space, not just at localized points. This even heat feels more comfortable and can reduce the overall temperature settings.

It should be noted that radiant systems—which are typically provided with concrete floors—also exist for other floor types, such as wood and other plank systems, as well as carpet and vinyl finishes. Keep in mind that naturally insulating materials can reduce the efficiency of a radiant system. Wood systems, moreover, should be engineered, as heat through solid wood flooring can cause the floor to shrink and crack.

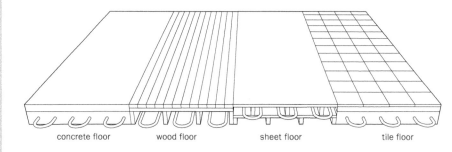

concrete floor wood floor sheet floor tile floor

POURED FLOORING SYSTEMS

Many types of floors are poured-in-place installations. These floors are then ground and polished to produce a continuous, monolithic surface. Poured floors, which are installed over a well-prepared substrate (underlying material), are quick curing, easily maintained, and have a high resistance to bacteria and damage due to chemicals and wear.

Concrete Floors

Exposed concrete can be an efficient finish for high-impact areas. It is also welcome where the aesthetic of the space requires a raw, industrial look. Concrete finishes are durable and economical; they are, as well, very reflective of sound and occasionally of light. In addition, concrete floors can act as natural conditioning surfaces—if the slab is on grade (supported directly on the ground), the earth's temperature can heat or cool the spaces directly above the floor.

A concrete finish can be added to an existing floor system. Skim coats and lightweight self-leveling toppings can be installed over a well-prepared subfloor to provide a finish similar to polished concrete. These finishes are thin and quick drying.

Stains

Chemical stains react with concrete's lime content to etch color into the surface of the slab. Acid penetrates the top layers of the concrete and allows the stain to take. Because staining is a surface process, however, the evenness and depth of color cannot be predicted. Moreover, damage to the concrete can expose areas where the color has not reached.

Stains are applied in a variety of ways: with brushes and mops, by spray, or even using natural materials such as leaves and branches to create depth in the surface. In addition, patterns can be stamped and cut into the surface, allowing for different colors and variations in finish within the same field.

Integral Color

Another coloring process is to add a liquid or powder pigment to the concrete mix. Unlike chemical staining, this method produces a far more consistent color. As a result, there is little need for repair due to scratching and chipping.

Sealers and Waxes

Sealers and waxes are clear coatings that give greater durability to a concrete finish. They also enhance the natural look of a floor or bring out the depth of a stained finish. Waxes must be evaluated prior to installation for proper slip coefficient—a measurement that determines how safe a floor finish is considered to be (0.5 or above is desired).

Epoxy and Resin Floors

Epoxy and resin floors are mixed on site and then trowel-installed over a monolithic slab. This finish is thin, extremely durable, and resistant to chemicals and other hazardous materials. The finish is continuous and can be tinted a variety of colors. Many mixes also contain material that helps to reduce slip coefficient. It is an ideal solution for commercial, institutional, and laboratory spaces.

Terrazzo

Terrazzo floors are random mosaic floors made by suspending marble chips in a matrix of cement or epoxy. The resulting mixture is poured and ground to a smooth finish that is then polished and sealed. Terrazzo can be precast in slabs and tiles, but more often is installed in-situ (original position or place) for larger spaces. The random patterns created by the chips and epoxy provide a beautiful floor finish.

The marble that comprises the flecks within the terrazzo is quarried, crushed, and passed through a screen to determine the kind of finish in which it can be used. Sizes of the marble mosaic are graded according to the following chart:

Size Number	Passes Screen	Retained on Screen
#0	$^{1}/_{8}$" (3.2)	$^{1}/_{16}$" (1.6)
#1	$^{1}/_{4}$" (6.4)	$^{1}/_{8}$" (3.2)
#2	$^{3}/_{8}$" (9.5)	$^{1}/_{4}$" (6.4)
#3	$^{1}/_{2}$" (12.7)	$^{3}/_{8}$" (9.5)
#4	$^{5}/_{8}$" (15.9)	$^{1}/_{2}$" (12.7)
#5	$^{3}/_{4}$" (19.0)	$^{5}/_{8}$" (15.9)
#6	$^{7}/_{8}$" (22.2)	$^{3}/_{4}$" (19.0)
#7	1" (25.4)	$^{7}/_{8}$" (22.2)
#8	1 $^{1}/_{8}$" (28.6)	1" (25.4)

Divider strips—typically made of zinc, aluminum, brass, or plastic—control shrinkage in the terrazzo, where changes of color occur or where joints occur in a concrete substrate. Aluminum strips are used with epoxy systems only. Divider strips can be shaped to develop complex patterns

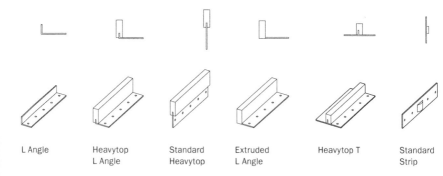

| L Angle | Heavytop L Angle | Standard Heavytop | Extruded L Angle | Heavytop T | Standard Strip |

TERRAZZO FINISHES

Description	Thickness	Divider Spacing	Advantages
Sand-Cushioned	3" (76) (including 1/2" [13] terrazzo topping)	4' (1 219) ≤ on center	interior floor use on lower levels of structure; separated from substrate by an isolation membrane; good for patterns and colors
Bonded	1 3/4"–2 1/4" (45–57) (including 1/2" [13] terrazzo topping)	6'–8' (1 829–2 438) on center	wherever thickness needs to be minimized, but a cementitious matrix is desired; good for walls and other vertical surfaces
Monolithic	1/2" (13)	20' × 20' (6 096 × 6 096) spans and all locations of concrete substrate joints	set directly on a level concrete substrate; economical and ideal for large areas
Thinset	1/4" (6) or 3/8" (9.5) (#2 chips only for 3/8" [9.5])	20' × 20' (6 096 × 6 096) spans and all locations of concrete substrate joints	set directly on a level concrete substrate; ideal for multilevel installations; wide range of colors available; resistant to chemical spills

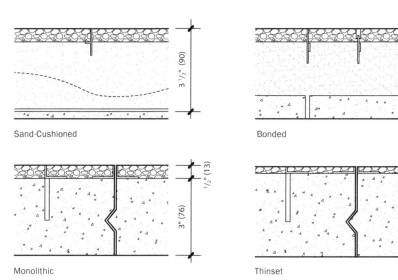

Sand-Cushioned 3 1/2" (90)

Bonded 1 3/4" (45)

Monolithic 1/2" (13) 3" (76)

Thinset 1/4" (6) 3" (76)

STONE FLOORING

Stone floors bring to an interior both beauty and durability. Found in an array of colors, finishes, sizes, and patterns, stone is one of the most versatile materials available to the designer and is *suitable for walls and counters as well as flooring*. The qualities of stone vary from soft to hard and from porous to impermeable. It is best to confirm with the manufacturer that the product is correct for its intended use. In flooring applications, stone comes in two configurations: dimension stone and dimension stone tiles.

Dimension Stone

Dimension stone floors are assembled from natural quarried stone that has been cut to a specified shape, size, and thickness. Dimension stone has one or more mechanically dressed surfaces—for example, flamed or honed—and is set in a thick mortar bed.

Flamed or Thermal

This rough finish is achieved by heating the stone to a high temperature and then rapidly cooling it. Its slip-resistant surface is ideal for bathrooms and other wet areas where stone may be used for flooring.

Honed

This smooth satin finish is achieved by stopping the polishing process early. It provides a softer looking surface that is less prone to showing damage.

Polished

This highly reflective, glossy finish is achieved through successive polishing with increasingly fine materials. It brings depth and color to a stone, but is also prone to slipping unless appropriately sealed.

Dimension Stone Tiles

Dimension stone tiles are quarried to standard sizes and thicknesses, usually less than $3/4$ inch (19 mm). Typical sizes range from 6 square inches (3 870 mm²) to 36 square inches (23 226 mm²), though the larger the tile, the more prone it is to cracking. Tiles are typically installed with a thin layer of mortar, thus the subfloor should be even and not prone to warping.

Stone Type	Formation	Description	Best Use
Limestone	sedimentary[1]	varies in hardness and is quite suitable as dimension stone; soft limestones should be used in low-traffic situations	flooring, countertops, interior cladding
Travertine	sedimentary	variety of limestone that is more compact and often banded in appearance	flooring, interior cladding
Marble	metamorphic[2]	varies in hardness and comes in a wide range of colors and types	flooring, interior cladding, vanity and tabletops, hearths, sills
Granite	igneous[3]	hard and dense; extremely resistant to scratching and etching; very difficult to stain but available in many colors, though most commonly black	flooring, countertops, tabletops
Slate	metamorphic	easily cleaved into thin slabs; thermally stable and chemically inert; when sealed, is stain resistant and durable	flooring, hearths, countertops, tabletops, laboratory tables
Sandstone	sedimentary	made from quartz and silica; available in a variety of colors, but most commonly the warm browns, yellows, and reds associated with sand	flooring, interior cladding, countertops

[1] Stone formed from sediment deposited by water or air.
[2] Stone formed by heat, pressure, or other natural agencies.
[3] Stone having solidified from lava or magma.

WOOD FLOORING

Solid Wood Flooring

Solid wood flooring, as its name suggests, is prepared from wood that is one piece from top to bottom. It takes stains and other finishes well and can be easily refinished. Because it is prone to damage from water and moisture, this flooring should be used on the ground floor and above only. It comes in several cuts.

Plainsawn: This most common cut of lumber provides the maximum yield. Plainsawn boards have a great variation in grain, as the direction of the cut makes growth rings more obvious. They add a unique texture to a wood floor.

Quartersawn: Cut at a 60- to 90-degree angle to center of the lumber, it yields less footage than plainsawn. Quartersawn boards have more parallel grain. They hold stains and other painted finishes well and create a homogenous wood floor.

Riftsawn: Cut at a 30- to 60-degree angle to center of the lumber, it is otherwise similar to quartersawn.

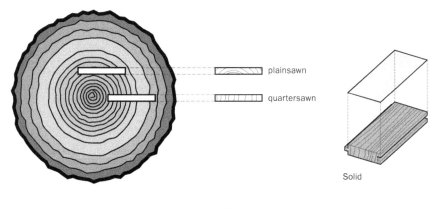

plainsawn

quartersawn

Solid

Plainsawn

Quartersawn

Other Wood Flooring

Engineered Acrylic-Impregnated

Engineered Flooring: Made of built-up layers with the wood grain running in opposite directions, engineered flooring is available in three-, five- and ten-ply. It is more dimensionally stable than solid wood and, as such, is better suited for highly trafficked areas. It can also be installed directly over a concrete subfloor. Engineered flooring is found in basements, kitchens, bathrooms, and utility rooms.

Acrylic-Impregnated Flooring: Acrylic injected into the wood creates an extremely durable and hard finish. It is used in restaurants and malls and sometimes in residential projects.

End Grain Flooring: Made of wood cut perpendicular to the grain and sized to specific dimensions, end grain flooring is very resistant to damage and can be used in high-impact conditions. The exposed grain provides a unique design element, but it is also easily stained to a variety of colors. End grain is suitable to all applications, from residential to warehousing.

End Grain

Patterns

Wood flooring is dimensioned for installation. Options abound for patterns, but first floors are categorized into three main types: strip—linear flooring that is $1^1/_2$, $2^1/_4$, or $3^1/_4$ inches (38, 57, or 83 mm) wide; plank—linear flooring with widths of 3, 4, 5, and 6 inches (76, 102, 127, and 152 mm); and parquet—small pieces of wood aggregated to created a geometric pattern.

Parquet Patterns

Finishes

Oil-modified Urethane: Easy to apply, this finish also has a long drying time and VOC (volatile organic compound) content. It tends to turn amber with age.

Moisture-cured Urethane: Solvent-based, this finish is difficult to apply and has a very long drying time. It is more durable and moisture resistant than oil-based finishes, however, and can be transparent.

Water-based Urethane: Requiring more coats than oil-based finishes, it has a lower VOC content. Multiple layers make it a more expensive finish. It is clear and nonyellowing.

Penetrating Stains and Waxes: Stains penetrate into the wood to provide a deep seal. Waxes provide protection and a low-gloss sheen to floors, but must be reapplied at regular intervals.

Installation

Wood flooring can be installed in many ways, and designers should consider the location before deciding on the type of flooring. A natural material, wood expands and contracts with changes in climate and moisture. Allowing for ventilation under the floor and expansion at the perimeters is essential.

Wood Flooring Locations

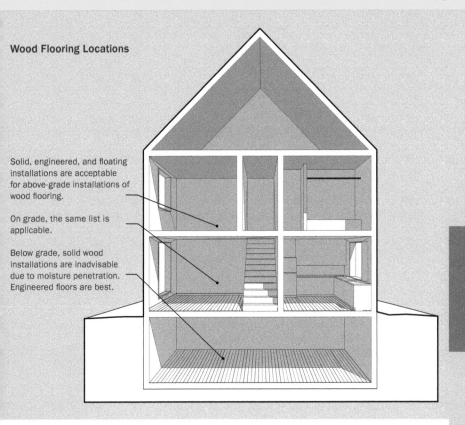

Solid, engineered, and floating installations are acceptable for above-grade installations of wood flooring.

On grade, the same list is applicable.

Below grade, solid wood installations are inadvisable due to moisture penetration. Engineered floors are best.

Typical Installation

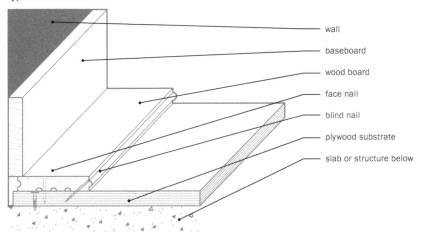

- wall
- baseboard
- wood board
- face nail
- blind nail
- plywood substrate
- slab or structure below

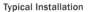

Material 171

RESILIENT FLOORING

Resilient floors are typically made of high-density materials that provide a durable, nonabsorbent finish. They also are more comfortable than other hard finishes, as they have a certain amount of elasticity. Resilient floors can be a cost-effective solution to a variety of residential and commercial applications. Moreover, their ease of maintenance and relative chemical stability render them ideal for institutional applications. Resilient flooring is manufactured in both rolls and tiles.

Vinyl and Rubber Tiles

Whether vinyl or rubber, resilient flooring tiles are attractive for high-impact areas. Tiles are easily installed both above and below grade and provide excellent resistance to moisture and other damage. Compared to resilient flooring in rolls, tiles do require higher maintenance, as their seams can accumulate dirt and allow moisture penetration; any standing liquid must be removed immediately. Tiles come in a variety of constructions. Vinyl tiles can be composite or solid. All are finished with a protective layer.

Vinyl Composite Tile

These tiles combine a backing layer, a printed design, a wear layer, and a protective film. Typically, they are 12 square inches (7 742 mm²) but do come in both larger and smaller sizes. Composite tiles are very easy to install on a well-prepared substrate and, when damaged, are easy to replace—though it is good practice to order extra during installation as colors can change from batch to batch.

Vinyl Composite Tile

Solid Vinyl Tiles

These solid tiles generally have no backing layer. Solid vinyl has a higher ratio of vinyl resin compared to composite, which makes it more resistant to damage due to wear; solid tiles are typically thicker as well, further increasing durability.

Solid Vinyl Tile

Rubber Tiles

Dimensionally stable rubber tiles resist spills from chemicals and other corrosive materials and provide support for activities that require long hours of standing. Textures applied to their finish offer protection from slips. Rubber tiles are available in two varieties: homogenous, where pigment is added to the rubber mix to create color throughout; and laminated, where the top layer is patterned with different colors.

Rubber Tile

NATURAL RESILIENT FLOORING

Linoleum

Linoleum is a natural composite that emerged as a flooring material in the nineteenth century. Linseed oil, cork, ground limestone, and resin are combined and then mixed with pigment. This mixture is oven-cured slowly for two to three weeks, providing dimensional stability and ease of adherence during installation. Next, the linoleum layer is calendared onto a jute backing and a protective finish is applied on top. The final rolls are cut to widths of 79 inches (2 007 mm) for installation. Durable and antibacterial, linoleum is suitable for both residential and commercial projects. Linoleum comes in an array of colors and is considered an environmentally conscious material selection due to its biodegradability.

Installing linoleum is difficult, though it can easily be cut into patterns and heat-welded at the seams. It also requires a wax polish to prevent staining and discoloration.

Linoleum

Cork

Cork is another natural flooring material that provides a resilient surface for both residential and commercial applications. Its natural cellular structure creates a beautiful surface that is an economical alternative to wood floors. It is also cushioned, much like a cut-pile carpet, and is a renewable and sustainable resource.

Cork floors are manufactured in a composite process that presses the cork to each side of a medium- or high-density fiberboard. This stabilization layer allows for ease of installation, as well as for a tongue-and-groove interlock. A top layer of varnish seals the cork.

Susceptible to discoloration, mainly through exposure to natural light, cork is also extremely absorptive, so any cleaning should be done with a minimum of water. Cork is produced by a sustainable process that reduces demands on ecosystems during its life cycle.

CARPET

Of the materials used for flooring, carpet may be the most difficult to qualify. Carpets cover 70 percent of floors in residential and commercial environments in the United States alone. Given the enormous variety of types and styles, from mass-produced to custom-designed, it is difficult to condense the choices, applications, and installation methods for different types of interiors. Carpets, however, offer many advantages: *Texturally*, they lend both visual and sensual qualities to a room; *acoustically*, they excel at absorbing and dampening sound; they are very *easy to clean*; they are *naturally insulating*; and their *range of color and pattern* is limitless.

Residential versus Commercial

Many carpet companies divide their product lines into residential and commercial applications. This distinction may seem obvious at first, but the material properties and qualities of carpets for each differ in their requirements for installation and maintenance.

Photos courtesy of InterfaceFLOR.

Residential Carpet

In choosing carpets for residential projects, designers should consider the following: the *amount of traffic* on the floor, the adjacency of the floor to *natural light*, and the *transition* from the carpet to hard or resilient flooring. Carpets in residential applications must also take into account the specific users of a space; for example, a carpet might need to be child- or pet-friendly. Residential installations do not have to be wall-to-wall; area rugs, when used in tandem with another floor surface, can provide a focus for specific furniture elements.

Commercial Carpet

Commercial carpets need to withstand the use of several times the number of people as in a residential application. Additionally, they may need to *perform under the stress* loads of equipment such as luggage, wheelchairs, and other transport devices; low-cut pile with a dense construction is the correct choice for these areas. Cut piles, especially high density, are well suited to concealing traffic lines and the dirt that can accumulate in areas of high activity. They are also recommended for offices, reception areas, and boardrooms in a work environment.

Carpet Construction

There are many ways to construct carpets. They can be tufted, woven, or fusion-bonded; or following more specialized processes, they can be hand-tufted, knitted, or needle-punched. Carpets are made of fibers woven to a backing material. Natural materials such as wool or sisal and other plant fibers have traditionally been used to manufacture carpet. Technological advances, however, have increased the amount of carpet made from synthetic fiber. Though wool remains more common in residential applications, over 90 percent of carpet is now constructed from materials such as nylon and polypropylene, which tend to be durable and resilient and take well to color.

Tufted: Tufted carpets account for 90 percent of the total manufactured carpet. On a machine containing hundreds of needles, fiber is stitched into a primary backing material—typically, a synthetic latex that allows for flexibility. Another backing is added to the carpet to provide dimensional stability and ease of installation.

Woven: Woven carpets account for approximately two percent of carpet production. They are created on a loom that weaves together the carpet fiber and backing material. This process is more dimensionally stable than tufting, although a latex back-coating is applied after the weave to ensure even greater stability and durability. Woven carpets are typically more expensive than either tufted or fusion-bonded.

Fusion-bonded: The fusion-bonding process sandwiches fibers in an adhesive backing, locking them in place. All fusion-bonded carpets are cut piles, as the sandwich is sliced apart with a cutter.

Modular Tile: The most common variety of fusion-bonded carpets are carpet tiles. Tiles offer the great advantage of easy replacement if damaged. Typically high-performance solutions for educational, work, and public environments, modular tile carpets are increasingly being used in residences.

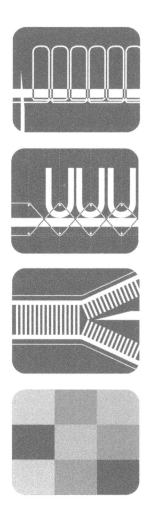

Cuts and Loops

Regardless of manufacturing processes, carpets are woven in specific ways that give them texture and depth and that can add complexity to their colors and patterns.

Loop and Multiloop Pile: A result of the initial weaving process, loop carpets are durable and high impact and hide traffic patterns well. Loop carpets can also be woven at different heights to create random or specific patterns. These are also known as Berber.

Cut Pile: Cut piles are constructed in the same manner as loops, but they have been split open to create a smooth, monolithic surface. Cut pile can be very dense or longer for a more casual appearance. It is also known as velvet or plush.

Cut and Loop: A blend of cut and loop piles creates texture, depth, and variation to the surface. Loops can contain linear, geometric, or organic patterns.

Tip Shear: In this multiloop construction, higher loops are sheared to create a subtle, relaxed appearance.

Frieze and Shag: Fibers are twisted and tightly wound to create variation in the surface. The varying lengths of the yarns help to conceal dirt, traffic patterns, and vacuum marks. Their depth and characteristic appearance add softness to a room.

Finishing

Once the carpet has been woven, tufted, or fusion-bonded, it is then finished and prepared for installation. Finishing consists of several processes. Depending on the end product, color is added either before or after the weaving process. In production, however, most carpet is postdyed to meet market demands. Carpet can be dyed in a number of ways:

Predyeing: Color is added to the yarn prior to the construction process. The color can be added either to the fiber itself or as it is spun into yarn.

Postdyeing: Color is added after the construction process. Carpets are immersed in dye before the final backing sheet is applied.

Silk-screening: Patterns are applied to the finished carpet. Printed patterns can be a cost-effective way to simulate the appearance of woven carpet.

Whatever the finishing process, the carpet is given a secondary backing, a foam cushion is attached for installation, and the assembly is sheared to dimension.

Carpet Terms

Backing: Vinyl or polypropylene material found on the back of a carpet.

Binding: Strip sewn to the edge of a carpet to provide strength and protection.

Broadloom: Carpet woven in widths of 6 feet (1.8 m) or greater.

Cushion: Padding used to reduce impact.

Density: Amount of pile yarn per area of carpet. Also refers to the distance between tufts.

Direct Glue-Down: Method of installation where carpet is glued directly to the floor.

Foot Traffic: Number of times per day a carpet is walked on by a single occupant. Light is less than 50, moderate is between 50 and 200, heavy is over 200.

Gauge: Number of needles per inch (2.5 cm) used in the construction of a carpet.

Pattern Match: Alignment of pattern in a carpet that determines cut.

Pile Height: Dimension used to determine carpet density, measured from primary backing to top of yarn.

Repeat: Measurement of the distance between instances in a pattern.

Serging: Heavy yarn close-stitched to the edge of area rugs as a finished edge.

Stitch Rate: Number of tufts along the length of a carpet, measured in stitches per inch (2.5 cm).

Yarn Ply: Number of yarns in a twisted, heat-set yarn.

LAMINATES

Laminates were developed in the early twentieth century as an alternative to the commonly used mica for electrical insulation. The product, a substitute "for mica," gave its name to a new company and a now familiar brand. The Formica company's process eventually led to the development of very durable surfaces suitable for a wide range of interior applications.

Laminate technology has improved dramatically as new methods for surface variation, replication of natural materials and metals, and two-sided applications have become available. Many companies now manufacture laminate, and the breadth of colors, textures, and styles is vast.

Laminates are thermally adhered to a core material—usually chipboard or medium-density fiberboard—that is engineered for dimensional consistency and is therefore recommended over plywoods and other materials. The type of adhesive used is based on both the core material and the intended application of the product.

GRADES OF LAMINATES

Name	Thickness	Use
General Purpose HGS	0.048" (1.2)	recommended for commercial and residential work surfaces, furniture, cabinets, and doors; can be applied to radii no smaller than 6" (152)
Horizontal Postforming HGP	0.039" (1.0)	recommended for applications that require radial bends, such as countertops; can bend to radii as small as 0.5" (12.5); such applications eliminate edges and seams
Vertical Postforming VGP	0.028" (0.7)	recommended for vertical use only; ideal for commercial cabinetry and furniture; a slightly thinner laminate that can be formed to radii of 0.375" (9.5)
Cabinet Liner CLS	0.020" (0.5)	recommended for the interior of cabinets; a nondecorative, light-duty laminate not designed for heavy use
Backing Sheet BGF or BKL	rated, 0.048" (1.2); unrated, 0.020" (0.5)	recommended for surfaces that are hidden from view and as a stabilizing surface to prevent warping due to moisture; comes in both fire-rated and unrated versions

Low-Pressure Laminates

Low-pressure laminates consist of four layers of material. A backer sheet is attached to a thin particleboard substrate, which is then faced with a decorative surface made of paper and a melamine resin. The resultant assembly is thermoset, or thermally fused, and ready for use.

Low-pressure laminates serve mainly to protect the interior surfaces in items such as shelving, cupboards, and panels. They are not especially durable and are therefore not specified for situations where high-impact use is expected.

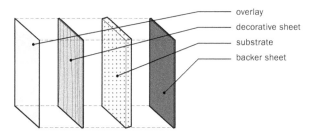

overlay
decorative sheet
substrate
backer sheet

High-Pressure Laminates

High-pressure laminates consist of many layers of phenolic resin-impregnated kraft paper faced with a melamine-impregnated decorative layer. The high temperatures and pressure at which they are set form a durable and homogenous material that is ideal for doors, cabinets, counters, and many other interior surfaces that receive extensive use. They are not impervious to staining, however, and cannot withstand extreme heat.

The classification of plastic laminates, their fabrication, and grading are outlined by the National Electrical Manufacturers Association.

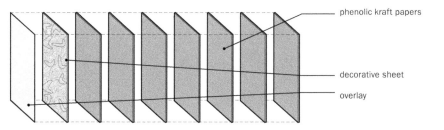

phenolic kraft papers

decorative sheet
overlay

Laminate Locations

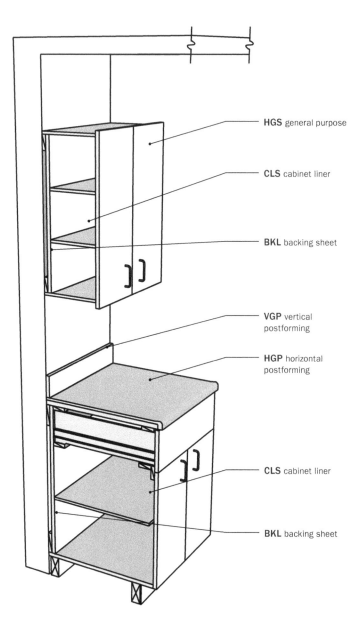

HGS general purpose

CLS cabinet liner

BKL backing sheet

VGP vertical postforming

HGP horizontal postforming

CLS cabinet liner

BKL backing sheet

VENEERS

Veneers are very thin slices of wood that are glued to a backing material for use in millwork (woodwork, such as doors, window casings, and baseboards) and other elements in an interior. Veneer can be sourced from a number of wood species, and irregularities such as diseases in the wood can lead to beautiful figuring in the final product. Veneers are available in various grades, which affect price and application.

Veneer is manufactured in a semiautomated process. A log is debarked and then readied for cutting. Very thin layers are sliced off the log. Different cuts and techniques produce a wide range of patterning and texture. Once the cuts have been made, the resulting fitches (a bundle of veneers arranged in the same order as they were cut from a log) are dried and bundled and then clipped and joined to make dimensioned sheets.

VENEER CUTTING METHODS

Cut	Description
Rotary Cut	The log is centered on a rotating lathe and turned against a blade. This process can produce single-sheet (one piece) faces.
Plain Slicing	The log is sliced parallel to its center. The result is an elongated cathedral pattern from the exposure of the innermost growth rings.
Half-round Slicing	The log is sliced as close to parallel to its center as possible. The resultant cathedrals are wider and flatter than in plain slicing, producing a veneer called flat cut.
Quarter Slicing	The log is cut perpendicular to its center. The resultant grain is straight in appearance.
Rift Cut	The log is sliced at a slight angle to produce a more even grain. Rift cuts occur only in oak logs, due to irregularities in the wood.
Lengthwise Slicing	Planed and flatsawn lumber is passed over a stationary knife to produce a variegated figure.

Rotary Cut Plain Slicing Half-round Quarter Slicing Rift Cut

Veneer Assembly

Book Match: Consecutive veneers are flipped as they are assembled, as though in a book. The result is a series of mirrored grains.

Slip Match: Flitches are lined up in the order they are taken from the log. The straighter the grain, the less obvious the seams.

Reverse Slip Match: Every other leaf is rotated 180 degrees to invert the cathedral patterns.

Random Match: Undesired repetitions—such as knots—are spread evenly across the sheet. This type of veneer is chosen subjectively.

Pleasing Match: Flitches are arranged by color consistency, rather than grain match.

Irregular Veneers

Veneers are also made from parts of the tree that may not be easily sliced or from parts of wood that have diseases and other malignant growths. The resultant veneers contain some of the more beautiful patterns due to this irregularity. These veneers are known variously as bird's-eye, burled, and flamed.

Rotary Cut Tamo

Redwood Burl

Quartersawn Zebrawood

Quartersawn Lacewood

Maple Burl

Bird's-eye Maple

Veneer Backing

Veneers must be reinforced with a backing material to be applied to a substrate. Each backing offers different properties, most notably their bend radius.

Backing	Description	Bend Radius
Paper	A single sheet of 10-mil or 20-mil paper is applied evenly to the back of the veneer to provide an adhesive surface.	$\frac{1}{2}$" (13) radius
Wood	2-ply: A lesser grade wood veneer is applied to the back of the veneer. 3-ply: A face veneer is backed with paper and then a lesser grade wood is applied to the paper.	$\frac{3}{4}$" (19) radius
Phenolic	Phenolic resin paper is applied to the back of the veneer. Typically used when the substrate has irregularities, this backing increases stability and durability.	1 $\frac{1}{2}$" (38) radius min.

TEXTILES

Textiles serve a vast range of interior applications, from wall and ceiling panels to panels for systems furniture, from carpeting to drapes, from home furnishings to bed linens. Thus, it is essential that the interior designer *understand the structure, properties, performance, finishing, dyeing, and printing techniques associated with different fabrics.* A textile or fabric refers to a material that is made of interlocking fibers that are woven, knitted, or felted. Textiles can be classified either by their constituent fibers, such as silk, cotton, rayon, or nylon, or by their weave, such as satin, leno, or twill. Weaves should not be confused with types of fabric; for example, jacquard is a weave that can be made of various kinds of fibers.

Fibers

Fibers can be categorized as *natural*, *man-made*, or *chemical*. Natural fibers are further grouped according to whether they come from animal (wool, mohair, cashmere, alpaca, silk, feathers), plant (cotton, linen, ramie, hemp, jute), or mineral (asbestos, glass fibers, aluminum) resources.

NATURAL FIBERS

Wool	Taken from a variety of animal coats that range from coarse to very soft in texture. Wool fibers are crimped and wavy and, when woven, create pockets that give depth to the fabric. The unique scaled texture of the outer surface of the fibers, similar to the scales of a fish, allows them to stick together and create felt. Alpaca, mohair, camel, and cashmere are wool specialty fibers.
Silk	Taken from the cocoon of a silkworm. A natural protein, a single silk fiber has more strength than a steel filament of the same thickness. It absorbs well and can be dyed in many colors. Organza, silk satin, and charmeuse are woven silk fabrics.
Cotton	Made from the seed pod of the cotton plant. Fibers are hollow in the center and twisted like a ribbon. Cotton can handle high temperatures, absorbs dye well, and stands up to abrasions. Muslin, sateen, terry cloth, and velveteen are woven cotton fabrics.
Linen	Made from the bast that surrounds the stem of the flax plant. It is the strongest of the plant fibers. The plant's wax content imparts a sheen to the fiber, whose natural color ranges from creamy white to tan. It can also be dyed.

Ramie	Made from the bast of a plant in the nettle family. It is often mistaken for linen. Like silk, it has a high luster. A very strong fiber, ramie resists bacteria, mold, and abrasion and is often blended with other fibers. It is also extremely absorbent.
Jute	Made from the stack and stem of the jute plant. This glossy fiber serves mostly as a backing material for carpet and flooring.

MAN-MADE AND CHEMICAL FIBERS

Rayon	Manufactured from wood pulp. Rayon was the first man-made fiber. Like cotton, it is very absorbent and strong.
Acetate	Manufactured from plant cellulose. It can be extruded in fibers of various diameters that can be woven to look like silk. Unlike silk, it is a weak fiber and sensitive to heat.
Nylon	Produced solely from petrochemicals. It is commonly used for carpet fibers and is very sensitive to heat.
Polyester	Produced from alcohol and carboxyl acid. It is resistant to crease and nonabsorbent. It is best blended with other fibers like cotton.

Performance Attributes

Abrasion Resistance: Durability of a fabric. Standard tests measure the performance of a fabric as it endures a repeated number of cycles or rubs; however, the results may not predict its suitability for a particular application.

Absorbency: Ability of a fabric to absorb moisture. Fibers may alter in strength when wet. Thus, the appropriate cleaning methods must be determined to prevent a fabric from changing properties afterward. Hydrophilic fibers absorb moisture easily, while hydrophobic fibers do not.

Acoustical Transparency: Measurement of sound transmission through a fabric. An open-weave fabric is typically less obstructive than a tight-weave fabric.

Fire Resistance: Degree of a fabric's resistance to heat and flame. The finish on a fabric plays an important role in its overall performance.

Common Weaves

Weaves are interlocking fibers that make a textile. Weaves are often confused for types of fabric. For example, jacquard is a weave and not a type of fabric and can be made of various types of fibers. The most common types of weaves are outlined below:

Plain Weave: In this most common weave, one warp yarn crosses over one weft yarn in an alternating pattern, which creates an even surface and texture. It is durable and inexpensive to produce. Common fabrics are cotton, percale, voile, chiffon, organza, and taffeta; common uses are draperies, upholstery, and bed linens.

Basket Weave: A variation of the plain weave, it is typically woven with two colors of yarn crossing in an alternating pattern that resembles a basket. Common fabrics are oxford and monk's cloth; common uses are bed linens and pillows.

Twill Weave: A strong weave, it produces a distinct diagonal pattern by slightly shifting the yarns over at each successive row. This weave creates a houndstooth, herringbone, or chevron pattern. Common fabrics are gabardine, tweed, serge, and denim; common uses are upholstery and pillows.

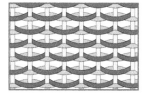

Satin Weave: Formed by each yarn floating over four yarns, the weave creates a smooth, lustrous surface. Satin weave drapes very well but is subject to snag due to exposed yarns. When woven in shorter or staple yarns like cotton, it is called sateen. Common fabrics are satin and sateen; common uses are draperies and pillows.

Jacquard Weave: Woven on a special jacquard loom that controls individual yarns, the weave allows for more complex design. It is used to produce patterned fabrics. Common fabrics are brocade, damask, and tapestry; common uses are upholstery and wall hangings.

Leno Weave: An open mesh, it is created by a pair of warp threads passing over and under the yarn in a figure eight or hourglass twist. Common fabrics are gauze and marquisette; common uses are draperies and blankets.

Fabric Treatments

Fabric Finishing

Water Resistance: Silicone or fluorochemical finish applied to a fabric to help it resist the absorption of moisture.

Stain Resistance: Finish applied to a fabric to help it resist water- and oil-based stains. It is typically sprayed on and can be combined with other fabric finishes.

Flame Resistance: Finish applied to a fabric so that it complies with building and fire code regulations. There are two types of flame-resistant treatments, polymers and salines, and their use is determined by fabric type.

Antistatic Treatment: Finish applied to a fabric to remove static buildup. Fabric softeners are effective because they coat the fibers, thereby reducing electrostatic conductivity.

Bacteriostatic and Antimicrobial Treatment: Finish applied to a fabric that is prone to mold, mildew, and rot when exposed to moisture. The finish can be applied to the fabric or to the fibers during manufacturing.

Dyeing Methods

Fiber Dyeing: Dye is applied to the natural fibers in their raw state or to the polymer or fiber solution. This process ensures colorfastness and excellent color penetration.

Yarn Dyeing: Dye is applied to the fibers after they are spun into yarn.

Piece Dyeing: Dye is applied to a woven material. If all the fibers are the same, it is very easy to achieve a uniform color.

Polychromatic Dyeing: Dyes are applied to a woven material at different speeds and in various directions through jets and rollers, which allows for random patterning. Computer technology is expanding options for this method of applying color.

Printing Methods

Direct Printing: Colors are applied to a fabric by a roller or cylinder imprint. A different roller is assigned for each color, and the background is typically white. There are two types of direct printing: block printing and flat-bed printing.

Screen Printing: Colors are applied to a fabric through a stencil. A different stencil is used for each color. There are two types of screen printing: flat-bed printing and rotary screen printing. For larger quantities, a rotary screen process is more efficient.

Discharge Printing: Color is lifted from a fabric in a controlled pattern with bleach or chemical dye removers. This reverse process is used for simple patterns like stripes and polka dots. It can be combined with other printing techniques for a more complex pattern.

CEILINGS

Ceilings are as important as any other surface in a room. Interior designers can use a number of materials to finish a ceiling, though, in some cases, they may wish to leave it exposed.

Many ceilings are rated according to their acoustic qualities. The main unit of measure for acoustics is the *noise reduction coefficient* (NRC), a number expressed as a percentage of how much sound is absorbed (an NRC of 0.8 will absorb 80 percent of the sound that is directed at the material).

Dropped Ceilings

Dropped ceilings are also referred to as suspended ceilings. Their main function is to conceal items such as ductwork, piping, and wiring. The area between the dropped ceiling and the underside of the construction above is known as the *plenum*. Runners and T-splines are hung from a wire attached to the underside of the construction. This forms a basic grid into which tiles of various types are laid. Grids can be concealed within the system for a more continuous ceiling plane.

Exposed T

Recessed T

Stepped T

Concealed T

CEILING PANELS

Type	Description
Metal Panels	Metal-faced panels available in a variety of finishes and perforation Absorptive material behind, combined with perforations in the pane provides various levels of acoustic dampening.
Acoustic Tiles	Mineral fiber or fiberglass panels available in a variety of edge details and embossed patterns. They provide the maximum acousti absorption.
Wood Panels	Fire-retardant panels faced with a wood veneer. Their acoustic qual ties are low, but the wood can be perforated to improve acoustic performance. They add warmth and sophistication to a space.
Metal Baffle	Linear metal strips hung perpendicular to a cross tee. They can conceal both systems and light fixtures. Available in many depths a colors, they offer a unique appearance.
Fabric Panels	Mineral fiber panels covered with woven fabric. They have a high acoustic absorption. Able to conceal both systems and light fixtures they add warmth to a room and can coordinate with other fabrics.

Hard Ceilings

For many residential and hospitality projects, designers may prefer a hard surface ceiling that can be painted or finished. These ceilings are installed under a wood or metal framing system and provide acoustic benefits through insulation in the ceiling plenum. Gypsum panels are the most commonly used, though it is not uncommon to find a layer of plaster installed over lath and wire mesh. The most important aspect of a ceiling is the level of finish and smoothness of the installation. Panels are hung, taped, covered with joint compound, and sanded smooth. Occasionally, a skim coat of plaster will be applied to create an even surface for the final application of paint. The six levels of finish are outlined below:

Level 0: Used in temporary construction or in situations where the finish has not yet been determined. Joints are not taped and the surface is not sanded.

Level 1: Used in areas where the connections between panels are concealed; e.g., ceiling plenums or fire shafts. All joints are taped with joint compound.

Level 2: Used for water resistant applications, such as in bathrooms and kitchens, especially where the board will receive a tile or stone surface finish.

Level 3: Used for heavy-grade finishes, such as textured sprays and commercial wall coverings. Two coats of joint compound are applied smoothly, and the surface is finished with a drywall primer.

Level 4: Used in residential and light-use construction for flat paint or other light textures. Two coats of compound are applied at joints and corners; all fasteners receive an additional layer. The surface is finished with a drywall primer.

Level 5: Used where gloss and other reflective finishes can telegraph imperfections or where fasteners might be visible. Compound layers are similar to level 4, with a final skim coat applied over the entire surface. The surface is finished with a drywall primer.

Chapter 11: Texture

Incorporating a range and balance of textures in a space can be as character-defining as a sophisticated color scheme. It is difficult to think of texture in isolation. More effective is to consider it combined with color as part of an integrated concept for the design of a room's primary surfaces. To work with texture, the designer must understand the effects of shadow and reflection caused by the surface configuration of materials, including fabrics, metal, stone, wood, glass, and painted plaster. Since all of these effects are concerned with how a surface catches light, the integration of texture into the design concept further requires the synthesis of material selection and lighting design.

TEXTURE IN MATERIALS

There are two basic types of textures: *visual* and *tactile*. Examples of materials with visual texture are wood and stone, their texture defined mostly by the natural graining and veining of the material. Tactile textures include hand- or machine-crafted fabrics and carpets. These textures are used most effectively when they are positioned adjacent to a contrasting texture. A rough texture next to a smooth texture, an opaque material next to a translucent material, or a matte surface next to a reflective surface are all strategies that designers should employ when thinking about finishes.

Paper

1 Metallic vinyl
2 Bark and aluminu‮
3 Woven veneer
4 Textured vinyl

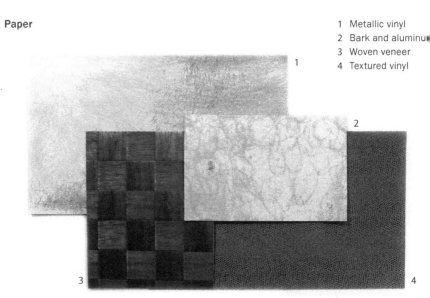

1

2

3

4

Wood

1 Wood, solid stock
2 Wood veneer
3 Pressed board
4 Cork
5 Cork, modeled
6 Cork, thin strip
7 Cork, wide strip

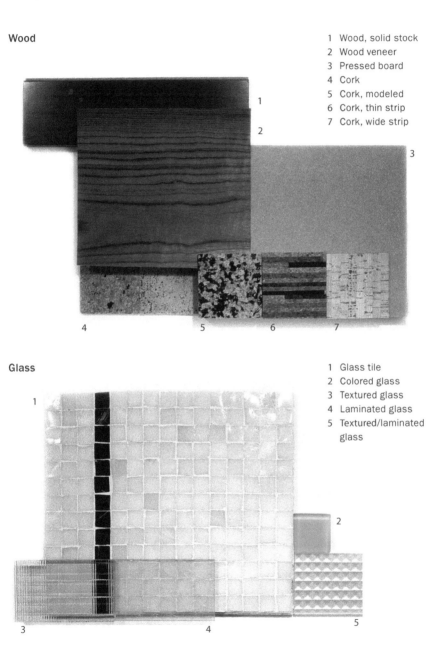

Glass

1 Glass tile
2 Colored glass
3 Textured glass
4 Laminated glass
5 Textured/laminated glass

Clay

1 Textured ceramic tile
2 Terra-cotta tile
3 Glazed and unglazed t
4 Porcelain tile
5 Metallic tile

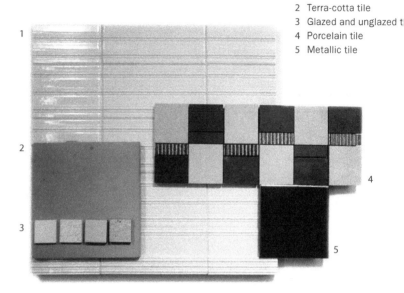

Stone

1 Composite stone tile
2 Marble mosaic
3 Marble
4 Limestone
5 Cast stone
6 Granite

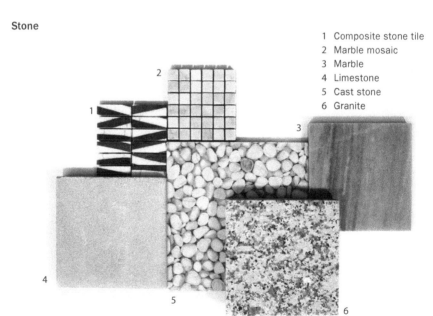

Metal

1 Aluminum sheet
2 Perforated sheet
3 Flexible weave
4 Stamped sheet
5 Woven wire

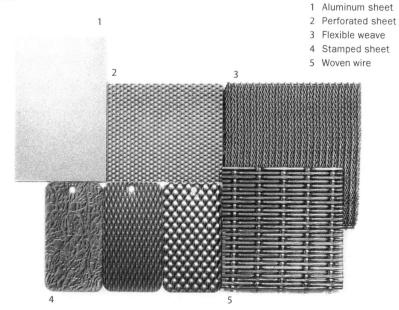

Composite

1 Quartz solid surface
2 Quartz solid surface
3 Epoxy coating
4 Solid surface
5 Epoxy coating
6 Quartz solid surface

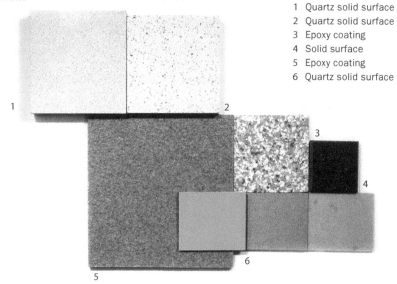

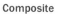

TEXTURE AND COLOR

The interactions of color, material, and texture, in turn reacting to light, all contribute to the character of an interior environment. More specifically, color value has a direct effect on how a material translates its visual or tactile qualities. Three general families of palettes have different implications for the role of texture within the overarching design concept: the white, neutral, and dark palettes.

White Palettes

With white color palettes, the shadows created by differences in material textures are more pronounced; as a result, this palette strategy often foregrounds texture as the primary design concept. A white palette is most successful with an abundance of natural light to highlight the contrast in surfaces and textures. For instance, the shadows of window shutters can cast strong patterns on surfaces that add to the richness of the finishes. This palette can also benefit materials with natural textures such as linens and sisal carpets. When paired with dark contrasting elements such as an ebonized floor or lacquered surface, a white palette can be refreshing and bold, but it demands meticulous maintenance and may not be practical for many clients.

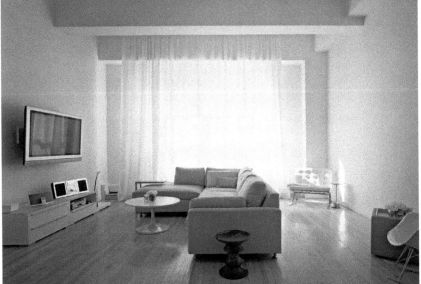

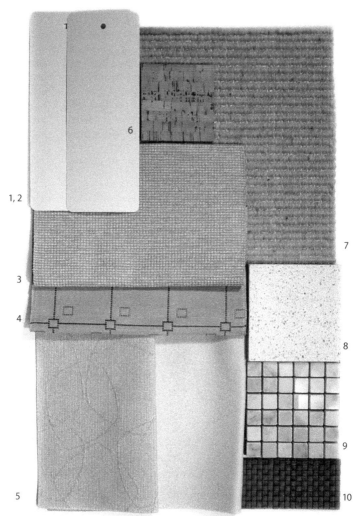

1 Paint
2 Paint
3 Fabric, woven texture
4 Fabric, pattern
5 Fabric, pattern
6 Cork
7 Sisal carpet
8 Quartz solid surface
9 Marble mosaic tile
10 Leather, woven

Neutral Palettes

Neutral palettes are the least risky from a design standpoint, the easiest to get approved by a client, and the most difficult to transform into a sophisticated scheme. A neutral palette has fewer associations with a particular era and is therefore unlikely to become dated. On the other hand, this approach runs the danger of being banal if a rich range of textures and materials is not achieved. Neutral palettes can easily incorporate many natural materials such as wood, cork, and stone to balance tactile textures with visual textures. When accent colors are injected into a neutral palette, they need only be applied in very small areas to create an overall compositional balance.

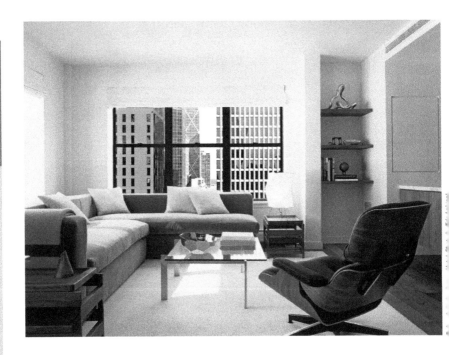

Neutral palettes cover a large spectrum of color, from creamy to cool gray tones. This range needs to be carefully matched with the appropriate natural materials, including wood, stone, and metal.

Creamy tones work well with medium-toned woods such as oak and anigre, warm stones such as limestone and travertine, and warm metals such as bronze and copper. Cool gray tones work well with dark woods such as walnut and ebony, lighter stones such as arabescato classico or thassos marbles, and cool metals such as stainless steel and chrome.

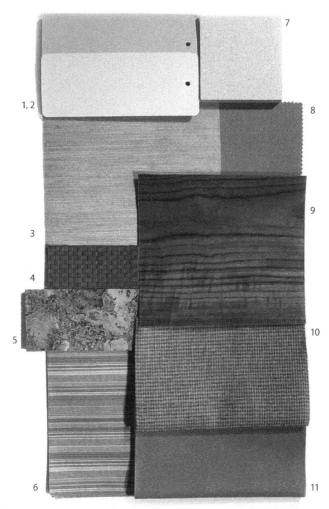

1 Paint
2 Paint
3 Grasscloth wall covering
4 Leather, woven
5 Cork
6 Fabric, pattern
7 Quartz solid surface
8 Fabric
9 Wood veneer
10 Fabric, chenille
11 Leather

Dark Palettes

In general, darker palettes require more textural contrast than lighter palettes because shadows are not as legible. As a result, dark palettes may rely more on reflection than material relief for textural contrast. Some reflective materials to consider are polished stone such as absolute black granite and black lacquered furnishings. Dark material palettes should include lighter contrasting wall surfaces so that the room does not become oppressive or gloomy.

Textures and Lighting

Both artificial and natural lighting affect the visual quality of textures. Shadows penetrating a room can provide visual interest, while reflected surfaces add depth to the overall composition.

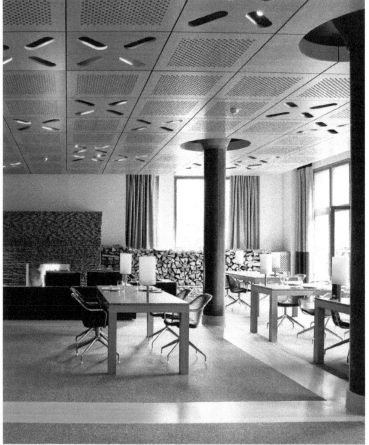

Ali Tayar, The OMNIA, Switzerland. Photo by Bruno Augsburger.

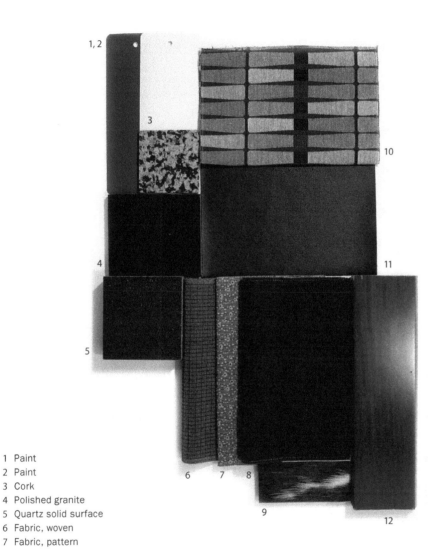

1, 2

3

10

4

11

5

6 7 8

9

12

1 Paint
2 Paint
3 Cork
4 Polished granite
5 Quartz solid surface
6 Fabric, woven
7 Fabric, pattern
8 Fabric
9 Cowhide
10 Fabric, pattern
11 Leather
12 Wood, solid stock

Chapter 12: Pattern

A pattern is a repetition of elements, typically laid in a grid. Patterns give visual interest to the surfaces of a room, whether in a textile, wall covering, or flooring. Although they are commonly associated with textiles, patterns can also be found in such textural elements as a brick wall. The repetitive elements create balance and order across surfaces, pleasing the eye, and a skilled interior designer can use patterns to establish a desired mood. Patterns can be employed in small quantities to highlight special features in a room or can cover every surface to blend all the elements together. Although there are no set rules for applying patterns, it is important to understand the effects of patterned surfaces on an interior.

EFFECTS OF PATTERNS

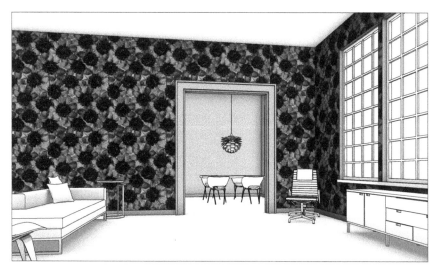

Patterned surfaces can alter the proportional readings of a space. Large-scale repeats with complex patterns and contrasting colors can be appealing in a large room but can overwhelm a small one. Complex patterns are best left for fabrics or floor surfaces and should be carefully considered for wall coverings.

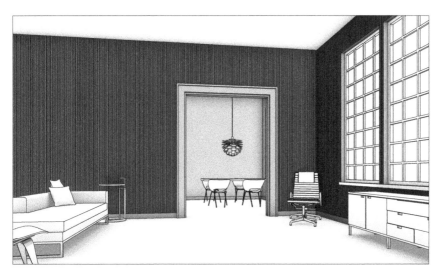

Patterns with vertical lines can add height to a room with low ceilings. Curtains with vertical lines that extend from floor to ceiling will make a room look taller. Conversely, patterns with horizontal lines can make a room or a piece of furniture look wider.

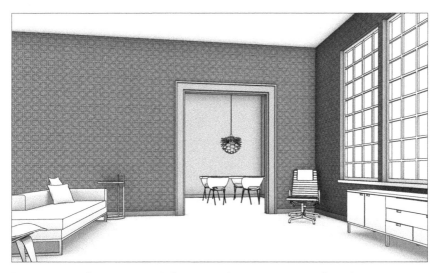

Pattern has an effect on the mood of a space. A floral pattern on a surface will create a much different feeling than a geometric pattern on the same surface. Patterns are expressive of style and sensibility and immediately set the tone for an interior environment.

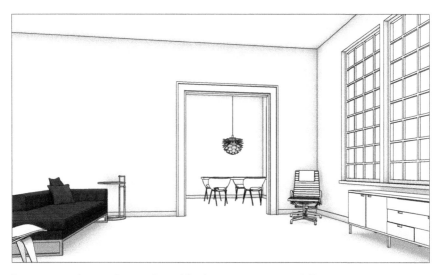

Pattern can make a surface or piece of furniture more pronounced. Pattern can be used strategically to drawn the eye to a particular focal point.

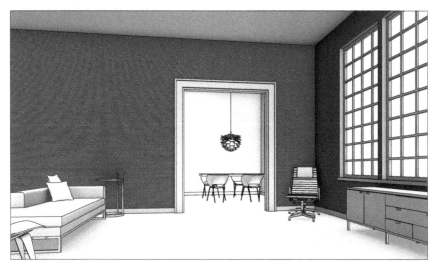

The scale of a pattern determines how complex or busy it will look on a surface. For instance, a pattern with a small repeat may appear as a solid color from across the room and only be discernible at a closer viewing.

Color plays a large role in pattern. The more contrasting colors in a pattern, the more dynamic the pattern. If a pattern is made up of different tones of the same color, it may be quite subtle.

Texture, too, plays a role in pattern making. A weave on a monochromatic textile can create a pattern that adds interest to an otherwise plain fabric.

CHARACTERISTICS OF PATTERN

The endless variations on patterns are impossible to quantify; however, most patterns share certain characteristics. Patterns are made up of repeats, which is the element repeated across the surface. At its simplest, the repeat is uniformly laid in a grid. To give variety to the pattern, it can also be rotated or mirrored along an invisible axis.

Uniform Repeat

Rotated Repeat

Patterns can also be categorized by the depth of the design. The repeat will be either a two-dimensional figure that plays up the surface of the material or a three-dimensional figure that gives it depth. Three-dimensional patterns are most effective across a flat surface, such as a floor or wall surface; they have less impact on a billowing or draped fabric.

Two-Dimensional Pattern

Three-Dimensional Pattern

Custom Patterns

The designer can incorporate patterns into the design of a space in one of two ways: The most obvious is to select and specify a premade pattern such as a textile, wallpaper, carpet, and so forth. The other is to custom-design a surface by laying out a pattern that is implemented in the installation of the material.

Pattern on a Floor

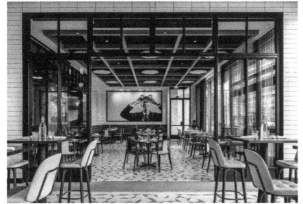

Hacin + Associates, Glass House Restaurant and Bar. Photo by Michael Stavaridis.

Pattern on a Wall

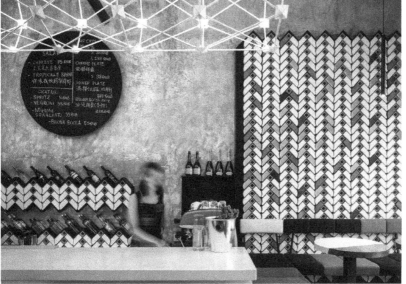

Studio Ramoprimo, BuonaBocca Bar. Photo by Cristiano Bianchi.

PERSPECTIVES ON SURFACE:
ANNABELLE SELLDORF

Annabelle Selldorf, describe yourself and your practice.

Selldorf Architects is an architecture and interior design firm with a reputation for projects exhibiting sensitivity and restraint. The success of our work relies on a clear and deliberate aesthetic and a commitment to engaging the client in a collaborative process that fosters specificity and a bespoke quality in the project. Our work is characterized by elegantly proportioned spaces, integrity of structure, clarity of distribution and function, and a deliberate rendering of light; this approach calls for exacting detail toward nuanced design.

The portfolio of our work includes a wide range of new construction and renovations, including high-end corporate, institutional, retail, and residential work. Selldorf Architects has completed, among others, numerous prestigious art-related projects: museums, galleries, and art foundations, as well as exhibition spaces and artists' studios.

You come from a family of architects. Were they your mentors? Do you have any other design mentors?

My father is an architect and a designer and has always had a great influence on my work. His work can be described as classically European modern, and certainly Selldorf Architects' aesthetic is also deeply rooted in the modern tradition. That being said, it's merely a starting point; I have my own distinct strategies and instincts.

Two other people who were part of my architecture education and had a great influence on me are Raimund Abraham, my thesis professor at Pratt Institute, and Colin Rowe, with whom I studied in Florence while pursuing my master's degree in architecture from Syracuse University.

To whom or what do you look to for inspiration?

In the case of interior architecture and interior design, I always start by looking to the space itself for inspiration. Each existing building has its own intrinsic quality, which I believe is useful to work with—not necessarily by assimilating, but as a statement of original character. For new construction projects, it is the real and the perceived context, the quality of the environment, the client's disposition, and the program that create the foundation for inspiration.

In your renovation work, how do you reconcile your aesthetic agenda with the preexisting patterns and ornamentation?

If the aesthetic is a given bias in terms of taste and style, then the reconciliation happens in a strategic fashion through critical analysis of the existing individual elements that make the context what it is. The result may be either a juxtaposition of opposing elements or an isolation of individual parts, but always within a greater whole.

The Hauser & Wirth Gallery in London and the Neue Galerie in New York are unusual places in which to display art because of the historic detailing; specifically, the wood paneling of the walls. How do you regard the display of art in these spaces?

My attitude regarding the display of art in these spaces is self-evident in the buildings and their layout.

Your use of color in the Palacio Canet in Mallorca, Spain, is effective and efficient. With a few bold colors in the furnishings, you captured both a Spanish palette and a modern sensibility. How do you approach color in your projects?

We tend to use color and texture more with fabrics and furniture than in architectural spaces, where we generally prefer white or neutral colors. In certain circumstances, however, color may be an appropriate response to context. In some ways, color is the most intuitive response to space.

You have designed residential projects for both individual clients and prospective buyers, as in the Urban Glass House project. Is your design approach different?

The design approach is the same in either case. When designing a space in the absence of an individual client, the program is somewhat speculative and the degree of specificity is generated by Selldorf Architects rather than the client; but the approach itself remains unchanged. In addition, of course, our designs take into consideration the experience.

Typically, we collaborate closely with an individual; but in the case of the Urban Glass House, we collaborated with a developer and a marketing consultant in an effort to better understand the needs of the prospective buyers.

What is your methodology for selecting a materials palette?

While we have certain likes and dislikes or a bias for certain juxtapositions of materials, we have no set strategy, per se, for selecting a materials palette. The choices we make are a reflection of the client's tastes and of considerations of feasibility with regard to practicality and cost; but more than anything, it's based on taste.

With your interior projects, do you have to rationalize your design decisions or do your clients trust your taste? Is it different with your architectural projects?

Having a client trust your taste is critical to the success of any project. It is equally important that you listen to your clients. You must develop and earn their trust, and on some level this has to do not only with listening carefully, but with guiding and directing and explaining your rationale to them. This is true with both interior projects and architectural projects.

You have your own line of furnishings, called Vica. Can you describe it and how it came about?

I grew up over a furniture factory founded by my grandmother. My father also designed furniture, and some of the pieces in the Vica line are reeditions of his original designs. Vica is an interior furnishings collection that offers profoundly functional, high-quality handcrafted pieces that are refined in scale and classically modern.

Is there a building or project type that you haven't done that you wish you could do?

I would like to do everything I haven't yet done, including schools and public spaces, so that people can more easily live.

Could you name some spaces that have really impressed or affected you?

I'm impressed by the Hagia Sophia in Istanbul, Turkey, due to its sheer space. Another favorite building is Erik Gunnar Asplund's Stockholm Library in Sweden because of its combination of beautifully proportioned space, influx of daylight, and amazing quality of detail.

Overleaf Left Martha Washington Hotel and Marta, New York, NY. Photo by Selldorf Architects.

 Right Van de Weghe Townhouse, New York, NY. Photo by Todd Eberle.

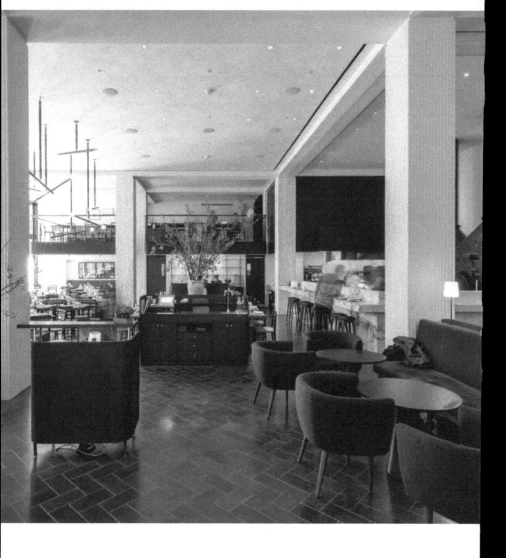

4.

ENVIRONMENTS

The intangible comforts of a room, often assessed intuitively, are just as important as the visual character of a space. To make a room feel cozy on a cold winter day has as much to do with the light quality, temperature, humidity level, and lack of air movement as it does any element that can be seen. As light, whether natural or artificial, impacts almost every aspect of an interior environment, both functionally and emotionally, designers must understand how to integrate it into their concept.

Interior designers do not design or specify heating, cooling, electrical, and plumbing systems, but rely on other professionals to achieve their vision. To this end, designers function like film directors, by orchestrating the larger concept of the environment. In addition to defining these intended qualities, the interior designer must be deft at integrating and disguising the vents, radiators, and control systems that provide comfort within.

Chapter 13: Natural Light

Too often in interior practice, the quality of natural light is generally considered, but not fully integrated into the design concept. Yet to control, channel, and filter natural light as it enters a space can be one of the most effective of design strategies. Light can be a powerful component of an environment, given our innate tendency to react to qualities of light in emotional and intuitive ways: Designers know that orchestrating a sequence of spaces to end in a sun-filled room is sure to brighten the mood of the occupants. Moreover, in practical terms, studies have shown that natural lighting promotes productivity in the workplace and in academic environments. Beyond the poetic and functional benefits of working with natural light, a successful outcome requires its careful manipulation to avoid uncomfortable levels of brightness, glare, and heat gain.

ENVIRONMENTAL CONDITIONS

To design effectively with natural light, the designer needs to understand the *solar orientation* of each room and the configuration and characteristics of the exterior environment adjacent to each space. For example, a room whose windows face south may benefit from a well-placed tree that filters sunlight—especially a deciduous tree whose filtering properties change with the season. At the same time, a north-facing room may benefit from a wall or landscape element that receives strong light from the south that then enters the interior as beautiful bounced light.

SOLAR ORIENTATION AND FUNCTION

Anticipated activities in a space will determine how natural light should be controlled. South-facing rooms have the best orientation for most functions since they admit the most consistent sunlight throughout the day. By contrast, a room with north-facing windows allows only diffused light to enter, making it an ideal location for an artist's studio. For the same reason, a north-facing room is also best for computers since it minimizes the potential for glare on the monitor screens. If a computer room needs to face south, the designer will have to consider window treatments as a central part of the design concept.

Window openings that face west receive late afternoon sun at a very low angle, an ideal condition for a dining room and/or living room, but window treatments will be required to cut down on the glare caused by direct sunlight deeply penetrating the space. East-facing windows allow early morning sun to enter, which is ideal for a breakfast nook or the coffee station in an office environment. The orientation of openings in a bedroom should influence the selection of window treatments, especially for windows that look east.

North: diffuse light
West: late afternoon sun
East: early morning sun
South: most consistent light

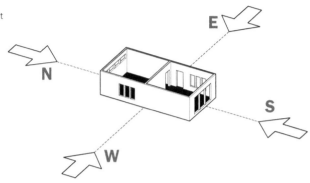

Seasonal Light

The altitude of the sun's path is constantly changing and is at its lowest angle in winter and its highest in summer. When the sun is low in the sky in winter, it allows more daylight and heat to penetrate a space, while the opposite is true in summer. Ideally, a designer should observe the changing daylight conditions of a space over the course of a year, paying close attention to the amount of light and shade in the morning, at noon, and in the afternoon, as the sun changes position in the sky from winter to summer. In lieu of direct observation, the effect of natural light based on the sun's movement can be predicted for any location and time of year.

The angle of the sun is always changing. Its highest angle is reached on 21 June and its lowest angle on 21 December.

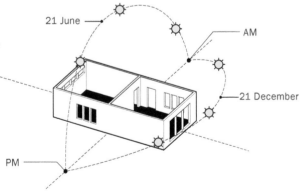

CONFIGURING OPENINGS

The dimension and configuration of openings in the walls and ceiling will also determine the character of natural light in a space. Windows are the most conventional way to channel sunlight into a space. Their size and configuration can be shaped to create a desired effect. In addition to the light passing directly through the glass, bounced light from window sills and jambs contribute to the overall level and quality of light in a room. The contrast between window apertures and their surrounding surfaces must be carefully considered. For instance, a south-facing room with a few punched windows in a large expanse of wall will produce an unacceptable contrast; the same space with a large expanse of glass, on the other hand, will have more evenly distributed light.

Skylights are another way to channel natural light into a space. It is important to configure the ceiling plane and soffits to control the amount of direct sunlight that can penetrate a room since it can lead to unwanted heat gain and can fade rugs, upholstery, and artwork. The best top-lit spaces are those that rely on light bouncing from soffits and ceiling coves rather than those that allow a direct view of the sky.

Neues Museum, Berlin.

Natural light bounces around the curvature of the cove to create a luminous effect, accentuated by the metallic gold trim.

CONTROLLING LIGHT

Natural light can be controlled in three ways: through *additive treatments* such as blinds, curtains, and shades; by the *specification of the glass*; and through the *configuration of the opening* itself. New glass technologies such as fritting allow the glazing itself to function as a light-filtering system. Coatings for glass can also be specified that filter light entering a space and reduce ultraviolet rays in particular. The location and the design of the window aperture can dramatically affect light quality. Windows that meet the ceiling plane or the wall of the room will allow natural light to illuminate an entire surface, enhancing light levels and reducing contrast. The depth of the wall can also be manipulated by creating deep jambs and sills; an outside wall, for example, can be lined with bookcases. Often, the jambs of windows in this configuration are canted toward the interior, to maximize the amount of light that reflects deep into the room.

Window treatments are not the only solutions for controlling light. When views cannot be compromised with a window treatment, various glass types may be used to filter harmful ultraviolet rays.

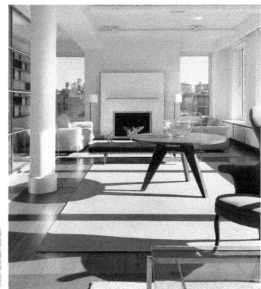

Shelton Mindel Associates, Mindel Loft. Photo by Michael Moran.
Photo: Michael Moran

SYNTHESIZING DESIGN ELEMENTS

Designing with natural light requires a careful synthesis with other design elements. Rooms that are prone to contrasts of light levels due to orientation and existing window apertures, for example, will need to be carefully balanced with artificial light. Color palettes should also be coordinated with the quality of natural light in a room. For rooms that benefit from direct and changing natural light, a more neutral palette may be more appropriate. Rooms that receive only northern or diffuse light may warrant more color. Vernacular architecture indicates such an approach: traditional Scandinavian architecture is richly colored, while the traditional houses of Greece and Spain are painted white.

Chapter 14: Artificial Light

Consider a strongly evocative interior space, one where the mood is immediately striking, and chances are high that lighting played a central role in its design. In a restaurant that is both cozy and contemporary, for instance, artificial lighting will inform the design features and the character of the space. Simple surfaces and colors will have been selected to take best advantage of the light: Walls might be a warm, buttery yellow, and mirrors and other reflective surfaces used to throw the focal glow of candles and soft light around the room.

Lighting design that creates a mood is based on an approach that is at odds with lighting design that seeks evenly distributed and specific lighting levels. This kind of "perfect" all-over task lighting may be appropriate for flexible office space, but it fails to produce an imaginative setting for most other human activities. By understanding the specific tasks intended for a space, however, the designer can readily determine the appropriate lighting strategies that will integrate function and inspiration into a design.

Arai Jackson Ellison Murakami, Veil Restaurant, Seattle; Studio Lumen, lighting design. Photo by Richard Spry.

TYPES OF LIGHTING

Artificial lighting is best examined according to the function it performs, typically described as *ambient, accent, focal,* or *task lighting.* Ambient lighting is the general-purpose light in a space. Ideally, the ambient light source comes from different fixtures that can be individually controlled and dimmed depending on the time of day or amount of natural light available.

Accent lighting acts as a spotlight to illuminate a specific artwork, architectural detail, or piece of furniture. Accent lights are typically low-voltage fixtures that can be manually adjusted to focus on a particular object. To avoid glare, the light source should be at a 30-degree angle to the object.

Unlike ambient or accent lighting sources, chandeliers, wall sconces, and lamps draw the eye to themselves. These glowing objects serve as focal points in a room and, in fact, are often referred to as *focal glow.* Most successful lighting design solutions balance ambient light with focal glow.

Task lighting provides light for a specific activity. In a typical office space, the light levels are evenly distributed by a grid of fluorescent fixtures, but are usually supplemented with a task light over each desktop. Different tasks require different lighting levels, for which there are general recommendations. Lighting levels can be described in *foot-candles,* which measure how much light a lit candle would throw on a surface that is a foot away. The metric equivalent is the lux.

RECOMMENDED LIGHT LEVELS

Task Area	Foot-candles	Lux
Kitchen	20	215
Reading or Writing	25	270
Classroom	50	540
Demonstration Lab	100	1076
Computer Lab	30	323
Auditorium	10	108
Conference Room	30–50	323–540
Enclosed Office	50	540
Office Landscape	75	807
Corridor and Stairway	10	108

LIGHTING BASICS

Lighting is measured by the amount of luminous flux on a surface, called *illuminance*. It is expressed either in foot-candles (illuminance in a square foot) or in lux (illuminance in a square meter). An artificial light source is referred to as a lamp. Although lamps are commonly identified by their wattage, this does not describe the output of light. A watt is the measurement of energy consumption from a particular light source. So an incandescent lamp and a fluorescent lamp can have the same light output of foot-candles or lux, while ranging dramatically in wattage. As an example, a 60-watt incandescent lamp has the same light output of a 15-watt fluorescent lamp.

Light coming from a single point source can, like direct sunlight, create dark areas of shadow around the pool of light it provides. A point source calls attention to the surface it is illuminating and highlights its inherent characteristics. Diffuse light, like that on a cloudy day, distributes light evenly and is not strong enough to create shadows. While this even distribution of light may be good in a working environment because it is easy on the eyes, it can seem a bit dull and lifeless over time.

An unshaded lamp or poorly positioned fixture with an exposed lamp can cause extreme brightness from a light source called glare. While not measurable, glare is easily recognizable. It can impair vision and induce discomfort as the eye usually squints to reduce the impact of its harshness. *Veiling reflection* is another type of glare that is caused by the brightness of a light source reflecting off a shiny surface such as glass. A familiar example might be the reflection of a bright window on a computer screen. The well-thought-out distribution and location of light fixtures can reduce glare significantly.

TYPES OF LAMPS

Many types of lamps are available, each with specific characteristics for color rendition, size, energy consumption, and lamp life. Juggling all the variables can be complex. To specify lamps correctly, designers should know their efficacy rating (1 = low/poor, 5 = high/excellent) as well as their correlated color temperature and color rendering index.

Correlated Color Temperature

Color Rendering Index (CRI)

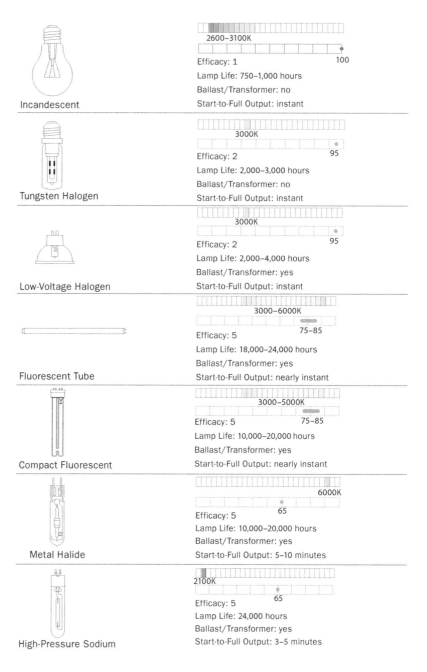

Incandescent

2600–3100K

Efficacy: 1 100
Lamp Life: 750–1,000 hours
Ballast/Transformer: no
Start-to-Full Output: instant

Tungsten Halogen

3000K

Efficacy: 2 95
Lamp Life: 2,000–3,000 hours
Ballast/Transformer: no
Start-to-Full Output: instant

Low-Voltage Halogen

3000K

Efficacy: 2 95
Lamp Life: 2,000–4,000 hours
Ballast/Transformer: yes
Start-to-Full Output: instant

Fluorescent Tube

3000–6000K

Efficacy: 5 75–85
Lamp Life: 18,000–24,000 hours
Ballast/Transformer: yes
Start-to-Full Output: nearly instant

Compact Fluorescent

3000–5000K

Efficacy: 5 75–85
Lamp Life: 10,000–20,000 hours
Ballast/Transformer: yes
Start-to-Full Output: nearly instant

Metal Halide

6000K

Efficacy: 5 65
Lamp Life: 10,000–20,000 hours
Ballast/Transformer: yes
Start-to-Full Output: 5–10 minutes

High-Pressure Sodium

2100K

Efficacy: 5 65
Lamp Life: 24,000 hours
Ballast/Transformer: yes
Start-to-Full Output: 3–5 minutes

NEW LIGHTING TECHNOLOGIES

Although fiber-optic and LED lighting technologies have been around for a while, they are now becoming more readily available to designers. Both lighting types are *more energy efficient* than fluorescent lighting, but also much more cost prohibitive. As the market continues to focus on energy efficiency, however, designers will see these technologies advance further and become more affordable.

Fiber-Optic Lighting

This technology relies on strands of acrylic cables to transmit light from the light source, called the illuminator, to the ends of the cables. The illuminator is simply a box with either a tungsten halogen lamp or a metal halide lamp of varying wattages. Tungsten halogen lamps are more common, while metal halide lamps are typically used for large installations. The ends of the acrylic cable are gathered in a bundle and placed in an aperture directly in front of the lamp. The illuminators should be conveniently located for easy access to relamp the fixtures. It is also important to note that the illuminators need ventilation to release the heat that is generated by the lamp.

Depending on the lighting design, there can be less than a handful of acrylic cables or hundreds of cables. The length of the cables can vary per installation, but as a general rule they should not exceed 50 feet (15 m) or light transmission will be compromised. The advantage of this system is that multiple lights can be located in difficult-to-access places, controlled by a single lamp inside the illuminator.

LED Lighting

Although *light-emitting diodes* (LEDs) use a fraction of the electricity and last up to ten times as long as fluorescent lamps, they are too costly for use in general lighting. LEDs are available in high intensities of red, green, and blue light, and the combination of all three colored lights

Comparative Correlated Color Temperature

| Incandescent | Tungsten Halogen | Low-Voltage Halogen | Fluorescent Tube |

yields white light. Varying combinations of the three colors can produce a full spectrum of color options. LEDs have the additional advantage of producing no heat. Currently, LEDs are used in interior design to create desired effects such as accenting a reveal or washing a wall with colored light. As the technology advances, it will become more affordable and eventually be applied to general purpose lighting.

LIGHTING TERMINOLOGY

Ballast: Small device that controls the flow of current by providing the required starting voltage and then reducing the current during operation.

Correlated Color Temperature (CCT): Spectral characteristic of a light source, measured in Kelvins (K). The lower the temperature, the warmer the (yellow/red) tones; the higher the temperature, the cooler the (blue) tones. Sunlight at dawn has a color temperature of 1900K while a uniform overcast sky is 6527K.

Color Rendering Index (CRI): Scale from 1 to 100 that describes the affect of a light source on an object or surface. The higher the index, the more natural and vibrant the object appears.

Dimming Ballast: Device used with fluorescent lamps to vary the output of light by the use of a dimmer control.

Efficacy, or Luminous Efficacy: Efficiency in which electrical power is converted to light. Efficacy measures the number of lumens emitted per watts consumed (lm/W).

Low-voltage Lamp: Incandescent lamp that operates with low voltage, ranging from 6 to 12 volts.

Luminance: Amount of light reflected or transmitted by an object.

Transformer: Device designed to raise or lower electric voltage.

| scent Tube–warm | Compact Fluorescent | Metal Halide | High-Pressure Sodium |

Chapter 15: Invisible Systems

The intangible comforts of a room, including temperature, air quality, and humidity, are taken for granted if successfully designed, but become the source of many complaints if they prove inadequate or off-kilter. In addition, the paraphernalia of comfort—diffusers, grilles, thermostats, lights, receptacles—can easily obtrude on a space with their ubiquitous off-the-shelf character. Given these challenges, it is important for designers to select the best mechanical and electrical engineers and to begin coordination early in the design process.

Central to a successful interior design project is a full accounting of all the accoutrements of control for mechanical, electrical, and plumbing systems. Designers must incorporate light switches, receptacles, and vents in the earliest interior elevations. Once accounted for and drawn, it will be far easier to find smart solutions for making these everyday elements less obtrusive. The mechanical diffuser, for instance, can provoke an entire ceiling design concept, with linear diffusers hidden away in the offset between two ceiling planes, and thus define the character of the space.

THE BASICS OF BUILDING SYSTEMS

Basic building systems include *heating, cooling,* and *ventilation* (HVAC); *electrical*; and *plumbing* systems. Other systems like fire protection and security are not discussed here, but should also be considered when designing a room. Engineers are responsible for designing the building systems, while architects and designers coordinate the integration of the systems. Consequently, designers need to have a conceptual understanding of the full range of building systems. For example, the light fixtures, supply and return diffusers, life-safety devices, and such are located on a reflected ceiling plan and coordinated with the engineering drawings by the designer.

MECHANICAL SYSTEMS

Thermal comfort can be provided by air, water, or electricity, each option having advantages or disadvantages for a particular situation. Ducted-air systems can provide both heating and cooling. Hydronic systems are economical for heating, but are not ideal for cooling. Electrical systems are very expensive to operate, but do not entail a lot of equipment.

Ducted-Air Systems

Various types of *air systems are used to provide heat* in buildings, the most common of which are described below.

Single Zone System	This system treats the entire building as a single zone, controlled by one thermostat and one air-handling unit. It is common in residential and small buildings. A slightly more complex system includes multiple subzones that incorporate thermostatic controls inside the ducts that feed different zones. While the temperature can be controlled within the various areas, all of the zones have to be on the same mode of either heating or cooling.
Multizone System	This system produces both hot and cold air from a central controller. The air is then distributed by ducts to different zones that are thermostatically controlled. Unlike the single zone systems, this system can produce hot and cold temperature simultaneously. The disadvantage of this amount of flexibility is that it drives up energy consumption.
Single-Duct Reheat System	This system forces very cold air into a single duct that feeds the entire building. Reheat coils at the ends of the duct run adjust the air to the desired temperature. This system is best used where constant climate control is preferred. Because it cools the air and then reheats it at each zone, the system is not energy efficient.
Variable Air Volume (VAV) System	This system controls the temperature by varying the amount of air flow in a zone through adjustable dampers in the ductwork. As the temperature lowers, the dampers close to reduce the amount of air flow; as the temperature rises, the dampers open to release more air. This system is very common for medium to large buildings because of its high energy efficiency. The disadvantage is that the system either heats or cools and cannot do both at once.

Locating Diffusers

Air *systems require diffusers, registers, or grilles* at the ends of duct runs. Depending on the design of the space, the ducts can be exposed or concealed above a dropped ceiling. Nonetheless, diffusers should be positioned evenly and close to the perimeter wall where either heat gain or loss is of most concern. Since warm air rises, the supply air is typically mounted in the ceiling or high on a wall. Return air draws warm and stale air from a room and should be located away from the supply air. Return-air diffusers, registers, and grilles can be positioned on ceilings, walls, or floors.

Hydronic Systems

Hydronic systems *adjust the temperature of water* to provide heating or cooling in a space. Boilers heat the water for heating systems, while chillers cool the water for cooling systems. The systems described below are the most widely used.

Fin-Tube Radiators	Fin-tube radiators are made of copper pipes with many copper fins that radiate heat from the hot water in the pipes. Cold air is drawn from the bottom of the fin tube and then heated. The warm air then rises and heats the room. Fin-tube radiators typically are located along the baseboard of an exterior wall and are designed to provide heat alone.
Fan-Coil Units	Fan-coil units provide heating and/or cooling to individual spaces. The fan-coil is made up of a fan with one or two coils that contain hot or cool water. The variable settings are controlled by changing the speed of the fan, adjusting the flow of water, or turning the electric coils on or off. Fan-coil units are typically located on an exterior wall and are rather bulky; however, recessed units and low-profile units take up less space.
Radiant Heating Systems	Radiant heating systems are a mesh of flexible tubes filled with hot water that radiate heat through the surface. They are typically mounted in the floor or ceiling and provide warmth and comfort to a space. They are most commonly used in residential applications such as bathrooms. Various types of systems are specifically made for new construction or renovation projects.
Steel Panel Radiators	Steel panel radiators operate similarly to the old cast iron radiator, but they are sleeker and more space efficient than their former counterparts. Water circulates in the panel via a water-supply branch and a return branch, heating the room by radiation and convection.

Electric Heating Systems

The main advantage of electric heating systems is that they do not require additional equipment. They are also easy to install and relatively small in size. The disadvantage is that they are very expensive to operate and consume a lot of energy. Perhaps the best use of an electric heating system is as a supplemental heat source in combination with a forced-air system.

Natural convection units heat cool air as it flows across them. The warm air then rises and warms the space. Theses units are typically mounted along a baseboard or floor, usually along an exterior wall.

Electric furnaces do not rely on natural convection to distribute air, but rather, deliver heat by blowing warm air into a room with a fan. They come in various shapes and sizes, depending on the required capacity.

ELECTRICAL SYSTEMS

Electricity is distributed from a local utility company via high-voltage currents to a transformer. The transformer then steps down the currents to single-phase currents. There currents are then tied into a meter that records the amount of electricity being used. The currents then journey to electrical panels, which distribute the separate circuits that serve different rooms. Insulated wires in rigid metal conduits carry the electricity to its final destination.

With guidance from an electrical engineer, an *interior designer may be responsible for locating switches, receptacles, dimmers, electric panels*, and the like. Designers should be able to read a wiring diagram to ensure that the controls for lighting and equipment work with the design intent. Some of the standard electrical devices are described below.

120-Volt Receptacles	Also referred to as convenience outlets, 120-volt outlets are the most common for everyday needs. Their spacing is regulated by code for different applications; ADA also provides guidelines for their appropriate mounting heights.
220- and 240-Volt Receptacles	Higher voltage outlets such as 220 and 240 are wired separately to serve specialty equipment such as stoves and refrigerators.
277-Volt Circuits	Some applications of fluorescent lighting may require 277-volt circuits. Their efficiency is increased by reducing the size of copper wires and allowing more fixtures on a circuit.
Ground-Fault Interrupter	Ground-fault interrupters are specified for receptacles that are near or exposed to water, typically in bathrooms and kitchens. When exposed to dampness, the device cuts off power to eliminate the possibility of fire or shock.
Data Receptacles	Data receptacles are low-voltage electrical systems that allow communication via the telephone or computer. Where data receptacles are difficult to retrofit, wireless systems are becoming increasingly popular.
Emergency Lights	Emergency lighting is required by code in commercial and larger residential buildings. During a power outage, the emergency lighting should be sufficient to allow occupants to exit the building safely. Emergency lights operate on a separate power source such as battery packs or, for larger applications, on an emergency generator.

LIGHTING CONTROLS

To complement the careful consideration and planning of the lighting scheme, designers need to have a basic understanding of all the options for lighting controls. They range from wallbox dimmers common in most domestic settings to complex lighting management systems appropriate for large buildings that monitor energy consumption. *Lighting controls serve two basic purposes: to create a mood/setting and to conserve energy.* Finding the appropriate system that works for a specific function and budget may require consideration of one or a combination of the following systems.

Wallbox Dimmers	Wallbox dimmers are the most common form of light control. They are wall-mounted dimmers that let occupants control the amount of light in a room. They come in a variety of designs with slide, rotary, or touch-plate control.
Preset Dimming Controls	Preset dimming controls are used to create specific lighting scenarios for a particular space. A conference room, for example, may have settings for a daytime meeting (adjusts for daylight), an evening meeting (accounts for no daylight), a projected presentation (enough light for note-taking), and off-hours/maintenance. The presets are programmed and adjusted by touching a control panel that is mounted in the wall like a standard switch plate. These presets can be combined with time-controlled systems to change the scenes at specific times of the day.
Time-Controlled Systems	Time-controlled systems use clocks to adjust the lighting systems by programming a schedule for the presets to change or turn on and off. The range and scale of options are broad. They can control a single room with an individual clock or an entire building with an electronic management system.
Occupancy Sensors	Occupancy sensors control the light by detecting occupants in a room. Passive infrared or ultrasound sensors are mounted to walls or ceilings, depending on the size of the room. Small rooms such as a bathroom will typically use a wallbox sensor with a combined on/off switch or dimmer. For large spaces, multiple overhead sensors work best. Most sensors can be adjusted for sensitivity to accommodate a particular space.
Daylight Sensors	Daylight sensors detect the amount of light entering a room and adjust the artificial lights when there is sufficient natural light. This can be significant for rooms that face south and receive a consistent amount of light throughout the day.
Lumen-Maintenance Controls	Lumen-maintenance controls maintain the lux level in a space by adjusting the brightness of a new lamp and the dullness of an old lamp and balancing them against the desired level through photoelectric sensors. These systems require dimming ballasts in all fixtures and a control system to adjust the output of lamps. Only recently have lumen-maintenance controls become affordable solutions for general use.

PLUMBING SYSTEMS

Plumbing systems *deliver water to and extract wastewater and sewage from a building*. These systems are designed by engineers, but must be understood by designers to know when locating or moving a fixture is reasonable or not.

Water is supplied by pressure through vertical pipes, called *risers*, to bathrooms and kitchens or wherever water is needed. These pipes are small in diameter and can go unnoticed within the thickness of a standard stud wall. The riser connects to a horizontal pipe that then connects to a fixture.

The more challenging counterpart is the drain, which uses gravity to mobilize waste down to the sewer connection. Drainpipes always travel downhill at a slope that is regulated by the building code for different fixtures. The vertical drain that carries wastewater from sinks and baths is referred to as the waste stack; its diameter is small enough to fit within a typical stud wall. The drain that connects to toilets is called a soil stack; it is twice as large in diameter and does not fit within a standard wall construction. Both the waste and soil stack must rise vertically through a building to the roof for proper ventilation.

Each plumbing fixture has an S-shaped pipe, called a trap, that prevents the water from draining or rising. The trap also prevents odors in the drainpipe from entering the room. Since every drainpipe must travel up and down, it is difficult to change the location of a plumbing fixture without affecting the spaces below and above.

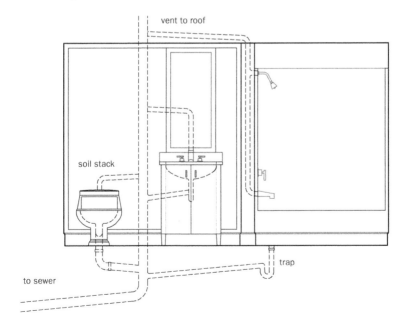

vent to roof

soil stack

trap

to sewer

PERSPECTIVES ON ENVIRONMENTS:
YABU PUSHELBERG

George Yabu and Glenn Pushelberg, describe Yabu Pushelberg and what you do.

We are an interior design practice specializing in two areas: retail shops and hotels. We have offices in Toronto and New York. We're looking to work with clients that are at the top of their game. We are not interested in the middle or the mass market, but if there is a client that's looking to achieve something as a vision, we work with them to achieve that vision.

We are always striving to become better at what we do. We have meetings with all of our team design leaders to decide what our goals are: How do we become better designers? How do we train our junior designers better? How do we find better clients? These are all aspirational goals—not to become bigger, but to become better. That is more important to us. We are also interested and curious always to try new things, to work in new areas of the world, to hone what we do but not have a singular style. Our process is about experimentation and moving our ideas around.

Your work ranges from furniture to hospitality to corporate interior spaces. Is there an underlying methodology that you bring to every project?

You look for your inspiration or your starting point. That could be meeting a new client, going to a new place, understanding a new program, understanding the context of where you are working, or the vision of your client or the architecture that you are working within.

These are the points where you start your research and begin to develop a conceptual program. For instance, we are working on the new Mandarin Oriental Hotel in Mumbai. We're obviously inspired by the depth and breadth of Indian cultures; we're inspired by the notion of the craft and art of India. We're also motivated by the vision of a young entrepreneur who wants to become the best hotelier in Mumbai and wants to attract both the Bollywood crowd—that established wealthy Indian crowd—and an international clientele. Within that, what does it mean to take an old luxury company like Mandarin Oriental and move it forward into something that's new but still appropriate?

We sift through all that information, distill it, and start to develop a visual language that is new and appropriate for a particular project. It's not a singular straightforward methodology, but one based on gathering mental and visual information, distilling it, and then twisting it so that it's new again. It is important that the work doesn't become stylistic, which is a really easy trap that designs can fall into. We aren't interested in that. We're not interested in being followers.

This section of the book focuses on aspects of interior design that appear at first to be secondary to the making of space, but actually are integral to understanding and experiencing design. How do you approach these issues in your practice?

We think that aspects of sound, light, and movement are extremely interesting. In the Amore-Pacific spa we did in Soho, we used behavioral software together with projected imagery that is keyed by movement. We project a scene of cherry blossoms falling in the wind, and as you come closer, the cherry blossoms follow you or images appear on the screen as you get closer to it. So, using one's senses and using technology in soft ways, done effectively, creates a more emotionally dynamic interior.

In designing restaurants, bars, or hotels, for us, the success of the interior comes not from one bombastic idea, but from a collection of parts that creates an emotional response: how you use light in a more painterly way; how you use technology in a soft way; what you hear in a space, the acoustics of a space, all of these things reinforce this notion. Sound is a bit trickier, but in some cases, it can also be used effectively.

How has this idea of soft technology changed the way you practice interior design, from when you started till now?

Right now we're using art in many of our installations because it automatically gives us a starting point in our interiors. We're commissioning art pieces, such as kinetic and video art, that use technology to customize a response to the person who is occupying the space. The actual viewing of art in interiors is the first stage; the next stage is experiencing the art.

We're also really starting to use technology as a tool for designing. We've recently used more graphic-oriented processes to create more complex patterns, not only for things like carpets, but also for building façades. We're doing a project for a grand hotel—you think of a traditional grand lobby with a big, high ceiling space, but with computers, you can conceive of more interesting volumes that are less expected.

It's a double-edged sword. There are times when you need to use technology to create things; there's a quality to it that is very modern and works well in some situations. But in other situations, we are against this process. We have a project where we wanted solid stone tubs, so we found stone carvers in India to handmake the tubs—there's a quality that comes from cutting the stone by hand. Whether we are doing a jewelry store for David Yurman, which is kind like of walking into a big sculpture, or a green hotel in Seattle, our work is moving toward creating a space that is more artistic and more sculptural in nature, and a little less rational, but that still solves the pragmatic issues. So, with technology, it really is a back-and-forth process.

How has lighting technology changed the way you present interiors? Is there more theatricality, or has the technology allowed for more subtle installations?

There is more energy conservation today, and it does have an impact on how we light our spaces. We choose to light our surfaces more judiciously and we try to avoid stray light as much as possible. The resulting effect is actually quite interesting. It's more like that Old World painting technique, chiaroscuro, where you have very intense areas of light and you contrast it with very little or no light. Your eye adjusts to it, so you believe that there is a higher level of intensity. In fact, you've dramatically reduced your energy consumption without a sense that your lighting has been compromised.

The toughest constraint on energy consumption and lighting is in retail, of course. But technology is moving so quickly. Light-emitting diode (LED) technology is really a savior in our industry, especially when you can have such a strong range of color temperatures now. There are interesting things happening in lighting that we are in some ways forced to do, but in the end, they are really good for design.

How do you approach issues of design that may not be visual ones? When you are designing an interior, do you think about ambiance?

First you start with the proportions of the space: How does that make you feel? Is it some- thing that is high and soaring? Or narrow? That makes you feel one way. Or are you coming from a space that is dark and moody and then you enter into light? Or do you have the sound of water around your feet? Certainly, there is this notion of the sensuality of the space. How you respond emotionally to the space is actually dealing with the temperature. How you feel about the space is visual. You use all these devices—whether the height or proportion of the space, the tactile nature of the materials, how the space is lit, and how you transition from space to space—all of these parts make the whole.

Do you design with music in your mind? Do you have a soundtrack to the spaces that you create?

It's less about music and more about the acoustic quality of the space. We are cognizant of acoustics a lot, especially in hospitality and public spaces. Can you have a decent conversa- tion? It's also having all of your senses working together. You can influence the way people respond to a space by the space itself. When you walk down a corridor in a good hotel, if the lighting is right and the materials are softer, your voice drops lower. If it's something that is high and grand and hollow, your voice gets bigger and the noise in your walk gets bigger. That is like music, as you move through different spaces and change them. There are rhythms in how they change, but it's not really connected—it's isolated.

Can you think of two or three recent projects that have inspired or impressed you?

There's a lovely hotel in São Paulo called Fasano. The restaurant is very grand, very formal, minimal, but very beautiful in its simplicity. You think the room has been there for a long time, it almost feels like it's from the 1960s, but it doesn't reference the decade in a direct way. All of the parts work to create the whole again. We're much more interested in that than in all this bombastic throwaway design that exists today.

The new Apple Store in New York, the entrance on Fifth Avenue. The glass box of the entrance on General Motors Plaza is so rigorous and rational. You can appreciate how it's very finely detailed in its simplicity.

A third project would be Tawaraya in Kyoto, the ultimate classic Japanese inn. We first went there twenty years ago. Every room has a view of a private garden. There's an order based on the proportion and number of tatami mats in relation to the garden, and the room converts from a bedroom to a dining room to a sitting room—it magically changes. The bath tub is crafted out of wood and it's always full of hot water for soaking. When you step over the threshold from the street into the hotel itself, there is this beautiful long rock, two meters wide, and it announces that you are stepping into another world, backward in time. It's a beautiful experience.

Overleaf Top Left Four Seasons New York Downtown. Photo by Scott Frances.
 Bottom Left Le Meridien Graves Hotel. Photo by David Joseph.
 Right Public Chicago. Photo by Nikolas Koenig.

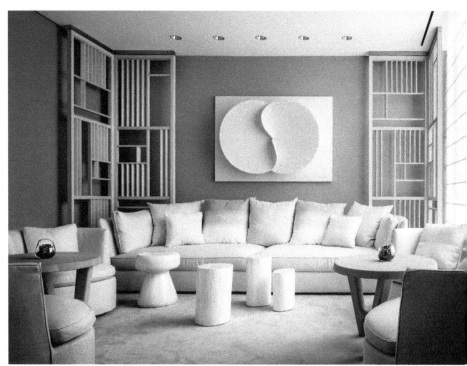

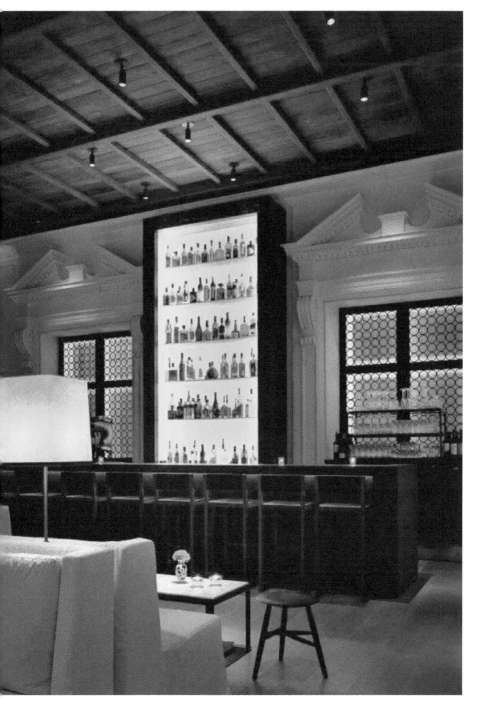

5.

ELEMENTS

The components of an interior environment fall into two categories: fixed elements—such as walls, moldings, light fixtures, and built-in cabinetry—and moveable elements—such as furniture, artwork, and the knickknacks and ephemera that are evidence of everyday life. Significantly, the selection of moveable objects requires a close collaboration between the interior designer and client. Small items play a disproportionately large role in suggesting the interests and tastes of their owners. Artwork and souvenirs can also have very personal associations. As a result, interior designers often serve as teachers, by contextualizing both the taste of their clients and the objects they own into a larger vision for an interior. A good interior designer will empower clients to make their own smart curatorial decisions long after the project is finished.

Chapter 16: Details

Key to the successful combination of materials, colors, textures, and patterns is how the elements of an interior are detailed. While detailing will vary from project to project, there are typical details with which every designer should be familiar.

WALLS

Fire-Rated Wall Assemblies

*standard metric equivalence

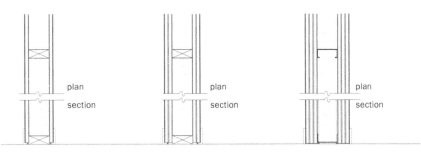

1-Hour-Rated Assembly

1 layer ⁵/₈" (16) gypsum wall board (GWB) on each side of 2" × 4" (38 × 99)* studs @ 16" (400)* on center (OC). Acoustic sealant top and bottom.

2-Hour-Rated Assembly

2 layers ⁵/₈" (16) GWB each side of 2" × 4" (38 × 99) studs @ 16" (400) OC. Acoustic sealant top and bottom.

3-Hour-Rated Assembly

3 layers ⁵/₈" (16) GWB each side of 2" × 4" (38 × 99) studs @ 16" (400) OC. Acoustic sealant top and bottom.

STC-Rated Partitions

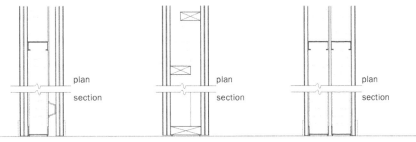

STC 40–47

2 layers ⁵/₈" (16) GWB each side of 2" × 4" (38 × 99) studs @ 16" (400) OC. Furring channel one side. Acoustic sealant top and bottom.

STC 50–54

2 layers ⁵/₈" (16) GWB each side of 2" × 4" (38 × 99) studs @ 16" (400) OC. Studs staggered to create air pocket. Acoustic sealant top and bottom.

STC 56–61

1 layer ⁵/₈" (16) GWB each side of 2—2" × 4" (38 × 99) studs @ 16" (400) OC. Studs nominally separated. Acoustic sealant top and bottom.

Partitions over Existing Walls

Direct to Structure

Furring channel @ 16" (400).
1 layer $^5/_8$" (16) GWB.

Structure with Mechanical

1 layer $^5/_8$" (16) GWB one side
of 2" × 4" (38 × 99) studs @ 16"
(400) OC. Tie back to wall with
metal clips.

Corner Bead

J-Mold

Shadowline J-Mold

Control Joint

Reveal Mold

Corner Conditions

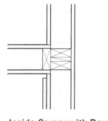

**Inside Corner with Reveal
One Side**

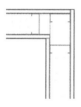

Typical Outside Corner

Base Conditions

**Low- and High-Profile
Reveals**

| **Recessed Poured Base** | **Recessed Wood Base** |

| **Direct Applied Vinyl** | **Direct Applied Wood** |

CABINETS

Typical Base and Upper Cabinet

Typical Counter Edges

upper cabinets

adjustable shelves on
recessed standards

cabinet pulls

blocking

integrated backsplash

laminated bullnose
countertop

lower drawer on
metal glides

door with pulls

adjustable shelves on
recessed standards

blocking

base

30" (762)

18" (457)

36" (914)

Square or Standard Edge

Beveled Edge
(dimensions vary)

Demibullnose or
Half-Round Edge

Full Bullnose Edge

Built-Up Bullnose Edge

Joinery Types

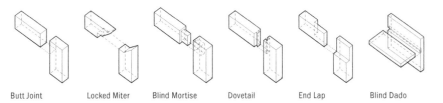

Butt Joint Locked Miter Blind Mortise Dovetail End Lap Blind Dado

Typical Desk with Transaction Top

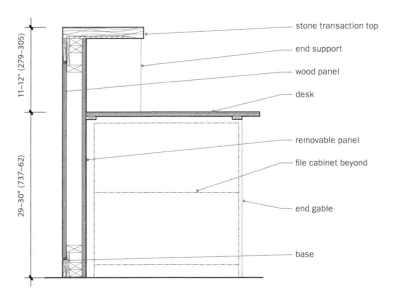

11–12" (279–305)

29–30" (737–62)

stone transaction top

end support

wood panel

desk

removable panel

file cabinet beyond

end gable

base

CEILINGS

Ceiling Assemblies

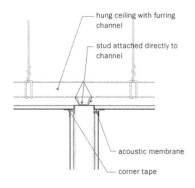

Wall to Underside of Ceiling

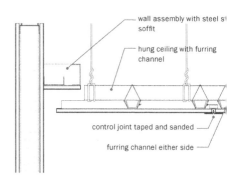

Return-Air Slot Control Joint

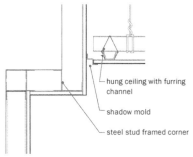

GWB Soffit

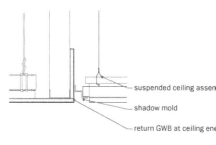

GWB to Suspended Ceiling

Lights at Ceilings

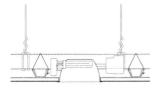

Compact Recessed Fixture

Fluorescent Fixture

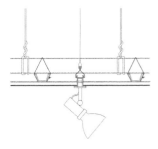

Recessed Track Lighting

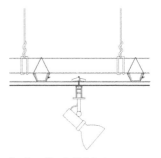

Surface Track Lighting

Cove Uplighting

Cove Accent Lighting

DOORS AND HARDWARE

Door Types

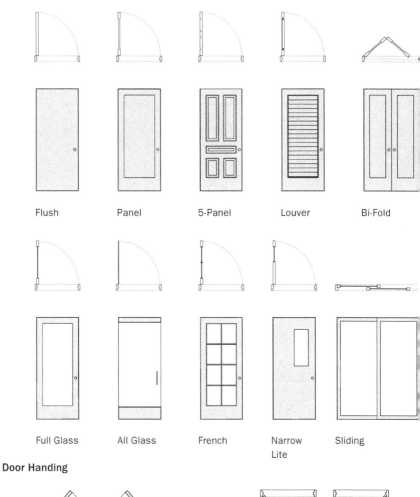

Flush | Panel | 5-Panel | Louver | Bi-Fold

Full Glass | All Glass | French | Narrow Lite | Sliding

Door Handing

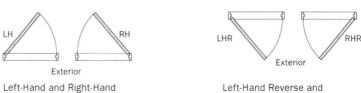

Left-Hand and Right-Hand

Left-Hand Reverse and Right-Hand Reverse

Butt Hinges

A plain bearing butt hinge is the most common hinge used to hang a door.

Butt Hinge

This hinge negotiates varying floor levels by allowing the door to lift.

Self-Rising Hinge

This hinge should be specified for heavy doors, doors with closers, or doors in high-traffic areas.

Ball-Bearing Hinge

This specialty hinge is invisible when the door is closed and can open 180 degrees.

Invisible Hinge

Pivot Hinges

This hinge offsets the pivot point away from the door jamb and allows the door to swing 180 degrees.

Offset Pivot Hinge

This hinge is centered on the pivot point and, in the absence of a door stop, allows the door to swing in two directions.

Center Pivot Hinge

FLOORING PATTERNS AND TRANSITIONS

Patterns

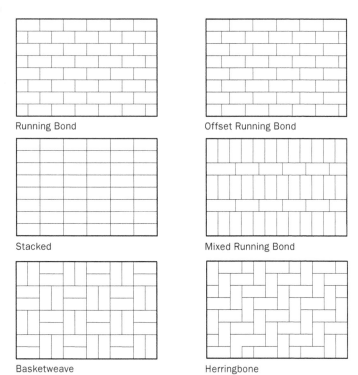

Running Bond

Offset Running Bond

Stacked

Mixed Running Bond

Basketweave

Herringbone

STANDARD DIMENSIONS FOR FLOORING MATERIAL

Flooring	Thickness	Standard Sizes
Stone Tile	$^3/_8$", $^5/_8$" (9.5,15.8)	12" × 12", 16" × 16", 18" × 18" (305 × 305, 406 × 406, 457 × 457)
Stone	$^3/_4$", $1^1/_4$" (19, 31.7)	24" × 24" (609 × 609), custom
Porcelain Tile	$^3/_8$" (9.5)	12" × 12", 12" × 24", 18" × 18", 24" × 24" (305 × 305, 305 × 609, 457 × 457, 609
Ceramic Tile	$^5/_{16}$", $^3/_8$" (8, 9.5)	1" × 1", 2" × 2", 4" × 4", 6" × 6", 12" × 12" (25 × 25, 50 × 50, 101 × 101, 305 × 305)
Solid Wood	$^5/_{16}$", $^1/_2$", $^3/_4$" (8, 12.7, 19)	2 $^1/_4$", 3", 4" (57, 76, 101) board width
Engineered Wood	$^1/_2$" (12.7)	3", 4 $^1/_2$" (76, 114) board width
Cork	$^3/_{16}$", $^3/_8$" (5, 9.5)	12" × 12", 12" × 24", 24" × 24" (305 × 305, 305 × 609, 609 × 609)
Vinyl Composite Tile	$^1/_8$" (3)	12" × 12" (305 × 305)

Transitions

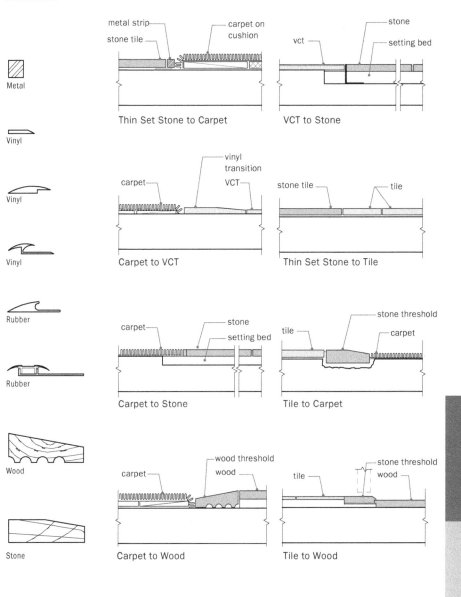

Metal

Vinyl

Vinyl

Vinyl

Rubber

Rubber

Wood

Stone

Thin Set Stone to Carpet

metal strip
stone tile
carpet on cushion

VCT to Stone

vct
stone
setting bed

Carpet to VCT

carpet
vinyl transition
VCT

Thin Set Stone to Tile

stone tile
tile

Carpet to Stone

carpet
stone
setting bed

Tile to Carpet

tile
stone threshold
carpet

Carpet to Wood

carpet
wood threshold
wood

Tile to Wood

tile
stone threshold
wood

UPHOLSTERY SEAMS AND WINDOW TREATMENTS

Upholstery Seams

Plain Seam: Simplest way to sew two pieces of fabric together.

Topstitch: Additional line of stitching that goes through three layers of fabric. The strongest seam.

French Seam: Two additional lines of stitching on either side of a plain seam. Often considered the most beautiful seam.

Welt: Round piping edge detail that hides the plain seam.

Topstitched Welt: Additional line of stitching adjacent to a welt.

Shades

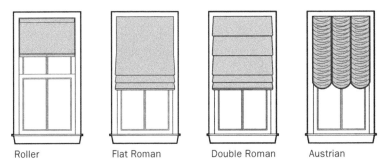

Roller Flat Roman Double Roman Austrian

Drapes

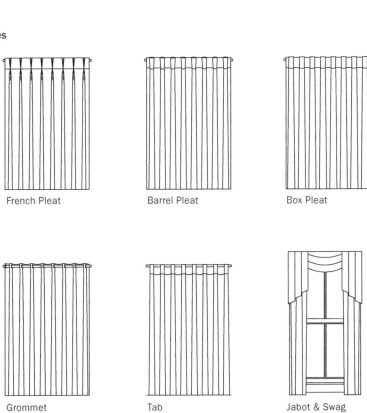

French Pleat Barrel Pleat Box Pleat

Grommet Tab Jabot & Swag

Chapter 17: Furniture

Knowledge of furniture and the role it has played historically in the development of the interior design profession is an integral part of the designer's toolkit. While the following pages illustrate canonic furniture that is decidedly modernist, they offer a good foundation for further research and exploration.

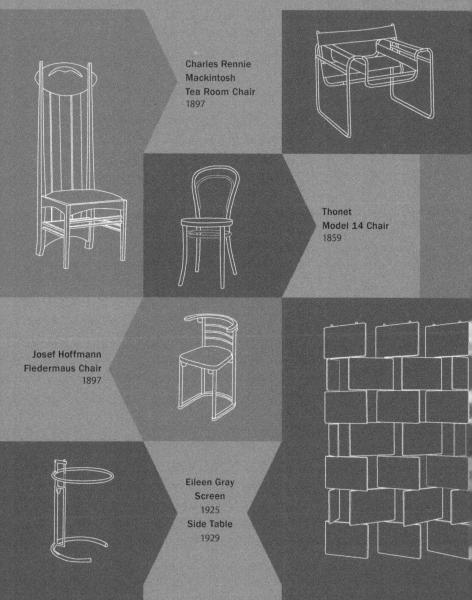

Charles Rennie
Mackintosh
Tea Room Chair
1897

Thonet
Model 14 Chair
1859

Josef Hoffmann
Fledermaus Chair
1897

Eileen Gray
Screen
1925
Side Table
1929

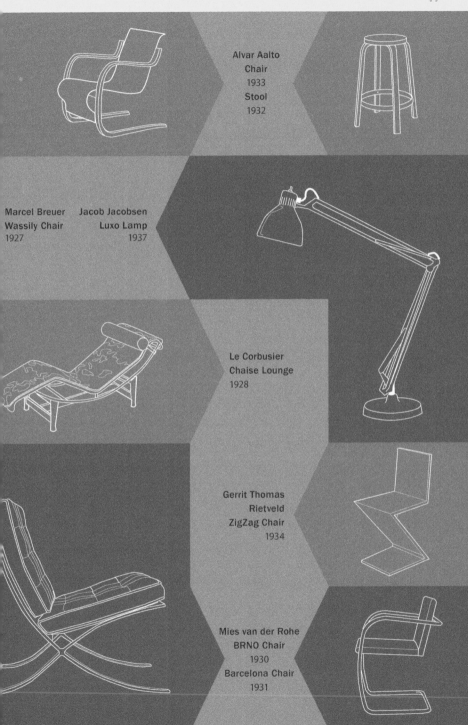

Alvar Aalto
Chair
1933
Stool
1932

Marcel Breuer Jacob Jacobsen
Wassily Chair Luxo Lamp
1927 1937

Le Corbusier
Chaise Lounge
1928

Gerrit Thomas
Rietveld
ZigZag Chair
1934

Mies van der Rohe
BRNO Chair
1930
Barcelona Chair
1931

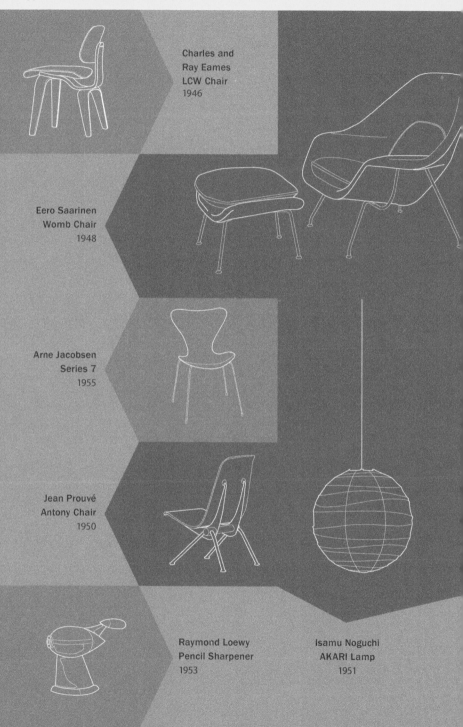

Charles and
Ray Eames
LCW Chair
1946

Eero Saarinen
Womb Chair
1948

Arne Jacobsen
Series 7
1955

Jean Prouvé
Antony Chair
1950

Raymond Loewy
Pencil Sharpener
1953

Isamu Noguchi
AKARI Lamp
1951

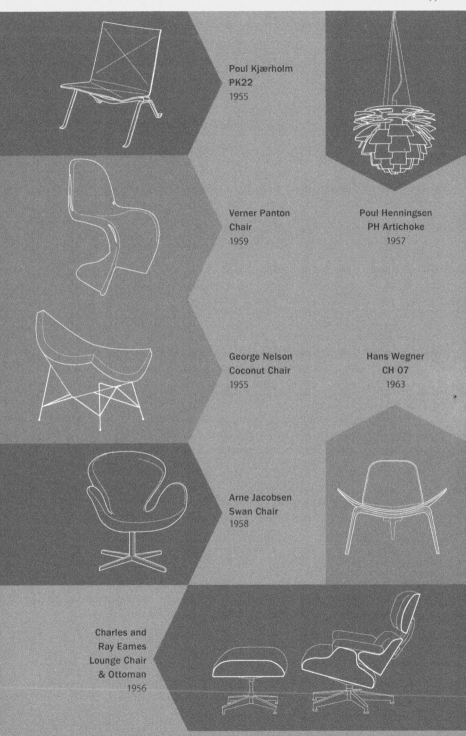

Poul Kjærholm
PK22
1955

Poul Henningsen
PH Artichoke
1957

Verner Panton
Chair
1959

George Nelson
Coconut Chair
1955

Hans Wegner
CH 07
1963

Arne Jacobsen
Swan Chair
1958

Charles and
Ray Eames
Lounge Chair
& Ottoman
1956

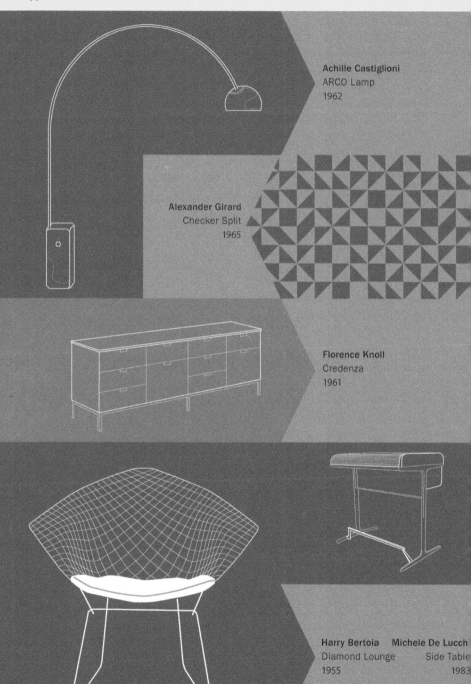

Achille Castiglioni
ARCO Lamp
1962

Alexander Girard
Checker Split
1965

Florence Knoll
Credenza
1961

Harry Bertoia
Diamond Lounge
1955

Michele De Lucch
Side Table
1983

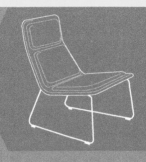

Jasper Morrison
Low Pad
1999

Droog Design
85 Lamp Chandelier
1993

Ron Arad
Tom Vac Chair
1997

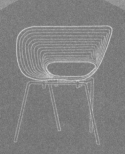

Joe Colombo
Boby Trolley
1970

Bill Stumpf
Aeron Chair
1992

George Nelson
Action Office
1964

Patricia Urquiola
Antibodi
2006

Chapter 18: Elements and Display

Accessories are items smaller than furniture that make up the visual field of an interior. Categories of accessories include functional items, such as wall clocks, umbrella stands, and magazine racks; items that have personal sentimental value, such as souvenirs and family photographs; and objects with specific aesthetic merit, such as collections and artwork. Fundamental to the idea of accessories in an interior is that they are worthy of display rather than being stored in a closed cabinet, drawer, or closet.

Accessories play two important roles in interior design: First, they introduce a smaller scale of elements within a comprehensive design strategy. Second, they personalize a space since accessories can convey individual interests, sentimental attachments, or a specific aesthetic taste.

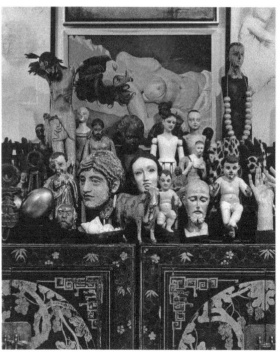

William Frawley, Frawley Apartment. Photo by Michael Moran.

Collections that are grouped produce a visually pleasing composition. The significance of an individual object is less important than the density of many objects.

FUNCTIONAL ACCESSORIES

Functional accessories comprise items that serve a need of the occupant of the space and range from bathroom towels to wastepaper baskets to television sets. Functional accessories can have aesthetic value, which a good designer can incorporate into the design of an interior. Kitchen pots and pans, for instance, can be transformed into accessories if they are displayed on an overhead rack or on custom-designed shelves. The designer has made a conscious decision to treat the pots as objects worthy of contributing to the overall composition. This choice could be inspired by the clients' desire to communicate their love of cooking as much as the wish to add character to the kitchen through small-scale objects. Books are another example of an everyday object that can be elevated to the role of an accessory, either collected on open shelves lining a library or as a single volume displayed among objects on a coffee table.

DECORATIVE ACCESSORIES

Decorative accessories include collections of objects, memorabilia, family photographs, cut flowers, and plants. Accessories of this type can serve a purely aesthetic role or can function as a personal expression of the owners' interests and passions. This category of accessories is best grouped and composed with an eye to larger compositional issues of scale and balance.

A collage of different types of objects can be equally effective as a collection of similar objects. More important is the contrast between surfaces where collections are displayed and surfaces that remain unadorned.

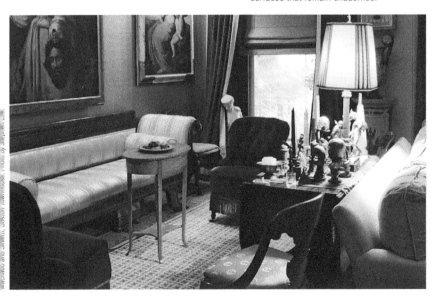

ARTWORK

Larger works of art with high value, aesthetic merit, and/or deep personal meaning are typically displayed as focal points in a room and sometimes might drive other aspects of the design. Lesser artwork is typically displayed in compositions—whether as a still-life arrangement on a table or in a mosaic of pictures on a wall. In this case, the artfulness of the combination can create its own aesthetic pleasure. Pictures can be hung directly on a wall with a picture hook; or, to allow for a changing display, a picture rail or shallow ledge can be incorporated in the room's design. Tackable wall surfaces might also be considered for displaying more informal graphic ephemera and children's art. Similar in spirit are chalkboard or dry-erase whiteboard surfaces to encourage spontaneous self-expression.

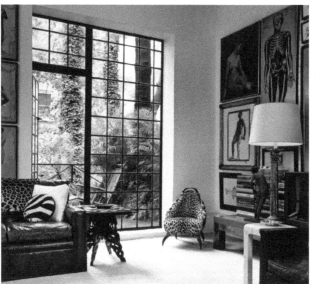

Frawley Apartment. Photo by Michael Moran.

A composition of drawings and paintings on a wall provides visual interest and takes the pressure off an individual work of art.

PLACES FOR DISPLAY

Since accessories and most works of art are relatively small elements within an environment, they tend to be grounded in larger arrangements of objects and in specific places. An assemblage of objects or pictures can create its own visual identity by virtue of the cohesion resulting from the close adjacency and similarities or differences among objects. There are two common strategies of arrangement. Collections are displays of like objects, such as antique mechanical toys, arrowheads, or prints of natural history phenomena. Still lifes are displays organized purely for aesthetic effect, typically through the juxtaposition of disparate objects that share one or several attributes. For example, a still life might combine green objects, but with a range of textures from rough to shiny and a range of proportions from tall to low and horizontal.

Both collections and still lifes require a setting for display. Cabinets with open shelves, floating shelves on walls, fireplace mantles, and built-in niches are all examples of surfaces specifically designed for the display of decorative objects. Side tables and coffee tables also accommodate displays, along with drinks and hors d'oeuvres or the daily newspaper.

MINIMAL VERSUS CLUTTERED

Tastes for the appropriate amount of accessories in a room can vary dramatically. Design aesthetics range from the starkly minimal, with a few carefully selected accessories, to the highly cluttered interiors of the Victorian era—as well as the Eames House in Southern California. The relative density of accessories can also create character across a sequence of spaces; for example, moving from austerity in formal spaces to coziness in more private rooms. In general, the most successful interiors avoid the conventionality of the middle ground, but aim rather toward a carefully edited minimalism or the excess of a thoughtful curator.

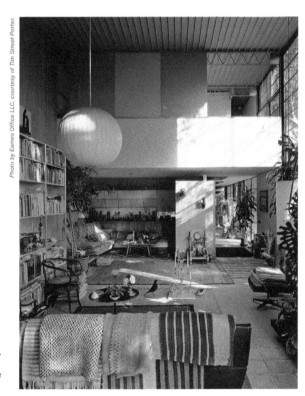

Photo by Eames Office LLC, courtesy of Tim Street-Porter.

Collections are never complete, they simply evolve, as seen in Charles and Ray Eames's home in Pacific Palisades.

Calvin Tsao, describe yourself and your practice.

As architects, we have an interest in bridging different design disciplines. We have a profound interest in approaching our work comprehensively, "total design" if you will; our work as interior designers should be understood in this context. We are interested in mapping out human behavior for different social conditions. We look at the world from a larger perspective while advancing an aesthetic; you simply cannot do one without the other.

Do you have a particular approach to placing furniture in a space?

Ultimately, we look at furniture anthropomorphically and therefore functionally because furniture is conducive to varying activities. However, I like looking at interior environments less as a collection of things in a room than as an intersection. Why draw the line between built-in furniture, loose furniture, and architecture? Some furniture is already placed because it is built-in and loose furniture is simply an extension of the whole reality. The envelope creates the space, and the surface can be altered to make niches, cantilevers, extensions, etc.; sometimes the surface becomes a table or a four-poster bed. I prefer to blur the boundaries of architecture, built-in furniture, and loose furniture.

What is your favorite type of space to design/furnish?

I love small, tiny spaces. As a child, I liked to make tents out of my sheets in bed and under the stairs. It's a very basic impulse and the next line of defense beyond clothing.

Small spaces lack the bravura of large spaces, and therefore spaciousness isn't the primary character. Modest space must be carefully orchestrated and tactility is an essential quality. Because the distance between the eye and an object is different in smaller spaces, you look closer; you touch more. I like the involvement of the senses when surfaces are closer.

Does your work have a particular style that you can define?

Style? An approach more than a style, really. It depends how you want to define the word style. One can have a developed taste, but style can be limiting.

Who are the most influential furniture designers of the nineteenth, twentieth, and twenty-first centuries?

In the nineteenth century, the Viennese designers, most notably Biedermeier, were addressing the social preoccupations of the rising middle class, who attempted to emulate the nobility. In contrast, Christopher Dresser, who foreshadowed modernism, was designing objects with a simple modern aesthetic that had a different, almost Asian, cultural sensibility. His designs open the way for people like Mackintosh. Simultaneously, the Herter Brothers were producing exquisitely crafted interior furnishings. Their work influenced the nuances of the language through craft. What is most notable about the nineteenth century is the parallel development of cultural assimilations and the forging of an aesthetic movement.

The twentieth century is complex in that you have Mackintosh and Fortuny advancing aesthetics through symbolism that partly explored psychosexual qualities in furnishings. On the flip side were Le Corbusier, Perriand, and Loos defining a new aesthetic via their romance with the machine age. Then there were Henry Dreyfus and Raymond Loewy, taking cues from the Corbusian romance with industry and incorporating that aesthetic into their designs. Simultaneously, Emile-Jacques Ruhlmann and Jean-Michel Franc were designing simple forms veneered in exotic finishes and patterns. Also, George Nelson, George Nakashima, and Vladimir Kagan were inspired by history but took it to a different place. Noguchi transcended the idea of pure craft and created functional art objects. Of course, one has to include Wright and the Eames.

The twenty-first century continues with designers like Marc Newson and Ronan and Erwan Bouroullec, as well as Marcel Wanders and other Dutch conceptual designers who make up the Droog Collective. There is also the Spanish designer Patricia Urquiola, who burst on the scene about five years ago. Ultimately, what I find most interesting about furniture design is that it remains an everyday design problem with a populist tradition serving a multitude of worlds and realities. The field continues to be diverse and exciting by being geographically specific in its influences.

Of these designers, who inspires you the most?

All of them. It is the multitude that gives you the confidence that you have to find your own vision. We embrace a nonegocentric approach, but believing in the self as it serves the world in a way that you desire to participate. We are like shaman; aesthetic chanellers of how people like to live.

What else (or who else) do you look at for inspiration?

In the end, nature is amazing: A hermit crab or the patterns of a leaf, there is nothing unnecessary in natural phenomena. Whether it is camouflage color or color to attract for procreation, it's all necessary.

I am also greatly inspired by movement and dance. My early training as a dancer and in the theater has influenced my awareness of movement. Dance has helped me understand the human interaction with a physical environment. I am deeply interested in mapping those impulses as part of daily life, even beyond walking and running. I am sensitive to left-handed and right-handed impulses. It is important to consider how one should open a door—should it swing out or in?

I am particularly fascinated with the eighteenth century. They created furniture based on the idea of movement, from straddling a chair to sitting low in front of a *boudoir*. The clothing of the time informed the furniture, the furniture informed the architecture, and the architecture informed the social politics of a situation—imagine the drama of a suite of *enfilade* rooms. Lastly, I am influenced by art and artists. Since artists are the most advanced prophets, I look to them not to copy but because they show the way.

When do think it is appropriate to use custom-designed furniture?

Custom furniture should not be revolutionary, but rather custom fit for a particular space. It should not be about inventing something new for the sake of novelty. I prefer to make the analogy to Savile Row; make a perfect suit to custom fit a person. When we design custom furniture, we aim to make the perfect chair to fit the space perfectly.

Who do you think is making well-designed mass-produced furniture?

Ikea is pretty damn good. They work with young talented designers and there is a clear agenda to promote affordable good design. In contrast, Target is mining well-known designers that they convert to brand names to promote more sales.

What are your top three resources for purchasing "one-of-a-kind" pieces of furniture?

1stdibs.com—A lot of dealers use this website for selling their treasures. It is essentially a web-catalogue, not unlike Ebay but for designers. If you're a dealer, you have to go to shows and it is costly. Some or all of the inventory on the website leads to a specific seller's website, making it a great way to connect to dealers as well as objects. However, I still feel weird about buying things without seeing and touching them. There's something about the human eye and body interaction that gives you a better sense of whether it is going to be the right piece.

Flea Markets—I still believe that everyone should travel and get up to speed on where the local flea markets are held. Some of my favorites are the first Sunday of the month in Arezzo, Italy; Portobello Road in London; Marche Paul Bert and Marche Serpette, both in Paris; in Brimfield, Massachusetts; and Pan Jia Yuan in Beijing. What I like most is that they are not edited. You don't know what you're going to find, but sometimes you can find unique items. Once I found a fabulous big chunk of wood—something I certainly wasn't shopping for. Only flea markets provide these wonderful kinds of revelations.

R 20th Century—Lastly, when looking for modern furniture, R 20th Century in New York is a great source. The owners are constantly looking. Right now they are focusing on the Brazil-

ians. Whether I buy or not, I always go there to see what they're looking at; it's a great place to train the eye. Good furniture dealers are almost like tutors, with their great eye they pick up new things. What's both fascinating and difficult about this market is that dealers are forced to move onto the next area of exploration as they price themselves out of the current trends. As a result, it is a constantly evolving market.

Does your design or project approach differ for a residential client versus a corporate or institutional client?

Yes and no. Because so much time is spent in the workplace, it is important to navigate with ease even though the concerns are totally different from those of a residence. The goal of office design is also to enhance living. I often ask, how residential can I make a corporate environment?

With corporate or institutional clients, I try to draw out the humanity. You can't serve anyone if you stay on the surface. If you treat them as entities, it's difficult to serve them. The human dynamic can be a pain or it can be wonderful; but in the end, if you can appeal to the human condition, better design is achievable.

How do you integrate an existing piece of furniture that a client may have and that you do not particularly like?

With each client, I try not to be static in my approach to design or to the design process itself. Because they have engaged me as an architect and designer, I assume that our clients want to evolve—that they want new space, furniture, art, accessories, etc. At the same time, if they have had a piece for a long time and are happy with it and not ready to let go of it, who am I to tell them that they must? That approach is right out of those marvelous Jacques Tati films, where the government authority adopts modern design as law and dictates that its citizens have to change the way they live in order to conform. It's brilliant satire, but I prefer not to play politics in that way, and I believe that to command clients or to try to persuade them on purely theoretical or intellectual grounds is fundamentally not good practice.

My role is to serve our clients as individuals, so my first task is to inquire about and understand how they live. Then, I continue by informing them about the furnishings and objects they already have, and whether I like or dislike them shouldn't really factor into the discussion. Finally, the most important and helpful thing I can do is to inspire them and to advise them as to what can be. Fully informed and aware—not just of the realities of the past but also of the possibilities of the future—clients might then realize, perhaps even to their surprise, that they are ready to discard existing design and to embrace new design. In this approach, everyone learns, everyone grows, and everyone is pleased with the design outcome. I evolve as a designer by gaining a deeper understanding of the spirit of each individual client. And our clients evolve, too, by gaining the experience and confidence they need to make informed and thoughtful decisions.

Overleaf	Left	Living Room by Octave. Photo by Seth Powers.
	Top Right	Berkshire Mountain House. Photo by Eric Laignel.
	Bottom Right	Pound Ridge Residence. Photo by Simon Upton.

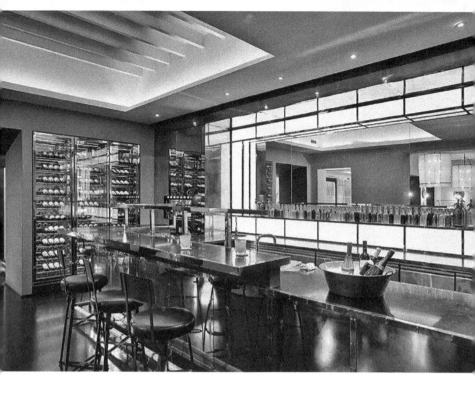

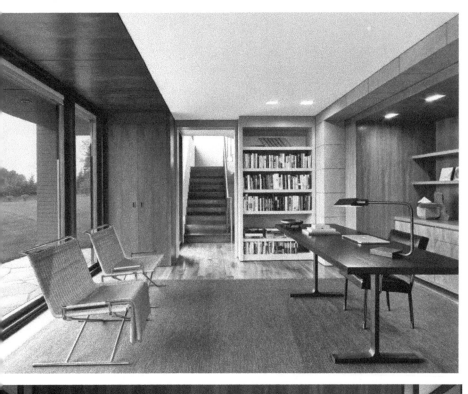

6.

RESOURCES

Every interior designer needs to build a library of publications that cover in greater detail the range of topics addressed in this volume. Included here are resources that would be indispensable additions to any collection. Of course, with the Internet and search engines, the number of resources available to interior designers has increased exponentially. Like any other subject, however, the quality of digital information is only as good as the content-provider for the website. The web links recommended here span the gamut from professional and nonprofit organizations to software companies and product manufacturers to the best and most provocative design magazines and blogs. Each, in turn, will provide their own interesting leads.

The ethical responsibility of the designer underlies all recommendations in this book. Foremost is the imperative to design for a more equitable and sustainable future. Beyond happily shopping for products and services, it is up to the design industry to generate the resources and ideas that make each project an opportunity to consider the impact of design choices on society and the environment.

Chapter 19: Sustainability Guidelines

Sustainable design is a holistic approach that combines the thoughtful selection of renewable and recycled materials and energy-conserving building systems and appliances with design choices that result in the healthiest possible environment for the occupants. Not only does such an approach allow the designer to reduce environmental impacts, it can also lower operating costs and create interiors that foster higher productivity and overall well-being.

Given the myriad issues that fall under the green agenda, benchmarking systems and checklists are often used to identify potential strategies and to track them during the design process. The most popular benchmarking system in the United States is LEED (Leadership in Energy and Environmental Design), developed by the U.S. Green Building Council, a nonprofit organization dedicated to the promotion of sustainable building. The LEED point system is organized into five content categories, four of which are of particular relevance to interior designers: water efficiency, energy and atmosphere, materials and resources, and indoor environmental quality.

| WATER | ENERGY | MATERIALS | INDOOR AIR QUALITY |

RESOURCE CONSERVATION

One way that sustainable design is mindful of the environment is by *designing and furnishing buildings to reduce water and energy consumption*. Low-flow toilets and low-pressure shower heads can be specified to reduce water demand. Tankless water heaters that instantly supply hot water eliminate the need to store heated water or to run the water until the desired temperature is achieved.

Electric demand can be reduced with the use of dimmers, occupancy sensors, and fluorescent and low-voltage lighting. Lights in small spaces like closets and pantries should turn off automatically when the door is closed. Electric loads can be further minimized if the lighting is zoned and designed to be task-specific; for instance, lighting the surface over a kitchen work counter is more efficient than illuminating the entire room. In addition, designers should always specify *Energy Star–rated appliances* or those with equivalent high performance standards.

PRACTICAL IDEAS FOR REDUCING ENERGY CONSUMPTION

Use multilamp or electronic fluorescent ballasts whenever possible.

Separate switches to allow flexibility of artificial light during daylight and nondaylight hours.

Include dimmers in rooms greater than 100 square feet (9.3 m²).

Incorporate occupancy sensors so that lights turn off automatically when a room is not occupied.

Incorporate daylight sensors with spaces that have skylights or clerestories.

Reduce overall room illumination while concentrating on task lighting.

Limit the use of incandescent and halogen lights to where good color rendering is essential.

INDOOR ENVIRONMENTAL QUALITY

Indoor air quality can be greatly improved by reducing or *eliminating volatile organic compounds* (VOCs), the toxic chemicals emitted from common building and home furnishing products in a process known as off-gassing. The biggest offenders are formaldehyde-based products. Common sources of VOCs include paint, adhesives, sealants, solvents, urethane (used as a wood floor finish), particleboard (used for furniture and cabinets), and carpet. Many of these products come in low-VOC versions, or designers can specify alternative products from an increasingly wide range of companies. Houseplants, too, can help mitigate the effect of VOCs in the environment: A single spider plant or philodendron will absorb VOCs within a 5-foot (1 520 mm) radius. The careful management of natural daylight in a space can do more than reduce the need for artificial lighting. Well-lit spaces with a combination of diffuse and direct natural light have been shown to improve the health and productivity of their occupants. Other strategies that can contribute to indoor environmental quality include monitoring carbon dioxide, increasing ventilation, and providing thermal comfort.

RENEWABLE, RECYCLED, AND RECLAIMED PRODUCTS

A green design agenda must also consider the use of renewable, recycled, and reclaimed resources. *Renewable sources* include fast-growing and responsibly harvested woods that have been certified by the Forest Stewardship Council (FSC) as neither endangered nor genetically modified nor originating from tree farms that have replaced forest land. Recycled materials can be found in numerous products on the market today that use *postconsumer waste* (a product that has been used and is recycled for reuse in another consumer product) as part of the manufacturing process, from recycled plastic carpets and carpet backings to crushed-glass or cement-based solid surfacing. *Preconsumer waste* is the process of recovering, reusing, and recycling the waste products—from household use, manufacturing, agriculture, and business—and thereby reducing their burden on the environment. (Of course, designers should also promote recycling by providing ample, convenient space for recycling

bins in the home or office.) Reclaimed goods are available from many companies that handle and make it easy to purchase and reinstall salvaged materials. In all cases, designers must be cognizant of local economies of labor and supplies.

PROFESSIONAL CREDENTIALS AND SUSTAINABILITY

Credentialing system for LEED accreditation:

1. LEED Green Associate—for professionals with a basic understanding of green building systems and technologies. This is the first credential needed to become a LEED AP.

2. LEED Acredited Professional (AP) with Specialty—there are five types of specialties in the LEED AP category:
 Building Design + Construction (BD + C)
 Interior Design + Construction (ID +C)
 Operations and Maintenance (O + M)
 Homes
 Neighborhood Development (ND)

Note: LEED project experience is required to be able to sit for any of the LEED AP speciality exams

3. LEED Fellow—signifies a level that demonstrates advanced accomplishments, experience and proficiency in LEED practices and principles.

ADDITIONAL SUSTAINABILITY GUIDELINES

Cradle-to-Cradle design (also referred to as C2C, or regenerative design) is a holistic economic, industrial, and social framework that seeks to create systems that are not only efficient but also essentially waste free. The model in its broadest sense is not limited to industrial design and manufacturing; it can be applied to many aspects of human civilization such as urban environments, buildings, economics, and social systems.

Living Building Challenge is a philosophy, advocacy tool, and certification program that promotes the most advanced measurement of sustainability in the built environment possible today. It can be applied to development at all scales, from buildings—both new construction and renovation—to infrastructure, landscapes, and neighborhoods. Living Building Challenge comprises of seven performance areas: site, water, energy, health, materials, equity, and beauty.

Chapter 20: Manual Resources

This book scratches the surface of what the interior design process encompasses. The start of any designer's education is a good resource library. Beyond the present volume, there are a number of publications with which the designer should be familiar. The list that follows is by no means exhaustive, but all these texts—some of which have served as references for this book—expand on the themes addressed here and form the basis of a strong library.

GENERAL REFERENCE

Interior Design, 4th ed.
John F. Pile; Prentice Hall, 2007

Interior Design & Decoration, 6th ed.
Stanley Abercrombie; Prentice Hall, 2006

Interior Design Visual Presention: A Guide to Graphics, Models and Presentation Techniques, 4th ed.
Maureen Mitten; John Wiley & Sons, 2012

Interior Graphic and Design Standards
S. C. Reznikoff; Whitney Library of Design, 1986

Interior Graphic Standards, 2nd ed.
Corky Binggeli and Patricia Greichen; John Wiley & Sons, 2010

Time-Saver Standards for Interior Design and Space Planning, 2nd ed.
Joseph DeChiara, Julius Panero, and Martin Zelnik; McGraw-Hill Professional, 2001

FUNDAMENTALS

Architectural Graphics, 6th ed.
Francis D. K. Ching; John Wiley & Sons, 2015

Construction Drawings and Details for Interiors: Basic Skills, 3rd ed.
W. Otie Kilmer and Rosemary Kilmer; John Wiley & Sons, 2016

The Designer and the Grid
Lucienne Roberts and Julia Thrift; Roto-Vision, 2005

Interior Design Illustrated, 3rd ed.
Francis D. K. Ching and Corky Binggeli; John Wiley & Sons, 2012

Thinking with Type: A Critical Guide for Designers, Writers, Editors, & Students, 2nd ed.
Ellen Lupton; Princeton Architectural Press, 2010

SPACE

Accessible and Useable Buildings and Facilities
International Code Council, 2009

Archetypes in Architecture, 1st ed.
Thomas Thiis-Evensen; Norwegian University Press, 1987

Architectural Graphic Standards, 12th ed.
American Institute of Architects, Dennis J. Hall eds.; John Wiley & Sons, 2016

Art and Visual Perception
Rudolf Arnheim; University of California Press, reprint ed., 1974

Bathrooms: Simply Add Water, Illustrated ed.
Terence Conran; Conran, 2006

The Codes Guidebook for Interiors, 6th ed.
Sharon K. Harmon and Katherine E.
Kennon, eds.; Wiley, 2014

Early American Architecture, reprint addition
Hugh Morrison; Dover Publications, 1987

**Human Dimensions & Interior Space,
revised edition**
Julius Panero and Martin Zelnik;
Watson-Guptill, 1979

**Key Houses of the Twentieth Century: Plans,
Sections and Elevations**
Colin Davies; Laurence King Publishing,
2006

**On the Job: Design and the American Office,
1st ed.**
Donald Albrecht and Chrysanthe B.
Broikos, eds.; Princeton Architectural
Press, 2000

The Place of Houses, new edition
Charles Moore, Gerald Allen, and Donlyn
Lyndon; University of California Press,
2000

The Monocle Guide to Cosy Homes
Monocle Book Collection; Gestalten,
2015

SURFACE

Alexander Girard: A Designer's Universe
Susan Brown, Jochen Eisenbrand,
Barbara Hauss and Mateo Kries;
Vitra Design Museum, 2016

**The Art of Color: The Subjective Experience
and Objective Rationale of Color, rev. ed.**
Johannes Itten; John Wiley & Sons, 1997

**Color Design Workbook: New, Revised
Edition: A Real World Guide to Using Color
in Graphic Design**

Sean Adams, Noreen Morioka, and Terry
Stone; Rockport Publishers, 2017

**Constructing Architecture: Materials, Processes
Structures, 1st ed.**
Andrea Deplazes; Birkhauser, 2005

**Designer's Color Manual: The Complete Guide
Color Theory and Application**
Tom Fraser and Adam Banks; Chronicle
Books, 2004

**Detail Practice: Translucent Material: Glass,
Synthetic Materials, Metal, 1st ed.**
Frank Kaltenbach; Birkhauser, 2004

**I Don't Have a Favourite Colour: Creating the
Vitra Colour & Material Library**
Hella Jongerius; Gestalten, 2016

**Interaction of Color: Revised and Expanded
Edition**
Josef Albers; Yale University Press, 2006

Kelly Hoppen Style: The Golden Rules of Design
Kelly Hoppen; Bulfinch Press, 2004

Knoll Textiles: 1945-2010, 1st ed.
Earl Martin (Ed), Angela Volker, Paul
Makovsky, Susan Ward, Bobbye Tigerman;
Yale University Press, 2011

**Patternalia: An Unconventional History of Polka
Dots, Stripes, Plaid, Camouflage, & Other
Graphic Patterns**
Jude Stewart; Bloomsbury USA, 2015

The Surface Texture Bible
Cat Martin; Stewart, Tabori and Chang,
2005

**Tile Makes the Room: Good Design from Heath
Ceramics, 1st ed.**
Robin Petravic and Catherine Bailey;
Ten Speed Press, 2015

**Transmaterial: A Catalog of Materials That Red
fine Our Physical Environment**
Blaine Brownell; Princeton Architectural
Press, 2005

ENVIRONMENTS

Applying the ADA: Designing with Disabilities Act Standards for Accessible Design
Marcela Rhoads; John Wiley & Sons, 2013

The Architecture of the Well-Tempered Environment
Reyner Banham; Architectural Press, 1984

Building Codes Illustrated: A Guide to Understanding the 2012 International Building Code, 4th ed.
Francis D. K. Ching and Steven R. Winkel; John Wiley & Sons, 2012

Fundamentals of Building Construction: Materials and Methods, 6th ed.
Edward Allen and Joseph Iano; John Wiley & Sons, 2013

Heating, Cooling, Lighting: Sustainable Design Methods for Architects, 4th ed.
Norbert Lechner; John Wiley & Sons, 2014

Lighting Design Basics, 2nd ed.
Mark Karlen, James R. Benya, and Christina Spangler; John Wiley & Sons 2012

Mechanical and Electrical Equipment for Buildings, 12th ed.
Walter T. Grondzik, and Alison G. Kwok; John Wiley & Sons, 2014

ELEMENTS

Classic Herman Miller
Leslie A. Piña; Schiffer Publishing, 1998

Design Since 1945
Peter Dormer; Thames & Hudson, 1993

Design of the 20th Century: 25th Anniversary Edition
Charlotte and Peter Fiell; Taschen, 2005

Interior Design of the 20th Century: Revised and expanded edition
Anne Massey; Thames & Hudson, 2001

Sourcebook of Modern Furniture, 3rd ed.
Jerryll Habegger and Joseph H. Osman; W. W. Norton, 2005

RESOURCES

Guide to the LEED Green Associate V4 Exam (Wiley Series in Sustainable Design), 2nd ed
Michelle Cottrell; John Wiley & Sons, 2014

HOK Guidebook to Sustainable Design, 2nd ed.
Sandra F. Mendler, William Odell, and Mary Ann Lazarous; John Wiley & Sons, 2005

Sustainable Commercial Interiors, 2nd ed.
Penny Bonda and Katie Sosnowchik; John Wiley & Sons, 2014

Sustainable Design for Interior Environments, 2nd ed.
Susan M. Winchip; Fairchild Books, 2011

Sustainable Residential Interiors
Associates III, Kari Foster, Annette Stelmack, and Debbie Hindman; John Wiley & Sons, 2006

Chapter 21: Digital Resources

PROFESSIONAL ORGANIZATIONS

American Institiute of Architects www.aia.org
American Society of Interior Designers www.asid.org
Interior Designer Canada www.interiordesigncanada.org
International Interior Design Association www.iida.org
U.S. Green Building Council www.usgbc.org

MAGAZINES AND JOURNALS

Abitare (Italy) abitare.it
Apartmento apartamentomagazine.com
Architect (USA) www.architectmagazine.com
Architectural Record (USA) www.architecturerecord.com
Azure (Canada) www.azuremagazine.com
Domus (Italy) www.domusweb.it
Dwell (USA) www.dwell.com
Elephant elephantmag.com
Elle Decor (USA) www.elledecor.com
Fast Company fastcompany.com
Interior Design (USA) www.interiordesign.net
Metropolis (USA) www.metropolismag.com
The New York Times Style Magazine www.nytimes.com/section/t-magazine
Surface surfacemagazine.com
Wallpaper* (UK) www.wallpaper.com

WEBSITES AND BLOGS

Architizer architizer.com
ArchDaily archdaily.com
Artsy artsy.net
Coolhunting coolhunting.com
Curbed curbed.com
Design Boom designboom.com
Design Observer designobserver.com
Designspiration designspiration.net
Design*Sponge designsponge.com
Dezeen dezeen.com
iGNANT ignant.com
Inhabitat inhabitat.com
Lynda lynda.com
MOCO LOCO mocoloco.com
officeinsight officeinsight.com
Remodelista remodelista.com

SOFTWARE

CAD and MODELING

ArchiCAD archicad.com
AutoCAD autodesk.com
Blender blender.org
Cinema 4D maxon.net
form·Z formz.com
Revit autodesk.com
Rhinoceros rhino3d.com
SketchUp sketchup.com
Vectorworks nemetschek.net

ONLINE MODELING

Onshape onshape.com
SketchUp sketchup.com
Tinkercad tinkercad.com

RENDERING

Arnold solidangle.com
Corona corona-renderer.com
Maxwell maxwellrender.com
Octane home.otoy.com
Thea thearender.com
Unity unity3d.com
V-Ray chaosgroup.com

INDUSTRY ASSOCIATIONS

Americans with Disabilities Act ada.gov
Architectural Woodwork Association awinet.org
Building Stone Institute buildingstoneinstitute.org
Carpet and Rug Institute carpet-rug.org
Design at the Design Museum designmuseum.org/design
Hardwood Plywood & Veneer Association hpva.org
National Association of Architectural Metal Manufacturers naamm.org
United States National Cad Standard nationalcadstandard.org
National Glass Association glass.org
National Wood Flooring Association woodfloors.org
National Terrazzo and Mosaic Association ntma.com
Oakwood Veneer Company oakwoodveneer.com
Whole Building Design Guide wbdg.org

Shashi Caan, describe yourself and your practice.

I am curious and optimistic. I enjoy understanding the intrinsic nature of people, things, and processes. The what, why, and how are important questions, and the underpinnings of human rituals intrigue me. Change is also a curious phenomenon to me and one that requires exploring edges and redefinitions.

That my life to date has been spent, in almost equal parts, in Asia, Europe, and the North Americas has helped me to question and understand the similarities and uniqueness of major cultures. This, coupled with formal education and degrees in interior design, industrial design, and architecture—all concerned with the human condition and our habitable world—has provided me with a depth of literacy, while helping to shape who I have become.

I am passionate about designing habitable interiors for optimal spatial and functional fulfillment. I am especially interested in helping to envision and shape an improved collective future.

The Collective, my practice, focuses on creativity as an essential ingredient for a design business. We ourselves practice what we preach to our clients by way of finding a creative solution for the shortcomings of today's time-poor work culture. My practice is unique in that it takes its business structure from the underpinnings of the film industry. We hire full-time expertise that is carefully aligned to the needs of a specific client and their project and for the full duration of the project. Our teams work only on one project at a time. We have total flexibility in the structure of the work day, and individuals determine their own schedule. A happy and well-balanced design expert who can intelligently support the client is a priority. We require project schedules and budgets to be maintained with the most innovative and creative design solutions. The quality of all our lives (staff, client, consultant) is fundamentally important for us. Our office culture is relaxed, with lots of play, wit, and respect for everyone concerned. We focus obsessively on research and study, both broad and specific, which informs the basis of all our work, and we have a lot of fun doing it.

Who were the mentors that taught you design and design methodologies?

Three individuals in New York continue to help shape my thinking:

Dr. Haresh Lalvani explores dimensional space and is an architect and scientist interested in empirical research. He has computationally explored the sixteenth dimension. By example, he has instilled in me the value of deeply understanding the nature of literal and perceived space and truly innovating by connecting cross-disciplinary dots.

William Catavalos is funny, irreverent, and has one of the most agile minds I know. He consistently reminds me to be alert, aware, and globally knowledgeable. Through him, I have learned that conceptualization has rational and smart underpinnings rooted in the common, everyday conditions of our lives, which require continued questioning and rethinking.

Dr Theodore Prudon, my business partner, is a genius. From him, I have learned to deeply appreciate logical inquiry and history as a vital reference point. He has taught me to appreciate the meaning that life makes of the ordinary and the extraordinary and everything in between. He is broad-minded and nonjudgmental, which I believe are very important attributes for designers.

I have been most inspired and have learned a lot from historical figures such as William Fogler (the art of creating beautiful and harmonious spatial objects), Rowena Reed (the art of manipulating the void and planer relationships), Anaïs Nin (who was courageous and dared to experience and committedly express herself in black and white), and Coco Chanel (who was a creative and business maverick).

The Collective ranges from built work to strong research and conceptual projects that question interiors and how they function—is there a common method to how you approach these projects?

Simplistically, I aspire to bridge the academy (research, inquiry, history, and theory) with design practice (the actualizing of ideas, building, and business). The two are intrinsically codependent and essential for a healthy public. We must foster a close cooperation and closer communication within these worlds. I also aspire to bridge art and science. I believe that for a holistic understanding of our universe, we need the creative, conceptual comprehension of the artist as well as the intellectual rigor and methodological process of the scientist. Central to all of this is the human being—one person at a time.

I believe that no matter what I am doing at any given time, I am being a designer. My common method is rationalized in the need for a broad cross-fertilization of disciplines and processes and a need to break down prescribed boundaries. There is great opportunity in crossing cultural and intellectual divides. For example, classic color theory (Albers, Itten, and Goethe) explores phenomena that is relevant and helps with visual stimulation and the understanding of our world in our daily experiences. But beyond the learning of the theory itself, designers and architects very rarely fully explore the theoretical phenomena of color. It is not easy to lift theoretical ideas and transplant them in design concepts. A great deal of research, interpretation, and play is required. Everyday life pressures and our cultural dictates hinder our making these connections that lead to innovation. At the Collective, it's my job to continue to try, no matter how difficult. I believe that deeper inquiry and research is critical from within the making and it's my business to find ways to manifest these beliefs. I think this is the single binding element to my work, regardless of the scale of the project or whether it is two- or three-dimensional.

Many practices often dedicate time and money to building a reference library. What kinds of material do you look to for inspiration, or to challenge your understanding of how you work?

While we do have some dedicated space for product binders and materials, our biggest space is our extensive book library on very diverse topics (history, art, philosophies, ideologies, science), both classics and new works. We use the Internet, college and public libraries, and a myriad of periodicals (including daily newspapers) for inspiration. I believe that we can best understand people and the human condition through the world of thought and what is being expressed by many and also by the actions that people are taking at any given time. Often, words are not in sync with actions. And herein sits an enormous opportunity for observation and critical analysis, leading to fresher and more appropriate solutions. Since all aspects of politics, world finance, technology, and commerce affect our lives, in practicing interior design, it is very important for us to keep a finger on the pulse of the world at large. I am as much intrigued by the latest wedding culture as by the significant scientific findings that could dramatically change our future. Through this very broad net of inquiry, at the Collective, we make it our business to keep the focus on interpretation and application within the built work.

Presentation is a major element in the transmission of design ideas to an audience—be it a client, student, or the general public. How do you present the results of your research?

This is a very important question for us in the practice. We believe in finding the most direct and simple communication—one that is succinct and articulate. We use multimedia and will explore new means of representation as long as the end result is clearly understood by all and within seconds at the outset. Since we are not interested in advocating a particular signature or style, we are constantly exploring and often layering and collaging presentations. One common feature of our work is that all research is shared back visually with an effort to engage as many of the senses as we can. We do not rely only on images or scale models. We try to capture movement and intentional change, which is a recurring theme in our work, and we avoid depending on an individual's imagination to interpret our work. Rather, we show and tell as explicitly as possible.

You have been chair of a major design school. What were your methodological aims in defining an educational program for young designers?

In my opinion, all good education aspires to imbue individuals with an ability not only to think but simultaneously to know and understand oneself in a lifelong quest. Using one's intelligence and creativity in a sound and just manner is critical to society. Design education is special in that it requires equally a focus on self-knowledge and access to one's creativity, while using it for the betterment of all. To achieve this, one must develop one's own process. Essentially, three components must be methodically honed:

First, the process of an objective inquiry and analysis toward solving societal concerns, problems, and issues—a process of thinking.

Second, the cultivation and learning of a broad skill set that allows one to select the most appropriate skills and tools for one's unique expression toward accurate and easy communication. A deep and sound knowledge of interior design: what it is, what it does, its significance and importance, how to do it, where it originates from and where one needs to take it for improved results toward shaping a better society.

Third, since interior design is a young formalized profession, we have to continue to more deeply and holistically define and evolve the discipline.

Do you think that the push toward professional licensure in interior design is necessary or beneficial? How will it change how the public perceives interior designers?

I believe that interior design as a discipline shapes human behavior and has a responsibility for well being. I also believe that interior design is to the built world what psychology is to the world of medicine or what physics is to the world of science. To this end, I think it is essential for the discipline to be better defined and publicly recognized as a legitimate profession. Today, we know exactly when to go to the psychologist versus the doctor. This level of professional clarity is required for interior design. Governmental ratification demands a clarity of professional responsibility, which translates into a clarity of the public's understanding. The public needs to be protected from unqualified interior designers who can do a lot of damage. Licensure helps to protect the public.

How do you see the emergence of sustainability affecting the ways in which we build interiors?

Environmental consciousness is not an emergence for us at the Collective. It is a responsible way of life and way of being. The thoughtful interior designer is intrinsically practicing it. It is not a stylistic choice or a marketing differentiator. Good interior design must lead the way.

Many place the origins of the interior design profession at the turn of the twentieth century. You locate the start of our understanding of interiors to a much earlier date. How do we begin to trace interiors through a macro history?

We start at the earliest beginning possible. The interior is a necessity. When we seek shelter, we don't think about a building typology and we don't think "architecture," we think "inside." The first-ever shelter was not built, it was found. It was an inside and it predated architecture. This is where interior design begins. We need to take it from there.

Overleaf Durkan Patterned. Renderings by Shashi Caan Collective.

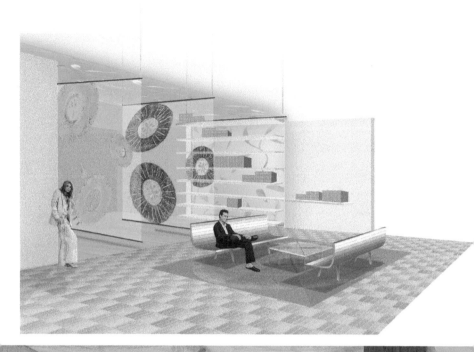

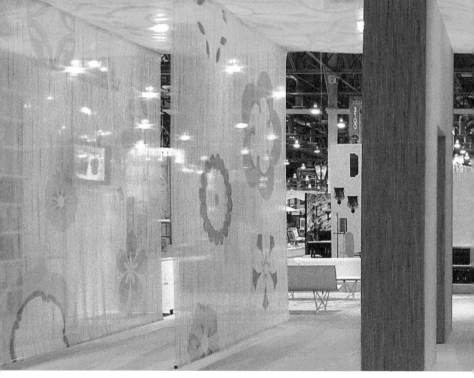

Index

Acknowledgments

Special thanks to Kelly Harris Smith and Tim Love—we could not have done it without their time and effort—and to Alicia Kennedy for her insight and encouragement throughout the process.

For additional assistance: Ann Theresa Karash, Shae Morley, Balasz Bognar, Christine Nassir, Paula Read, Tina Luk, Ian Kenney and Chris Minor.

For her invaluable assistance, Betsy Gammons at Rockport Publishers.

For their generosity in sharing their perceptions of the discipline, the designers interviewed here.

Deborah Berke **www.dberke.com**
Shashi Caan **www.sccollective.com**
Michael Gabellini **www.gabellinisheppard.com**
Annabelle Selldorf **www.selldorf.com**
Calvin Tsao **www.tsao-mckown.com**
George Yabu and Glenn Pushelberg **www.yabupushelberg.com**

CREDITS

Photographic sources are cited alongside the images; uncredited photographs and all renderings and drawings are by the authors.

Every attempt has been made to cite all sources; if a reference has been omitted, please contact the publisher for correction in subsequent editions.

About the Authors

Chris Grimley is a partner at the firm over,under, an interdisciplinary practice that creates built environments and designed experiences through the lens of advocacy. Chris has organized, designed, and implemented city-wide master plans, interiors, and branding initiatives for clients ranging from small municipalities to large institutions. The firm's designs, research, and the exhibits of its gallery have been widely published.
www.overunder.co

Mimi Love was born in Laredo, Texas. She received a professional degree in architecture from the University of Texas, Austin. She worked in the New York at Perkins & Will and later at Kohn, Pedersen & Fox on various building types that ranged from new construction to renovation projects. At Machado & Silvetti Associates she was the lead designer for the renovation of the J. Paul Getty Museum of Antiquities in Pacific Palisades, California. She was also the project coordinator for the renovation and expansion of the Bowdoin College Museum of Art. She is currently a principal at Utile, Inc., focusing on interior renovation projects. www.utiledesign.com

CPSIA information can be obtained
at www.ICGtesting.com
Printed in the USA
LVHW071007051222
734596LV00020B/1236

9 781631 593802